OXFORD WORLD'S CLASSICS

LIFE, LETTERS, AND POETRY

MICHELANGELO BUONARROTI was born in 1475 in Caprese, where his father, a member of the minor Florentine nobility, was *podestà*. Apprenticed in Florence to Ghirlandaio in 1488, Michelangelo learned the elements of fresco technique and developed his lifelong, absorbing interest in sculpture, possibly with Bertoldo di Giovanni. His talent attracted the notice of Lorenzo de' Medici, and patrons in Florence and Rome, the cities between which he subsequently divided his time, fulfilling commissions for the Medici family and for the Popes.

Michelangelo's masterpieces, such as the *David*, his magnificent frescos in the Sistine Chapel, and the Basilica of St Peter's, are his greatest legacy. But in his poems and his letters to friends and patrons he also left an impressive record of his unique artistic talent and forceful personality, that of a 'divine genius' endowed with *terribilità*, or intense, emotional power. Michelangelo died in Rome in 1564.

GEORGE BULL is an author, publisher, and journalist who has divided his working life between editing and writing on economic and financial subjects, and historical studies. His books include *Michelangelo: A Biography*, *Inside the Vatican* (translated into Italian, German, and Japanese), and his translations from Italian of works by Machiavelli, Cellini, Vasari, Aretino, Pietro della Valle, and Castiglione. He is editor of *International Minds*.

PETER PORTER, collaborator on the translation of Michelangelo's poetry for this edition, is a poet, writer, broadcaster, and critic who came from Australia to England in 1951. His many volumes of verse include the translations *After Martial* (1972); his collected poems were published in 1983.

W9-CGM-419

OXFORD WORLD'S CLASSICS

*For over 100 years Oxford World's Classics have brought
readers closer to the world's great literature. Now with over 700
titles—from the 4,000-year-old myths of Mesopotamia to the
twentieth century's greatest novels—the series makes available
lesser-known as well as celebrated writing.*

*The pocket-sized hardbacks of the early years contained
introductions by Virginia Woolf, T. S. Eliot, Graham Greene,
and other literary figures which enriched the experience of reading.
Today the series is recognized for its fine scholarship and
reliability in texts that span world literature, drama and poetry,
religion, philosophy and politics. Each edition includes perceptive
commentary and essential background information to meet the
changing needs of readers.*

OXFORD WORLD'S CLASSICS

MICHELANGELO

Life, Letters, and Poetry

Selected and translated with an Introduction and Notes by
GEORGE BULL

Poems translated by
GEORGE BULL
and
PETER PORTER

OXFORD
UNIVERSITY PRESS

OXFORD
UNIVERSITY PRESS

Great Clarendon Street, Oxford OX2 6DP

Oxford University Press is a department of the University of Oxford.
It furthers the University's objective of excellence in research, scholarship,
and education by publishing worldwide in

Oxford New York

Athens Auckland Bangkok Bogotá Buenos Aires Calcutta
Cape Town Chennai Dar es Salaam Delhi Florence Hong Kong Istanbul
Karachi Kuala Lumpur Madrid Melbourne Mexico City Mumbai
Nairobi Paris São Paulo Singapore Taipei Tokyo Toronto Warsaw

with associated companies in Berlin Ibadan

Oxford is a registered trade mark of Oxford University Press
in the UK and in certain other countries

Published in the United States
by Oxford University Press Inc., New York

This selection and translation © George Bull 1987

The moral rights of the author have been asserted

Database right Oxford University Press (maker)

First published as a World's Classics paperback 1987
Reissued as an Oxford World's Classics paperback 1999
Reissued 2008

British Library Cataloguing in Publication Data

Data available

Library of Congress Cataloging in Publication Data

Michelangelo, life, letters, and poetry.
(Oxford world's classics)
Bibliography: p.
1. Michelangelo Buonarroti, 1475–1564. 2. Artists—Italy—Biography.
I. Bull, George Anthony. II. Porter, Peter.
N6923.B9M549 1987 700'.92'4 [B] 87–11315

ISBN 978-0-19-953736-5

3

Printed in Great Britain by
Clays Ltd, St Ives plc

TO
Peter and Linda Murray

ACKNOWLEDGEMENTS

In preparing the translations that follow I have been helped generously by Professor Giovanni Aquilecchia; Professor Peter and Linda Murray; Professor Sir John Hale; my fellow-translator, the late Bruce Penman; and Professor J. H. Whitfield. I owe them thanks for encouragement, counsel, and invaluable advice on particular problems of language. Dr Michael Hirst has strongly influenced my assessment of the significance of Condivi's *Life*. My daughter, Jennifer, has been a responsive and responsible typist.

G.B.

CONTENTS

INTRODUCTION

AMONG all artists' lives that of Michelangelo Buonarroti is the best documented, and the very varied sources yield not only rich insights into his talent but also valuable information about the Italian Renaissance and the course of Italian cultural history during the sixteenth century. Michelangelo lived to be nearly 90. He was born on 6 March 1475 and died on 18 February 1564. Ever proud of his noble family ancestry, he grew up in Tuscany and spent most of his life in Rome, where he worked as an artist for seven Popes in turn.

Pride of place in the biographical material about Michelangelo must go to his devoted follower, Giorgio Vasari, a fellow-Tuscan and prolific painter, whose *Lives of the Artists*, when they were first published in 1550, ended with an account of the life and works of Michelangelo, the only living artist then included in Vasari's literary masterpiece. Destined to shape the way the Renaissance was perceived for centuries to come, and still influential, Vasari's *Lives* interpreted the history of art as a divinely assisted process of development in long cycles of progress and decline, culminating in his own time in the triumph of Michelangelo.

The benign ruler of Heaven, Vasari's *Life* begins, seeing how vainly the artists were striving to perfect their arts, decided to send down to earth a genius who would be competent in each and every art and all branches of learning, succeeding by himself (*per solo*) in bringing to perfection the techniques of painting, sculpture and architecture. In his second edition of the *Lives*, published in 1568, Vasari added more accounts of living artists, including himself; but the centrepiece and true climax of his history of the development of art remained the relatively long heroic life of Michelangelo, who had 'surpassed and

vanquished the ancients' and brought the three fine arts to 'complete perfection'.

Michelangelo was not alive to read these glowing words but he had read the first edition and been less than satisfied. Not vanity but a fierce self-regard, a sense of grievance, and determination to explain himself sharpened his anxiety to set down or have recorded the true story as he saw it of his genesis as an artist and of the tragedy of the Tomb of Julius II: a giant project on successive scaled-down versions of which he laboured for decades. This need was the inspiration for the *Life* of Michelangelo written by Ascanio Condivi.

The book was not supervised in detail by Michelangelo nor, after Vasari's first effort, did it in turn satisfy him as wholly accurate; but, despite some serious factual errors, Condivi's *Life* conveys Michelangelo's authentic voice and feelings, reading in many parts as if the old artist were standing and talking at his pupil's elbow. 'When I was discussing this with Michelangelo one day . . .' Condivi writes in one place; 'many times i have heard him say . . .' he adds in another. Condivi's *Life* published in 1553 helped decisively to round out the fuller picture of Michelangelo drawn in the second edition of Vasari's *Lives*. It constitutes a critically important source for Michelangelo's life and, carefully interpreted, for Michelangelo's vision of himself; also, though hurriedly written, its eager simplicity of style and anecdotal content make it vividly readable as it describes Michelangelo's works and sketches his character in all its poignancy and power.

Vasari wrote unkindly that among the pupils whom Michelangelo chose to live with him, but who were hardly capable of following him, was Ascanio della Ripa Transone who 'worked very hard indeed but never produced results, either in the form of designs or finished works . . . and all in all the high expectations he aroused have gone up in smoke'. Apart from this jaundiced remark, we know little of Condivi's work as an artist and not a great deal about his life. Ripatransone, where he was born in 1525, is between Ancona and Pescara near the Adriatic coast. He

lived with Michelangelo in Rome for several years and returned to his home town to paint an altarpiece for the local church in 1554. In 1556 he married Porzia Caro, the niece of Michelangelo's friend, the courtier and man of letters, Annibale Caro, and he was elected to the Florentine Academy after Michelangelo's death. He died in 1574, by drowning, as he attempted to ford a stream.

Condivi's *Life* was published in Rome in 1553. Addressing the reader, Condivi says that he was rushing into print 'because there have been some who in writing about this rare man . . . on the one hand said things about him that never happened, and on the other have left out many of those most worthy of being recorded'. Vasari's response to this, in his second version of Michelangelo's *Life*, was to point to the close and affectionate ties between himself and Michelangelo, and to take issue over one particular point: namely, Condivi's claim that in his youth Michelangelo was given no help by his fellow-Florentine Domenico Ghirlandaio, who was, on the contrary, envious of his talent. Michelangelo, asserts Vasari, citing his sources, in fact did his apprenticeship as a painter with Ghirlandaio. This dispute reflects Michelangelo's reluctance to acknowledge the artistic debts he owed to others. It has the same ring of subjective truth as the reported remark that from him Raphael learned all he knew. Similarly, the works chosen for comparatively lengthy discussion in Condivi's *Life*, or those passed over in silence such as some of the unfinished sculptures and the bust of Brutus, point to Michelangelo's own views of the proper work by which he should be judged, possibly a sense of defeat over the abandoned statues and the fact that the subject for his Brutus may have commemorated the murder of Lorenzino, the assassin of Alessandro de' Medici, and attest to Michelangelo's repressed republican sentiments. Above all, the stress in Condivi's *Life* on the details of the prolonged argument between Michelangelo and the heirs of Julius II, over his delays in completing the Pope's Tomb, and over the financial detail of this heart-breaking saga increases the importance of Condivi's book as a

revelation of Michelangelo's tormented mind: his own *apologia*. Read in conjunction with relevant letters of Michelangelo, the *Life* as well as meat for scholars furnishes fascinating insights into his raw nerves and self-esteem and also his artistic values. But he was a rounded man of genius and Condivi's *Life* serves to charm with its intimations of his humanity as well as instruct through its lively expressiveness and observation.

The enthralling description of the statue of Moses, 'sitting there in the attitude of a wise and thoughtful man, holding in his right hand the tablets of the law', ends with the important comment that despite the fact that the figure is clothed this does not destroy the beauty of his body which illustrates a practice 'universally followed by Michelangelo in all his clothed figures, either sculpture or in painting'. Michelangelo's love of beauty and above all the beauty of the human body is stressed and illustrated throughout the *Life* by illuminating references to particular works. The *Last Judgement*, in the Sistine Chapel, 'represented everything it is possible for nature to do with the human body'. For all the figures Michelangelo painted 'he never made two alike or with the same attitudes . . .'.

These tantalizingly few fragments of criticism of Michelangelo's philosophy and practice of art are accompanied in Condivi's *Life* by glimpses of his personality and behaviour which enhance the book's value. They include the story of the faun which he did in the Medici garden, and his encounter there with Lorenzo de' Medici; the dramatic incidents of his emotion-laden relationship with Pope Julius II; the moving story of his subsequent regret that when he saw Vittoria Colonna as she lay dying, he kissed not her brow or her face but simply her hand. These passages, along with instances of Michelangelo's wit and temper, the description of his face and physique, and the spirited rejection of attacks on his sexual behaviour, round off the worth of Condivi's *Life* as the basis for the history and myth of Michelangelo as the exemplar of the artist.

My translated selection of the letters of Michelangelo is

meant to illustrate different aspects of his life as a man and an artist and to demonstrate the variety and vigour of his style: a robust Tuscan, ranging from flowery language for formal approaches to blunt invective for family use and employing a great deal of vivid metaphor and verbal play, as in his letter to the priest Giovan Francesco about a joke statue.

The letters take up the theme of Michelangelo's long struggle over the tragedy of the tomb; they rarely but illuminatingly deal directly with his techniques and intentions as an artist; they notably throw into relief his complex, sardonic, sensitive, witty, and passionately affectionate and ambivalent character. Undertones of anger and irony run through most of them. Although often dealing with simple practical matters—the investment of money or the measurements of a marble block—they complement Michelangelo's works of art in also touching constantly on the great themes of human affection, ambition, religion, and death. They are among the very many paths which can be profitably followed to gain an understanding of Michelangelo's genius which comprehended the grotesque as well as the sublime.

The letters add substantially to the image of Michelangelo the supreme artist, obsessed with all aspects of life. Many of them gain from being read with relevant artistic works of Michelangelo's also in mind; thus the brief letters to Tommaso Cavalieri express almost shyly and awkwardly what the drawings he did for Cavalieri capture with extraordinary power.

Michelangelo was a constant writer and from innumerable letters 490 survive, mostly in the original autographs. From these I have translated 52, covering the years from 1496, when he first went to Rome, to 1563, when he was protesting to his nephew Lionardo that he was not to be treated like a child. The letters are addressed chiefly to his relations, and mainly his father Lodovico, to his fellow-artists and agents, to his patrons and friends, and in one instance to his knowing and jealous critic, Pietro Aretino. (The generous writer, none the less, of the tribute that

'The world has many Kings but only one Michelangelo . . .'.) Michelangelo's letters to his family—the majority of those extant—and the practical letters yield diverting, useful information about his emotions and movements; those to his fellow-artists, patrons, and friends are a rich source of speculation and reflection on his deepest emotions and artistic ideals: his homosexuality, his neo-Platonism and his piety. As the painter Francis Bacon has said of the sculpture which was his preferred art, there is a 'wonderful sense of volume' to it.

Michelangelo was one of the most original of Italian poets, giving to the forms he inherited, especially the Petrarchan sonnet, fresh verbal freedom and inventiveness, and a deep spiritual and emotional intensity. The *Rime* of Michelangelo, who loved music and the human voice, have attracted composers from contemporary madrigalists to Hugo Wolf and Benjamin Britten in our own time. He was held to be a luminous poet by his contemporaries, and after a long period of neglect (in Italy especially) his poetry has come into its own as literature worthy of study, intellectually and emotionally challenging and expressive, and pleasurable to read. It is immensely variegated, ranging from black humour, surrealism, and obscenity in verses of agonized complaint or self-parody to the baroque imagery, Platonic fervour, and lyricism of his amorous and religious stanzas. As with the letters, Michelangelo's poems sometimes shed light on his artistic thinking and techniques, the subject of art being one of the overarching themes of his poetry, along with sacred and secular love, illness and death, and his native land. He used verse, constantly varying in tone and pace, as a vehicle for an amazingly wide range of purposes: from fleeting thoughts on the theme of Night or Fire, to messages of anger, self-mockery, or consolation.

Michelangelo's verse was an instinctive way for him to turn his experiences, where they did not fit into one form of art or craft, into yet another—nothing wasted—never without some flash of originality of thought and language,

and sometimes with results approaching the splendour of his pictures and statues. Interweaving with his work as an artist and with his letters, strengthening the impression of his intellectual cohesion, his poems shift our view of Michelangelo's spiritual and mental landscape, omitting some subjects covered by his art, such as the classical nudes, extending the observation of others, such as death and resurrection. They cluster in several distinct groups and show poetical skill in several demanding forms, from sonnets (chiefly) to madrigals, stanzas in *terza rima*, and epigrams. Following the verses inspired successively by the personalities of Tommaso de' Cavalieri, Vittoria Colonna, and Cecchino Braccio (and the autobiographical and burlesque material) in the last decades of his life, Michelangelo's poetry grew more deeply and poignantly religious, like his sculpture and painting.

Translating poetry whose language and sentiments reflect both an age in complex transition and a personality of tremendous force using language boldly and experimentally and words like chisels, is an exhilarating and perilous enterprise. From my blocked out versions of eighteen of the sonnets and madrigals and five epigrams, Peter Porter—respectful of Michelangelo's tortured Muse—has aimed to produce, in his own words, not 'cobbled together English translations' but disciplined poems. The poems translated are thus twice removed from Michelangelo's idiosyncratic Tuscan, with its dense content expressed mostly through often violated Petrarchan form in lines teeming with paradox, inversion, alliteration, and internal rhyme. But they ring true to Michelangelo's poetic methods and moods, and, I think, do not depart from his intentions. They are also beautifully crafted and moving English-made poems.

There are interesting parallels between themes and phrases in the poetry of Shakespeare and that of Michelangelo (who died in the year that Shakespeare was born) though direct influences seem to be ruled out. The sonnets translated by Wyatt from Petrarch's *Rime*, with their anticipations of Donne, point to the receptiveness in

Renaissance England for the kind of conceits and verse forms which influenced Michelangelo. But though he was less neglected as a poet in England than (till recently) in Italy, Michelangelo has received only spasmodic and often exasperated attention from English-speaking poets. For Richard Duppa's *Life and Works of Michel Angelo Buonarroti* at the beginning of the nineteenth century, Southey translated two of the sonnets, those on Dante, and Wordsworth translated a 'fragment' from the ingenious half-pastoral, half-allegorical octave stanzas in praise of rustic life; the quatrain spoken by the statue *Night*; and two of the religious sonnets. (Four, possibly five, depending on attribution, of Wordsworth's translations of the sonnets are extant, one of them in two versions.) The combination of Wordsworth and Michelangelo inevitably produced some memorable lines, such as the conclusion of the sonnet *Ben può talor col mie 'rdente desio* (Girardi, 259):

> But, in chaste hearts uninfluenced by the power
> Of outward change, there blooms a deathless flower,
> That breathes on earth the air of paradise.

Wordsworth, however, abandoned his original thought of translating fifteen of the sonnets, after he had already written in a letter of 1805 that Michelangelo's poetry was 'the most difficult to construe that I have ever met with, but just what you would expect from such a man, showing abundantly how conversant his soul was with great things ...'. He added that Michelangelo packed so much excellent meaning into so little room, that he found the problem of translating 'insurmountable'. Later, John Addington Symonds, Longfellow, and Emerson were the most distinguished nineteenth-century poets to produce selective translations of the sonnets which, though honest and well-intentioned, were coloured by Victorian sentiment and terminology whose rhetoric could not express Michelangelo's range of religious and erotic feeling, or reproduce the force and muscularity of his language and syntax. In our own century, the challenge has been bravely taken up

by a few poets ranging from Robert Bridges to Elizabeth Jennings.

In Italy the first edition of the *Rime* came from Michelangelo Buonarroti the younger (son of Michelangelo's nephew, Lionardo) in 1623, but the verses were here and there unabashedly rewritten, with the poems meant for Tommaso Cavalieri, for example, rephrased as if addressed to a woman. Not until 1863 did there appear a better and respectable edition of the *Rime*, by Cesare Guasti, who was followed by the German Carl Frey (in 1897) and by Enzo Girardi (in 1960). In this edition, Michelangelo's poetry covers 302 poems and 41 fragments of verse, underlining the abundance as well as the brilliance of his sane and versatile genius, which as Vasari said of his friendships, was indeed most copious.

SELECT BIBLIOGRAPHY

FROM the vast literature, I recommend the following for pleasurable and instructive reading.

In English

The Life of Michelangelo Buonarroti, John Addington Symonds (various from 1892).

Life and Works of Michelangelo Buonarroti, Charles Heath Wilson (London, 1876).

Michael Angelo Buonarroti, Charles Holroyd (London, 1903, includes a translation of Condivi's *Life*).

Michelangelo's Theory of Art, Robert J. Clements (first published in England, 1963).

The Poetry of Michelangelo, Robert J. Clements (first British Commonwealth edn., 1966).

Michelangelo, Herbert von Einem, trans. Robert Taylor (London, 1973).

Michelangelo: Sculptor, Painter, Architect, Charles de Tolnay, trans. Gaynor Woodhouse (Princeton University Press, 1975. A reduction of the five volume edition, Princeton University Press, 1943).

Michelangelo, Linda Murray (London, 1980).

Michelangelo, Howard Hibbard (London, 1975).

The Architecture of Michelangelo, James S. Ackerman (London, 1961; Penguin, 1970).

Michelangelo's David: A Quest for Identity, Charles Seymour (University of Pittsburgh Press, 1967).

Sculpture, Rudolf Wittkower (London, 1977).

Michelangelo and the Language of Art, David Summers (Princeton, 1981).

Michelangelo: His Life, Work and Times, Linda Murray (London, 1984).

Michelangelo's Poetry: Fury of Form, Glauco Cambon (Princeton, 1985).

The Sistine Chapel, Michelangelo Rediscovered, trs. Paul Holberton (London, 1986).

Michelangelo: A Biography, George Bull (London, 1995).

Michelangelo Drawings, ed. Craig Hugh Smyth with Ann Gilkerson (Washington, 1988).

The Poetry of Michelangelo: An Introduction, Christopher Ryan (London, 1998).

Michelangelo: Selected Scholarship in English, ed. William Wallace, five volumes (New York and London, 1995).

Michelangelo: The Vatican Frescoes, Pierluigi de Vecchi, with Gianluigi Colalucci (New York, 1996).

Vasari's Florence: Artists and Literati at the Medicean Court, ed. Philip Jacks (Cambridge, 1998).

'"Ché Ultima Mano!": Tiberio Calcagni's Marginal Annotations to Condivi's *Life of Michelangelo*', Caroline Elam, *Renaissance Quarterly,* 51/2 (Summer 1998), 475–95.

In Italian

Il carteggio di Michelangelo, ed. Barocchi and Ristori (Florence, 1965–83).

Le Lettere di Michelangelo Buonarroti, Gaetano Milanesi (Biblio Verlag Osnabrück, 1976).

Rime di Michelangelo, ed. Girardi (Bari, 1960).

Michelangelo scrittore, Walter Binni (Rome, 1965).

Studi sulle Rime di Michelangelo, Enzo Noe Girardi (Milan, 1964).

Michelangelo e la Controriforma, Romeo de Maio (Rome, 1981).

I Ricordi di Michelangelo, ed. Lucilla Bardeschi Ciulich and Paoloa Barocchi (Florence, 1970).

Translations

The Letters of Michelangelo, 2 vols., trans., ed., and annotated, E. H. Ramsden (London, 1963).

The Life of Michelangelo, Ascanio Condivi, trans. Alice Sedgwick Wohl (Baton Rouge and Oxford, 1976).

Complete Poems and Selected Letters of Michelangelo, trans. Creighton Gilbert (first Princeton paperback printing, 1980).

The Sonnets of Michael Angelo Buonarroti, trans. John Addington Symonds (Many edns.).

The Sonnets of Michelangelo, trans. Elizabeth Jennings (Folio, London, 1961).

The Complete Poems of Michelangelo, trans. Joseph Tusiani (London, Peter Owen, 1961).

The Lives of the Artists, Giorgio Vasari, trans. George Bull (Penguin Books, 1965).

Michelangelo: The Poems, ed. and trans. Christopher Ryan (London, 1996).

A CHRONOLOGY OF MICHELANGELO

1475 Michelangelo (Michelangiolo di Lodovico di Lionardo di Buonarroto Simoni) born 6 March in Caprese, near Arezzo (today, Caprese Michelangelo). He was the second of five children. His father was then *podestà* of Caprese and Chiusi; his mother, Francesca di Neri di Miniato del Sera, died when he was 6.

1488 1 April: apprenticed to Domenico and Davide Ghirlandaio for a period of three years.

1489–90 Continued his studies in the Medici garden museum, near San Marco, under Bertoldo di Giovanni, sculptor and pupil of Donatello. Befriended by Lorenzo the Magnificent.

1492 8 April: on the death of Lorenzo, Michelangelo returned home but later was asked to live in the Casa de' Medici and work for Piero.

1494 Quit Florence for Venice and Bologna, where he stayed with the Bolognese nobleman, Gianfrancesco Aldovrandi.
9 November: expulsion of Piero de' Medici from Florence.

1495 Michelangelo went back to Florence.

1496 25 June: Michelangelo arrived in Rome where he stayed till 1501, enjoying the patronage of Cardinal Raffaele Riario, Jacopo Galli, and Cardinal Jean Bilhères de Lagraulas.

1497 To Carrara for first time to quarry marble for the *Pietà* (the *Madonna della Febbre*). July: death of his stepmother, Lucrezia.

The main known works of this period were the *Madonna of the Steps; Battle of the Centaurs; Hercules;* wooden Crucifix for Santo Spirito; three small marble statues for the tomb of St Dominic; *St John; Sleeping Cupid; Bacchus;* the *Pietà*.

1501 Michelangelo returned to Florence, now a Republic

under Soderini. Statues commissioned for Piccolomini altar in Siena cathedral.

1503 Election and death of Pius III. Election of Julius II. Michelangelo commissioned to make twelve statues of Apostles for Santa Maria del Fiore.

1505–8 Michelangelo was summoned to Rome by Julius and commissioned to build his tomb, and fled to Bologna. Julius secured his services in Bologna and then in Rome where he was commissioned to paint the vault of the Sistine chapel, after the abandonment of the original project for the tomb.

1512 The Medici came back to rule Florence. Uncovering of the vault of the Sistine chapel.

1513 20/21 February: death of Julius II. Election of Leo X, second son of Lorenzo the Magnificent. Michelangelo signed a contract for the tomb with the Della Rovere heirs of Julius.

1516 Second contract for the tomb of Julius II.

1518 Contract from Pope Leo for the façade of San Lorenzo in Florence, the Medici family church, subsequently abandoned for (probably) lack of funds.

1520 Plans for the Medici Chapel, the New Sacristry of San Lorenzo.

1521 1 December: death of Leo X.

1522–3 Election and death of Adrian VI. Election 19 November 1523 of Clement VII, Giulio de' Medici, grandson of Lorenzo the Magnificent.

1524 Michelangelo worked on the Medici tombs, the new Sacristry, and the Laurentian Library.

1527–9 6 May: sack of Rome by mutinous Imperial troops. The Medici were expelled from Florence, Michelangelo elected to the *Nove della Militizia* (10 January 1529) fled from and returned to Florence, to resume his position as Governor for the fortifications. His brother Buonarroto died of the plague.

1530 12 August: capitulation—and end—of the Republic of Florence. Michelangelo pardoned by Pope Clement VII.

1531 Michelangelo's father died.
 1 May: Alessandro de' Medici made Duke of Florence.

1532 New (third) contract for the tomb of Julius II. Michel-
 angelo's (probable) first meeting with Tommaso Cava-
 lieri.

1534 23 September: after making brief visits to Rome from
 1532, Michelangelo went to live there for good. Death
 of Clement VII.

These years, starting with the swift ascent of Michelangelo to
fame in Florence and marked by political turmoil in Italy and his
agonizing over the tomb of Julius, yielded chiefly: the giant
marble statue of *David;* the Doni Tondo; the *Bruges Madonna*;
the cartoon for the *Battle of Cascina* (in competition with
Leonardo da Vinci); the Pitti Tondo and the Taddei Tondo; the
bronze statue of Julius II; the vault of the Sistine chapel; the
Moses, the two *Slaves,* or *Captives,* the architectural frame, and
the *Victory* for the tomb of Julius II; the *Leda and the Swan;* the
Risen Christ in marble; the four Florentine *Slaves* for the tomb;
the New Sacristy of San Lorenzo and the Medici Tombs with
statues of Lorenzo and Giulano de' Medici, of *Night* and *Day,*
Dawn and *Dusk;* the Laurentian Library with its projected
vestibule staircase—not finished for many years.

1534 13 October: election of Paul III, humanist and reformer
 and protagonist of the Counter-Reformation. Michel-
 angelo to decorate the end walls of the Sistine chapel, as
 already agreed with Clement VII.

1535 Michelangelo appointed chief sculptor, painter, and
 architect to the Pope.

1536 Michelangelo started work on the *Last Judgement*
 fresco. About now he met Vittoria Colonna, widow of
 the Marquis of Pescara, for the first time. A Papal *motu
 proprio* exempted him from the penalties for not fulfill-
 ing the contract for the tomb of Julius.

1537 Cosimo de' Medici became ruler of Florence.

1541 31 October: *Last Judgement* uncovered and (25
 December) on show to the public.

1542–5 Work on the frescos of the Pauline chapel. Last contract
 for the tomb of Julius II (February 1545). Vittoria, and
 Michelangelo himself were seriously ill during these
 years and his fondly admired young Cecchino Bracci
 died.

1546 Michelangelo made a Roman citizen. Death of his close friend Luigi del Riccio and of the architect Antonio da Sangallo the Younger.

1547 1 January: Michelangelo was appointed architect of St Peter's. Death of Vittoria Colonna and of Sebastiano del Piombo.

1548 9 January: death of Giovan Simone, Michelangelo's brother.

1549 10 November: death of Paul III, shortly after he had conferred on Michelangelo the title of supreme architect of St Peter's and viewed the nearly complete fresco of the *Martyrdom of St Peter* in the Pauline chapel.

During these fifteen years taking Michelangelo to his mid-seventies and a serious illness from gall stones, he chiefly: decorated Paul III's private chapel with the two frescos of the *Conversion of St Paul* and the *Crucifixion of St Peter;* worked on the bust of *Brutus;* completed the Farnese Palace; and began planning the Roman Capitol and St Peter's.

His friendship with Tommaso Cavalieri and his acquaintance with Vittoria Colonna inspired an outpouring of verse.

1550 8 February: election of Julius III. Publication of the first edition of the Lives (culminating with the Life of Michelangelo) by Giorgio Vasari.

1553 Michelangelo's nephew Lionardo married Cassandra di Donato Ridolfi. Ascanio Condivi's *Life* of Michelangelo published in July.

1554 Birth of a son, Buonarroto, to Lionardo and Cassandra.

1555 23 March: death of Julius III. Pope Marcellus II reigned for about two weeks and the rigorous, austere Paul IV was elected on 23 May. Michelangelo was affected by the death of his brother, Sigismondo, and, very deeply, by that of his friend and servant Urbino (Francesco d'Amadore).

1559 18 August: death of Paul IV and (25 December) election of a magnificent patron of the arts, Pius IV.

1563 Michelangelo was elected an academician (the second after the Duke) of the Florentine *Accademia del Disegno*.

1564 18 February: death of Michelangelo in his home at Macel de' Corvi.

In his seventies, Michelangelo was chiefly engaged in performing his duties as architect of St Peter's; but his deepening versatility found expression also in: architectural projects for the church of San Giovanni dei Fiorentini and for the Cortile del Belvedere; the *Pietà* of Santa Maria del Fiore; the *Rondanini Pietà;* many strong drawings of religious subjects; and, at the last (before the final reworking of the *Rondanini Pietà*) plans for rebuilding the gates of Rome and reconstructing the Baths of Diocletian.

Life of
Michelangelo Buonarroti

BY

ASCANIO CONDIVI

TO THE PONTIFF JULIUS III*

Holy Father,

As an unworthy servant and a man of low fortune I would not dare to appear before Your Holiness, if my unworthiness and lowliness had not first been raised up and enheartened by you yourself, when you so condescended towards me that you had me admitted to your presence, and with words conforming with your kindliness and eminence deigned to give me courage and hope beyond my merit and condition. Truly apostolic behaviour, by virtue of which I am aware of becoming more than I am; and I have followed my studies and the teaching of my master and idol, just as Your Holiness encouraged me to do, so fervently that I have produced work which if not now then at some future time will, I hope, perhaps bear fruit to deserve the grace and favour of Your Holiness, and the honour of being servant and disciple to such as Michelangelo Buonarroti: the one, prince of Christianity, the other, of the art of design.

And to give Your Beatitude proof of what your own kindness has wrought in me, just as I have dedicated to you all my purpose and devotion for ever, so I dedicate to you successively now all the works that will issue from my hands,* and especially this one, the life of Michelangelo; thinking that they must be pleasing, since the talent* and excellence of the man whom Your Holiness proposes I should imitate are indeed pleasing to you. This contains all that is needful for me to say about him here. Some important material, derived directly from him, has been omitted for the present; but these passages will be published at a later stage for the light they shed on the subtleties of the art, and for the rules they establish,* and to the glory of Your Holiness, who favours both the art and those who master it. Meanwhile I beg you not to take

offence at my offering these poor first fruits of mine, with which I bow down very humbly at your most holy feet.

Your Beatitude's most unworthy servant,
ASCANIO CONDIVI

TO MY READERS

From the hour when the Lord God, by His outstanding kindness, made me worthy not just of the presence (which I could scarcely have hoped to enter), but of the love, of the conversation, and of the close intimacy of Michelangelo Buonarroti, the unique sculptor and painter, from then on, conscious of such favour, and being a lover of his profession and admirer of his merit, I gave myself with all possible attention and study to observing and assembling not only the precepts he taught me about the art of design, but also his sayings, deeds, and habits, with everything in his whole life that seemed to me to merit wonder, imitation, or praise; and I also intended to write about it at some future time. This was as much to show him some gratitude for my infinite obligations towards him, as to give others the benefit of the advice and example of this great man: for I know how greatly our present age and times to come are obliged to him, having been enlightened by his works to the extent we can easily recognize by looking at the work of those who flourished before him. I find then that I have made two collections relating to him, one concerning his art, and the other his life. And while both of these are still in part being added to and in part still being digested, circumstances have arisen that for two reasons force me to hurry forward, indeed to rush out with this material on the life itself. First, because there have been some who in writing about this rare man,* since (I believe) they have not been as familiar as I have with him, on the one hand have said things about him that never happened, and on the other have left out many of those most worthy of being recorded; and next, because some other people, to whom I handed over and entrusted these endeavours of mine, had appropriated them in a way that suggests they design to win credit for them as their own. Hence to make up for the shortcomings of the former, and to forestall the injury by the others, I have resolved to publish my notes on his life

in their present imperfect form. And as for the method I have used to set them down, since my studies have concentrated on painting rather than writing, and for the reasons I stated, I have been denied the time to attend to the matter myself, or as I intended, to have myself helped by others, I shall be readily excused by perceptive readers. But I am not concerned to excuse myself, as I am not looking for praise. And if I earn any, I am content that it should be not as a good writer, but as a diligent and loyal compiler of these matters, and I affirm that I have collected them honestly, that I have drawn them deftly and most patiently from the living oracle himself, and finally that I have checked and confirmed them with the testimony of writings and men worthy of belief. But clumsy writer though I may be, I hope at least to be praised for this, that as best as I can I have provided, with what is now being published, for the fame of my master, and, with the part in reserve, for the conservation of a great treasure-house of our art. And for the benefit of our art I shall later on communicate the remaining material to the world more carefully than I have done the present work. Now let us come to the Life.

LIFE OF MICHELANGELO BUONARROTI

MICHELANGELO BUONARROTI, that outstanding sculptor and painter, traced his origin from the counts of Canossa, noble and illustrious family of the territory of Reggio through their own quality and antiquity as well as their relationship with the imperial blood. This is because Beatrice, the sister of Henry II, was given as wife to Count Boniface of Canossa, then Lord of Mantua, and the child born to them was the Countess Matilda, a lady of rare and outstanding religious practice and prudence; and she, after the death of her husband Godfrey, in addition to Mantua, held in Italy Lucca, Parma, and Reggio, and that part of Tuscany which today is called the patrimony of St Peter. And having done many things worthy of memory during her life, she was buried on her death in the Monastery of St Benedict outside Mantua, which she herself had built and generously endowed.

It was, then, from this family that a certain Messer Simone came as a magistrate* to Florence in 1250, and because of his ability he was found worthy of being made a citizen of that town and head of his own *sestiere*;* for the city then was divided into six districts, as today it is divided into four. Now the Guelf party was ruling Florence, and because of the many favours he received from that party, from a Ghibelline he became a Guelf,* changing the appearance of his coat-of-arms that was formerly gules, a dog rampant with a bone in his mouth, argent, and making it azure, a dog, or; and subsequently the Signory granted him five lilies, gules, in a rake,* and similarly the crest with two bull's horns, one or and the other azure, as can still be seen today painted on their ancient escutcheons. The old arms of Messer Simone may be seen in the palace of the *podestà* where he had them made in marble, the custom of the majority of those reaching that office.

The reason why the family living in Florence changed its name, so that from being da Canossa its members became thereafter de' Buonarroti, was as follows: this name of Buonarroti had been in the family from generation to generation for ages, until the time of Michelangelo, who had a brother always called Buonarroti; and many of these Buonarroti had been in the Signory, that is the magistracy of the Republic, particularly Michelangelo's brother who found himself among their number at the time when Pope Leo was in Florence, as can be seen in the Annals of that city. Thus this name, having been continued by so many of them, became the surname of all the family; all the more naturally, in so far as the custom of Florence in ballots and other elections is to add, after the citizens' own names, those of the father, the grandfather, the great grandfather, and sometimes further back still. So through the many Buonarroti continuing that practice, and through Simone, who was the first of this family in that city, those from the house of Canossa come to describe themselves as de' Buonarroti Simoni; and so they are called today. Finally when Pope Leo X went to Florence,* in addition to all the many privileges he gave to this house, he also added to their coat-of-arms the balls, azure, of the arms of the House of Medici, with three lilies, or.

So with this family name Michelangelo was born, and the name of his father was Lodovico di Lionardo Buonarroti Simoni. He was a good, religious man, rather inclined to the old ways of life; and when he was mayor of Chiusi and Caprese in the Casentino this son of his was born in the year of our Saviour 1474,* the sixth day of March, four hours before daybreak, being a Monday.

Certainly this was a splendid horoscope, and it plainly showed the kind of child he was to be, and how highly gifted. For Mercury with Venus had propitiously entered the house of Jupiter peaceably disposed, promising as later came to pass that this offspring would be of such noble and lofty talent as to triumph in all and every enterprise, but principally in those arts which delight the senses, as do

painting, sculpture, architecture. When his term of office was over his father went back to Florence, and handed the child over to a wet-nurse in a village called Settignano, three miles from the city. Here there was still a family possession, one of the first things that Messer Simone da Canossa had bought in that region. The wet-nurse was the daughter of a stonemason, and she had also married a stonemason. Because of this, Michelangelo used to say it was no wonder he took such pleasure in a mason's chisel; this was a casual joke, but also doubtless meant in earnest, from his knowing that the milk sucked from the breast sometimes influences us so strongly that, as the body's constitution changes, our natural disposition is succeeded by another which is very different in kind.

So the boy grew up past the age of childhood,* and his father, realizing his talented nature, and desiring that he should attend to his letters, sent him to the school run by a teacher called Francesco da Urbino, who at that time taught grammar in Florence; but, although he drew some fruit from this, both heaven and his own nature, which are difficult to contest, pulled him back to painting. In consequence, whenever he was able to steal some time, he could not resist running off to draw in one place or another, and seeking out the company of painters; and, among these, one very familiar to him was a certain Francesco Granacci, a disciple of Domenico del Ghirlandaio,* who on seeing the boy's burning will and inclination, resolved to help him, and continually encouraged him in his endeavours, now providing him with drawings, now taking him along with him to the workshop of the master or some place where there was some work of art, from which he could gather fruit. This course of action was so effective that, added to the constant stimulus of his own nature, it led him to abandon learning his letters altogether. This brought him the disapproval of his father and his father's brothers, who hated the art of design, and very often he was outrageously beaten: as they were ignorant of the excellence and nobility of the art, it seemed shameful to

them that it should be practised in their family. Although this was extremely disagreeable for him, none the less it was not enough to make him turn back; indeed with his resolve strengthened, he now wished to try to make use of colour.

And then it happened that Granacci put before him a print, with a drawing of the scene of St Anthony being assailed by devils, from the hand of a certain Martin of Holland,* an able man for that time, which he copied on a wooden panel; and having also been supplied by Granacci with colours and brushes, he produced such a distinctive composition that he not only caused amazement among those who saw it but also, as some people implied, aroused the envy of Domenico (the most esteemed painter of that age, as became manifestly clear later on from some of his other works). Domenico, to make the work seem less amazing, used to say that it had come from his workshop, as if he had himself had a hand in it.

As well as the likeness of the saint, there were many strange demonic shapes and monstrosities in this little picture, and in doing it Michelangelo took such assiduous care that he coloured nothing without first having taken note from nature. Thus he went along to a fish market, where he studied the shape and colour of the fishes' fins, the colour of their eyes and other parts, in order to reproduce them in his painting; after he had completed it as perfectly as he knew how, he thenceforward won everyone's admiration but also, as I have said, some envy from Ghirlandaio. And this was revealed still more, because one day when Michelangelo wanted to have back his book of drawings, in which were depicted shepherds with their flocks as well as dogs, landscapes, buildings, ruins, and similar things, he did not want to hand it over. To tell the truth he had rather a name for envy, because he appeared most discourteous not only towards Michelangelo but also towards his own brother, whom, when he saw him making progress, and showing great promise for himself, he sent away to France; this was not so much to help him, as some said was the reason, as to remain himself the first in his art in Florence.

I wanted to make mention of this, because I have been told that the son of Domenico used to attribute the divine excellence of Michelangelo in great part to the teaching of his father, who in reality gave him no assistance at all; and yet rather than complaining about that, Michelangelo praised Domenico both for his art and his behaviour. But that was somewhat of a digression; let us return to our story.

No less amazement was caused at the same period by another enterprise of Michelangelo, accomplished in the same delightful way. He had been given a head, which was for him to draw, and he reproduced it so exactly that, when the owner was given the copy instead of the original, he did not recognize the deception until it was revealed to him after the boy had confronted one of his companions with it, and told him all about it. Many people wished to compare it, and found no difference; and this was because as well as the perfection of the drawing, Michelangelo had used smoke to make it appear the same age as the original. This brought him much reputation.

So the boy continued drawing now one thing and now another, still without any settled workplace, or studio, when one day Granacci happened to take him to the garden of the Medici at San Marco, which Lorenzo the Magnificent,* father of Pope Leo, a man distinguished for every kind of excellence, had adorned with various antique statues and figures. When Michelangelo had seen these, and tasted the beauty of the works to be found there, no longer did he go either to Domenico's workshop, or anywhere else, but instead all day long, as in the best school of all for this branch of art, stayed in the garden where he was always working.

There was the occasion one day when he came to consider the head of a faun, in appearance already old, with a long beard and laughing looks, although the mouth could scarcely be seen it was so ancient, nor could it be seen for what it was; but it pleased him beyond measure,

and he resolved to copy it in marble. Now meanwhile Lorenzo the Magnificent was having some blocks, or rather slabs, of marble dressed in order to adorn that most noble library of his, which he and his ancestors had brought together from all the world. (The great building, neglected through the death of Lorenzo and other events, was taken up again after many years by Pope Clement, but all the same it remains imperfect, and so the books are still as yet stored in chests.) And so, as I said, with these marbles being dressed, Michelangelo got those master-masons to give him a piece; and being provided by the same men with tools, he set himself to copy the faun with such attentiveness and zeal that within a few days he brought it to perfection, supplying from his imagination all that was lacking in the antique, namely the mouth open in the manner of a man laughing, so that one could see the inside with all the teeth. In the meanwhile the Magnifico appeared, wanting to see at what stage the building was, and he found the boy who was busy polishing the faun's head; and drawing somewhat nearer to him, he first considered how excellent the work was, and having regard to the boy's age, he marvelled greatly; then although he praised the work, none the less teasing him as a boy, he said: 'Oh, you have made this faun old yet left him all his teeth. Don't you know that in creatures of that age some are always missing?'

It seemed an eternity to Michelangelo before the Magnifico went on his way, and he could correct his error; and when he was left alone, he removed an upper tooth from his old fellow, boring into the gum, as if it had come away from it with its root, and the next day he waited for the Magnifico very eagerly. When the latter arrived, having seen the boy's simplicity and goodness, he laughed over it a great deal. But then, pondering on how perfectly the work was done and what the boy's age was, as the undoubted father of all the talents, he determined to help and favour such genius, and to take him into his own house; and learning from him whose son he was, 'Go', he said, 'and tell your father it would please me to talk with him'.

So having returned home, Michelangelo delivered the Magnifico's message, but his father, who guessed why he was being sent for, could bring himself to make the visit only after great efforts by Granacci and others; indeed he lamented that his son was being taken away from him, all the time holding to this: that he would never suffer his son to be a stonemason. Nor was it any use Granacci instructing him how much difference there was between a sculptor and a stonemason, though he disputed about this a long time. However, after he had come into the presence of the Magnifico, and been asked that he should consent to hand over his son, he had no idea how to say no. 'Indeed,' he went on to say, 'not only Michelangelo, but all the rest of us with our life and belongings are at the disposal of Your Magnificence.'

And then being asked by the Magnifico what he did, he replied: 'I have never had any trade; but always till now I have lived on my tiny income, attending to those few possessions that have been left me by my ancestors; seeking not only to maintain them but to add to them as much as was possible through my own diligence.'

Then the Magnifico said: 'Good, look to see if in Florence there is anything that can be done for you; and make use of me, for I will do you the greatest possible favour that I can.'

And having dismissed the old man, he had Michelangelo given a good room in the house, allowing him all the conveniences that he desired, nor treating him, either at table or elsewhere, otherwise than as a son; and at his table, being the person he was, there gathered to sit down every day most noble personages, of great consequence. Now it was the custom there that among those who found themselves present at the start, each one might sit next to the Magnifico according to his rank, not moving after that from his place, no matter who might then come along. So very often it happened that Michelangelo sat at table above the sons of Lorenzo and other esteemed persons, who constantly filled and adorned that household; and by all of them Michelangelo was held very dear,

and he was fired to continue honourable studies. But most of all this was true of the Magnifico, who many times a day had him summoned, and showed him jewels, cornelians, medals and similar things of great value, in the manner of one who knew him for a person of intelligence and of judgement.

Michelangelo, when he joined the household of the Magnifico, was 15 to 16 years old, and he stayed there for around two years until the latter's death, which was in 1492. At this time, when there fell vacant a post in Customs, which no one who was not a citizen could hold, Lodovico, the father of Michelangelo, came to find the Magnifico and sought it from him with this little speech: 'Lorenzo, I know nothing except how to read and write. Now in the Customs-house the partner of Marco Pucci has died, and I would love to take his place, as it seems to me that I am very suitable for that post.'

The Magnifico clapped him on the shoulder and said with a smile: 'You'll always be poor', for he had expected to be asked for something more.

Even so he added: 'If you want to be in partnership with Marco, you can do it, until something better comes along.'

The post brought in 8 crowns a month, or thereabouts.

In the meanwhile Michelangelo attended to his studies, showing the fruit of his labours to the Magnifico every day. In the same household there was Poliziano,* a man, as everyone knows and as his writings give full testimony, very learned and shrewd. He himself loved Michelangelo greatly, knowing him for the exalted spirit he was, and, though not needing to, he constantly spurred him on to study, always expounding to him and giving him things to do. For instance, one day he suggested to him the rape of Deianira and the battle of the centaurs,* and he expounded the whole story to him stage by stage.

Michelangelo set himself to do it in marble, in half-relief, and the result of the enterprise was such that I remember hearing him say that, when he set eyes on it

again, he realized how much wrong he had done to nature in not readily pursuing the art of sculpture, being able to judge from that work how well he could have succeeded. He did not say this to boast, being a most modest man, but because really and truly he grieved at having had the misfortune, through the fault of others, to have done nothing in that line, sometimes for ten or twelve years at a stretch, as we shall see later.

This work of his is still to be seen in his house in Florence, and the figures in it are about 2 palms high.* Scarcely had he finished it, when Lorenzo the Magnificent passed from this life. Michelangelo returned to his father's house; and he was so grief-stricken by Lorenzo's death that for many days he could do simply nothing. But then when he recovered himself, he bought a large piece of marble, which for many years had been lying in the wind and rain, and from this he carved a Hercules, 8 feet high,* which was then sent to France.

While he was making this statue, there was a heavy snowfall in Florence and Piero de' Medici,* Lorenzo's eldest son, who had inherited his father's position, but not his gifts, wanting, in his youthfulness, to have a statue made of snow in the middle of his courtyard, remembered and sent for Michelangelo and had him make the statue. And he also wished Michelangelo to stay in his house, as in his father's time, giving him the same room, and as before having him constantly at his table; and there the same custom prevailed as when the father was living, namely that whoever might sit down first at the board should not move from his place for anyone arriving afterwards, no matter how great.

Lodovico, Michelangelo's father, had already become more friendly towards his son, and when he saw him nearly always in the company of great men, he provided for him more honourably with better clothes to wear. So for several months the young man stayed with and was treated most affectionately by Piero, who was in the habit

of boasting about two men in his household family as being persons of rare worth, one Michelangelo, and the other his Spanish groom. The latter, in addition to the beauty of his body, which was marvellous, was so agile and hardy and possessed such vigour that when Piero rode his horse flat out he did not outdistance him by an inch.

At that time, to oblige the prior of Santo Spirito, a most respected church in the city of Florence, Michelangelo made a wooden crucifix,* a little larger than life-size, which may still be seen today on the high altar of that church. He enjoyed very friendly relations with the Prior, both receiving many courtesies from him and also being accommodated with a room and with bodies so as to be able to practise dissection, which gave him the greatest possible pleasure. This was the beginning of his involvement in that practice, which he then pursued as long as chance allowed.

Frequenting the house of Piero was a certain man whose nickname was Cardiere and from whom the Magnifico had derived much pleasure, through his singing and improvising to the lute so marvellously; and Lorenzo himself was also a performer on the lute. So every evening after supper he devoted himself to it. As a friend of Michelangelo, this man confided to him a vision he had experienced as follows: that Lorenzo de' Medici had appeared before him in a torn, black garment covering his naked body; and he had commanded him to say to his son that shortly he would be chased from his home and he would never go back. Piero de' Medici was insolent and overbearing, so that neither the goodness of his brother, Cardinal Giovanni, nor the courtesy and humanity of Giuliano could work as well to keep him in Florence as could those vices of his to have him chased away. Michelangelo besought Cardiere to give an account of his vision to Piero, and to obey the command of Lorenzo; but Cardiere, knowing Piero's nature and being frightened, kept it to himself.

One morning again, when Michelangelo was in the

courtyard of the palace, he spied Cardiere all fretful and terrified and then once more he told him that Lorenzo had appeared to him in the night in the very same clothing as before, and as he awoke and watched him he had given him a box on the ear for not reporting what he had seen to Piero. Then Michelangelo rebuked him to such good effect that Cardiere, having plucked up courage, set out on foot to go to Careggi, a villa of the Medici estates, about three miles from the city. But when he was nearly half-way, he ran into Piero who was returning home, and, having stopped him, he explained what he had seen and heard. Piero made a joke of it, and after the grooms were called over, he encouraged them to keep jeering at him over and over again; and his chancellor, who later became Cardinal Bibbiena,* said to Cardiere: 'You're a madman. Do you think Lorenzo prefers his son or you? If his son, then wouldn't he, if that were so, sooner have appeared to him than to any other person?'

After he had been mocked in this way, they let him go. Then having returned home Cardiere complained to Michelangelo and spoke to him so effectively about the vision that he, believing it for certain, two days later left Florence, with two companions, and went to Bologna and from there to Venice, fearing that, if what Cardiere predicted should be true, he would not be secure in Florence. But a few days on, for lack of money (because he paid his companions' expenses), he thought to return to Florence; and then having reached Bologna, he found himself in the situation I shall now describe.

At the time of Messer Giovanni Bentivogli,* there was a law in that city, that whatsoever foreigner entered Bologna should have the nail of his thumb marked with a seal in red wax. So when Michelangelo had entered, inadvertently without the seal, he was led along with his companions to the licence office, and fined 50 lire in Bolognese coins.* And while they stood in the office without any means of paying, a Messer Gian Francesco Aldovrandi, a Bolognese gentleman, who was then one of the Sixteen,* seeing

Michelangelo there, and understanding the situation, had him set free; especially having recognized that he was a sculptor. He invited him to his house, where Michelangelo thanked him and explained that he unfortunately had two companions with him whom he could not abandon, though he did not want to bother Aldovrandi with them. The gentleman replied: 'I'd come and travel the world with you too, if you'd pay all my bills!'

Having been persuaded by words such as these, Michelangelo made his excuses to his two companions and dismissed them, giving them the few coins that he found on his person, and he went to lodge with Aldovrandi.

Meanwhile the House of Medici with all its followers was chased out of Florence, and they came to Bologna and lodged with the Rossi family. And so Cardiere's vision, whether it were a diabolical delusion or divine prediction or strong imagination, proved to be true: a truly marvellous thing, worthy of being written down, and something which I have narrated just as I heard it from Michelangelo himself.

About three years ran their course from the death of Lorenzo the Magnificent to the exile of his son, so Michelangelo must then have been 20 to 21. And to steer clear of those early riots among the populace, waiting until the city of Florence should achieve some settled rule, he stayed in Bologna with the above-mentioned gentleman, who did him great honour, being delighted by his intelligence. Indeed every evening he had something read by him from Dante or from Petrarch and now and then from Boccaccio, until he fell asleep.

One day, when he was taking him around and about Bologna, he led him to see the tomb of St Dominic,* in the church dedicated to this saint, from which there were missing two marble figures, namely a St Petronius and a kneeling angel with a candelabrum in his hand. Being asked whether he dare try to make them, Michelangelo replied, yes; and so he arranged for them to be given to him to do. For these, he had him paid 30 ducats: for the

angel 18, and for the St Petronius 12. The figures were 3 palms in height, and they can still be seen in that same place.

But then, Michelangelo became afraid of a Bolognese sculptor, who complained that this commission had originally been promised to him, and that Michelangelo had robbed him of it, and threatened to do him harm; and therefore he returned to Florence, particularly as things had quietened down, and he could live safely at home. He had stayed with Messer Gian Francesco Aldovrandi little more than a year.

Having come back to his own country Michelangelo applied himself to making a god of Love,* 6 to 7 years of age, lying down, in the form of a man asleep: and when this was seen by Lorenzo di Pier Francesco de' Medici (for whom in the meantime Michelangelo had made an infant St John) he judged it to be extremely beautiful, and he said to him: 'If you were to prepare it, so that it should appear to have been buried, I shall send it to Rome and it would pass for an antique, and you would sell it much more profitably.'

Hearing this, Michelangelo, from whom no path of genius was hidden, at once prepared it so that it appeared to have been made many years before. And so when it was sent to Rome, Cardinal San Giorgio bought it as an antique for 200 ducats; however, the man who took this amount of money wrote to Florence that Michelangelo should be paid 30 ducats, that being what he had got for the Cupid,* thus deceiving both Lorenzo di Pier Francesco and Michelangelo. But in the meanwhile, it came to the ears of the cardinal just how the *putto* had been made in Florence, and indignant at being tricked he sent there a gentleman of his, who, after seeing several others, was invited to the house of Michelangelo. And when he saw the young man, being wary of revealing what he wanted, he requested him to show him something he had done. But, as he had nothing to show, he took a quill pen (since at that time chalk was not in use) and depicted a hand for

him with such grace and lightness that he stood there stupefied. Then he asked him if he had ever made a work of sculpture; and when Michelangelo responded yes, and among the other things a Cupid of such and such a size and pose, the gentleman learned what he wanted to know.

The story having been told as it had happened, he promised Michelangelo, if he would go with him to Rome, to have him recompensed for the difference, and to arrange matters for him with the owner, who he knew would be very pleased with that. Michelangelo, therefore, partly from indignation at having been defrauded, partly in order to see Rome, so highly praised to him by the gentleman as a very large field where everyone could demonstrate his talents, went along with him; and he lodged in his house, which was near the cardinal's palace.

The cardinal, having in the meantime been advised by letter how matters stood, had the man who had sold him the statue for an antique apprehended; and, after his own money was returned, he gave him back the statue. Subsequently, I do not know by what path, it fell into the hands of Duke Valentino* and was then given to the Marchioness of Mantua and sent by her to Mantua where it is still to to be found in the house of those rulers. Some people blamed the Cardinal of San Giorgio over this affair: for if, when seen by all the artists of Rome, the work was judged by all of them, unanimously, to be very beautiful, it should hardly have given so much offence as a modern work that for the sake of 200 crowns a rich and moneyed man should deprive himself of it. If he was smarting over having been deceived, he could have punished so and so by having the balance of the money, that he had previously taken home, paid out to the statue's patron.

But no one suffered as a result more than Michelangelo, who other than what he had received in Florence made nothing out of it. And that Cardinal San Giorgio little understood or enjoyed statues, this makes clear enough: in all the time that Michelangelo stayed with him, which was around a year, he was never commissioned by San Giorgio to do anything.

He did not, however, lack someone who recognized the opportunity and made use of him; because Messer Jacopo Galli,* a Roman gentleman of fine intelligence, had him make at his home a marble Bacchus, 10 palms high, whose form and appearance corresponds in every detail to the meaning intended by the ancient writers: the merry face, and the squinting, lascivious eyes, such as are usual in those who have fallen excessively in love with wine. In the right hand he holds a cup, in the manner of someone wishing to drink, and he is looking at it intently, as one who takes pleasure in that liquor, which he first discovered; and in recognition of this, he has his head encircled with a garland of vine-leaves. On the left arm he has the skin of a tiger, an animal dedicated to him, as it takes so much pleasure in the grape; and he showed the skin rather than the animal itself, because he wished to signify that he who loses himself in sensuality and the cravings for that fruit and its liquor in the end loses his life over it. In the hand of this arm Bacchus holds a bunch of grapes, which a lithe and happy little satyr, placed at his feet, is furtively eating. He appears to be about 7 years old, and Bacchus 18.

The said Messer Jacopo also wanted him to make a Cupid; and both one and the other of these works can be seen today in the house of Messer Giuliano and Messer Paolo Galli, worthy and courteous gentlemen, with whom Michelangelo has always maintained intimate friendship.

A little later on, the Cardinal of Saint-Denis,* called Cardinal Rouen, commissioned him to make from one piece of marble that marvellous statue of Our Lady. This is today in the Madonna della Febbre, although at first it was placed in the chapel of the King of France in the church of Santa Petronilla, near to the sacristy of St Peter's, and once, some say, the temple of Mars: a building destroyed by Bramante to allow for the design of the new church.

Our Lady is positioned seated on the rock, in which the cross was sunk, with her dead Son on her lap, and of such

and so rare a beauty, that no one sees her without being inwardly moved to pity. An image truly worthy of the humanity which belongs properly to the Son of God and to such a mother; although there are some who make the reproach that the mother is shown as too young, in relation to her Son. But when I was discussing this with Michelangelo one day, he replied to me: 'Don't you know that chaste women remain far fresher than those who are not chaste? So much more the virgin, in whom never has the least lascivious desire ever arisen that might alter her body. Moreover, let me add this, that besides such freshness and flower of youth being maintained in her in this natural way it may be believed to have been assisted by divine power to prove to the world the virginity and perpetual purity of the mother. This was not necessary in the Son; rather completely the opposite; because to show that, as He did, the Son of God took a truly human body, and was subjected to all that an ordinary man endures except sin, there was no need for the divine to hold back the human, but to leave it to its order and course, so that the time of life He showed was exactly what it was. Consequently you are not to wonder if for these reasons I have made the most Holy Virgin, mother of God, far younger in comparison with her Son than her age would ordinarily require, and that I left the Son at His own age.'

This reflection would be worthy of any theologian, and doubtless amazing if heard on the lips of others, but not when coming from him, whom God and nature have formed not only to produce unique workmanship but also to be the worthy author of the most inspired concepts, as can be recognized both from the above and from very many of his discourses and writings.

When he made this work, Michelangelo would have been 24 or 25 years old. He acquired great fame and reputation from this effort, and indeed it was already everyone's opinion that he not only far surpassed all his contemporaries, and those who came before him, but that he also contended with the ancients.

After these things were done, he was forced to return to Florence on family business; and there, having stayed a while, he made that statue, which everyone calls the Giant,* and which is still standing today at the end of the balustrade in front of the door of the palace of the Signoria.

This is how it came about: the Wardens of Santa Maria del Fiore had a block of marble 18 feet high which a hundred years earlier had been brought from Carrara by a craftsman, who, it could be seen, was not as experienced as he needed to be. For, in order to be able to transport it more conveniently and with less effort, he had roughed it out in the quarry itself, but in such a manner that neither he nor anyone else ever had courage enough to set about carving a statue from it, whether of the same height or even much smaller. Since they were not able to carve anything good from this block of marble, a certain Andrea del Monte a San Savino, thought he could obtain it from them, and he enquired if they would make him a present of it, promising that, by adding certain pieces, he would be able to carve a figure from it. But before being disposed to give it to him, they sent for Michelangelo, told him the wishes and views of Andrea, and having heard his opinion on carving something good from it, they finally offered it to him. Michelangelo accepted it, and without any other pieces carved from it the above mentioned statue, so exactly, that as can be seen on the crown of the head and on the base, the old rough surface of the marble still appears.

He has done this sort of thing in other works, such as the tomb of Pope Julius II with the statue which represents the Contemplative Life: and this represents one of the master-strokes on the part of those who are leaders in the art. But there appears something still more marvellous in the statue: for besides the fact that he did not add any pieces to it, it is also (as Michelangelo used to say) impossible or at least very difficult in statuary to remove the traces of faulty blocking-out. He had 400 ducats for this work and carried it out in 18 months.

Then so that there should be no material employed for statuary in which he had not worked, at the request of Piero Soderini, his great friend, after the Giant he cast in bronze a life-size statue which was sent to France; this was a David with Goliath underneath.* The one to be seen in the middle of the court of the Palazzo della Signoria is from the hand of Donatello, a man who excelled in that art, and who was much praised by Michelangelo except for one thing, that he did not have the patience to polish his works; as a result, splendidly successful when seen from afar, close to they lost their reputation.

He also cast in bronze a Madonna with her infant son on her lap;* and this was sent to Flanders, by certain Flemish merchants, the Moscheroni, a very noble family in their own country, who paid 100 ducats for it. And so as not entirely to abandon painting, he did a Madonna on a round panel for Messer Angelo Doni, a Florentine citizen, for which he was paid 70 ducats.

He remained for some time doing almost nothing at all in these arts, but devoting himself to reading Italian poets and orators*, and writing sonnets for his own amusement, until after Pope Alexander VI died he was called to Rome by Pope Julius II,* having received in Florence 100 ducats for the journey. At that time Michelangelo would have been aged 29; for if we count from his birth which, as already said, was in 1474, up to the death of the above-named Alexander, which was in 1503, we find that number of years have gone by.

After he had come to Rome, many months passed before Julius II resolved how he should make use of him. At last he made up his mind to have Michelangelo make his tomb; and the design Julius saw pleased him so much that he at once sent him to Carrara to quarry whatever quantity of marble might be needed for the enterprise. And he had him paid by Alemanno Salviati in Florence 1,000 ducats for that purpose. Michelangelo stayed in those mountains with two assistants and a mount, with no provision other than foodstuffs, for over 8 months. And while there, one day seeing all those places from a mountain which over-

looked the sea-coast he formed the wish to make a colossus, that would be visible to mariners from afar. In this he was encouraged especially by the available mass of rock, which could be carved most conveniently, and by emulation of the ancients, who perhaps to the same purpose as Michelangelo, having lighted on some place by chance, or to escape idleness or for whatsoever purpose, have left some imperfect, roughly-hewn memorials, that provide very good proof of their workmanship. And he certainly would have done it, if he had had enough time and if the enterprise which had brought him there had permitted it; and once I heard him complain sadly about this.

Well, when what seemed to him enough marble had been quarried and chosen, after he had brought it to the sea-coast, and left one of his men to have the pieces loaded, he returned to Rome. And for the reason that he had stopped a few days in Florence, he found, when he reached Rome, that a part of the marble had already arrived at Ripa; and after it was unloaded, he had it carried to the square of St Peter's, behind Santa Caterina, where his own room was situated next to the Corridor. So great was the quantity of marble that, spead out on the square, it aroused wonder among all and joy in the Pope: and Julius showered such boundless favours on Michelangelo that after he started work, many and many a time he went right to his house in order to find him, discussing with him the tomb and other matters just as if they were brothers. And to be able to go there more conveniently, he gave orders for a gang-plank to be slung from the Corridor to Michelangelo's room,* by which he could go there privately.

All the many favours of this sort were the reason (as so often happens at courts) why he began to arouse envy and why, in the wake of envy, he encountered endless persecutions. For the architect Bramante,* who was loved by the Pope, said what the common people generally say, namely that it was a bad omen to make one's tomb while still living, and other such tales, and so made him change his mind. Besides envy, Bramante was spurred on by his fear

of the judgement of Michelangelo, who revealed many of his errors.

For Bramante, as everyone knows, was given to every sort of pleasure and was a spendthrift, and the provision made for him by the Pope, no matter how lavish, was not enough for him; and so he sought to make extra profit from the works he did, building the walls with bad materials and making them insufficiently strong and secure for their great height and size. And this as everyone can see is manifest in the building of St Peter's in the Vatican, in the Belvedere Corridor, in the priory of San Pietro ad Vincula* and in the other buildings he made; it has been necessary to restore the foundations for all of them and to fortify them with abutments and buttresses, as if they were collapsing or would shortly collapse. Now because he had no doubt that Michelangelo recognized these errors of his, he always sought to remove him from Rome, or at least to deprive him of the favour of the Pope and of the glory and advantage that his industry enabled him to acquire. This so happened in the case of the tomb: a tomb which, if it had been built according to the first design, would undoubtedly have enabled Michelangelo to have taken the honours in his art (be it said without envy) above anyone ever esteemed as an artist, since he would have had such a broad field in which to show his worth. And what he would have achieved is demonstrated by his other works and by those two Prisoners,* which he had already made for the tomb. All those who have seen them consider that nothing better has ever been made.

And to give some evidence for this, let me say briefly that this tomb was to have had four faces: two of 36 feet, at the sides, and two of 24, front and back, so that it would have constituted a square and a half. All around the outside were to be niches, for statues, and between one niche and another were to be term figures, with statues upon certain dados rising from the ground and projecting outward, of prisoners in bonds, representing the Liberal arts, as well as painting, sculpture and architecture. And each one would have had its symbol, so that they could be

easily recognized for what they were; this denoted that, together with Pope Julius, all the virtuous arts were prisoners of death, and would never find anyone to favour and nourish them as much as him.

Above these would have run a cornice, binding all the work together, on the top of which were to be four large statues. One of these, the Moses, can be seen in San Pietro ad Vincula; and this will be discussed in the proper place.

So the work would have risen to end with another storey where there were to be two angels supporting a bier: one of them would have been smiling, as if to rejoice that the soul of the Pope had been received among the blessed spirits; the other weeping, as if to lament that the world had been deprived of such a man. The way into the sepulchre was to be at one end, where the entrance would lead to a small room built like a temple, in the middle of which was to be a marble coffin, for the interment of the body of the Pope; and everything was to have been finished with superb craftsmanship.

Briefly, the whole work would have contained over 40 statues, not including the scenes in half relief, to be cast in bronze and all in keeping with the subject and showing forth the deeds of this great pontiff.

After he saw this design, the Pope sent Michelangelo to St Peter's to see where the tomb could be suitably located. The form of the church was then in the shape of a cross, at the head of which Pope Nicholas V had started to push on with building the tribune; and when he died, it had already risen to a height of 6 feet above ground. It seemed to Michelangelo that this work would be wholly in keeping, and he returned to the Pope and explained what he had in mind, adding that if His Holiness thought the same it would be necessary to raise the building and to roof it over.

The Pope asked him: 'What would this cost?'

To which Michelangelo replied, 'A hundred thousand crowns.'

'Let it be two hundred thousand,' said Julius. And after

he sent the architect San Gallo and Bramante to see the place, during these dealings the Pope formed the wish to build the whole church afresh. More designs were made and Bramante's was accepted, as being more elegant and better thought out than others. Thus Michelangelo was the reason why the part of the building already started was finished (for if this had not happened, perhaps it would still be as it was) and also that the Pope formed the wish to rebuild all the rest using a new and more beautiful and more magnificent design.

Now to return to our story. Michelangelo realized that the Pope had changed his intentions in this way. The Pope had instructed Michelangelo that, if he needed money, he should not approach anyone other than himself so that he should not have to wander here, there and everywhere. Then one day the rest of the pieces of marble that had remained at Carrara happened to arrive at Ripa. Michelangelo had them unloaded and brought to St Peter's and then, as he wanted to pay charges for unloading and transportation, he went to ask the Pope for money; but he found access to him hindered and the Pope occupied. Thereupon when he returned home, so as not to leave those poor men who needed their recompense at a financial loss, he paid them all himself, thinking he would recover his money as he could easily get it from the Pope. Another morning, he returned and entered the antechamber to seek an audience, only to be accosted by a footman who said: 'Begging your pardon, I have instructions not to let you enter.'

There was a bishop present, and when he heard the words of the footman he rebuked him, saying: 'You cannot know who this man is.'

'Indeed I know him,' answered the footman, 'but I am bound to do what I am instructed by my masters, without enquiring further.'

Michelangelo (against whom till then no curtain had ever been drawn nor door bolted), when he saw how he was being goaded, became indignant over all this and

answered him: 'And you tell the Pope that from now on if he wants me, he can seek me elsewhere.'

So having returned home, he ordered two servants that he had, once they had sold all the household furniture, and received the money, to follow him to Florence. He rode with the post and at the second hour of the night he reached Poggibonsi, a little town in the countryside of Florence, 18 or 20 miles from the city. Here, feeling he was in a safe place, he rested.

Shortly after, there arrived five of Julius's couriers, who had been instructed to bring him back wherever they found him. But he had arrived at a place where they could not do him any violence, and with Michelangelo threatening that if they tried anything he would have them murdered, they turned to entreaties. And when these were of no avail, they obtained from him the assurance that he would at least respond to the Pope's letter, which they had presented to him; and particularly that he should write that they had caught him up only after he had reached Florentine territory, so that the Pope would believe they had not been able to bring him back against his will. The tenor of the letter from the Pope was that when he saw the message, he should at once return to Rome, under pain of his disfavour.

To which Michelangelo replied briefly that never would he return; and that he did not deserve for his good and faithful personal service to have this in exchange, to be chased from his presence like a rogue; and since His Holiness wished no longer to continue with the tomb, he had discharged his obligation, nor did he want any other obligation.

Then after the letter was dated, as described, and the couriers were dismissed, he went to Florence; and there, in the three months that he stayed, three Briefs were sent to the Signoria, full of threats, ordering that they should send him back by force or favour.

Piero Soderini, who at the time was Gonfalonier for life of that Republic, having previously let him go to Rome against his will, and intending to employ him to paint the

Council hall, after the first Brief did not force Michelangelo to go back, because he hoped that the Pope's anger would pass. But after the second and the third, he called Michelangelo and said: 'You've tried and tested the Pope as not even the King of France would dare, so he will no longer wait to be asked. We don't want to wage war with him over you and put our State at risk; so prepare to go back.'

So then Michelangelo, seeing the pass he was in, and fearful of the Pope's anger, thought that he would go to the East; especially as he had been pursued with very great promises by the Turk* through the agency of certain Franciscans wanting to employ him on building a bridge from Constantinople to Pera, and on other business. But hearing of this the Gonfalonier sent for him and dissuaded from such an idea, saying that he should choose rather to die through going to the Pope than to live through going to the Turk: and none the less he should not be afraid of that, for the reason that the Pope was kind, and he recalled him because he wished him well, not to do him harm; and if he was still fearful, that the Signoria would send him with the title of ambassador, for the reason that it was not usual to offer violence to public persons, since it would be as if it were done to those sending them.

Because of these and similar promises, Michelangelo prepared to return.

But in the meanwhile, when he was in Florence, two things happened. First, he finished that marvellous cartoon begun for the Council hall,* in which he represented the war between Florence and Pisa, and the many, varied occurrences that took place during it; and all who ever subsequently took up the brush drew enlightenment from this most skilfully executed cartoon. However, I do not know through what misfortune, it later came to harm, after it had been left by Michelangelo in the so-called hall of the Pope, situated in Florence at Santa Maria Novella. Some pieces of it are still to be seen in various places, preserved with the greatest care as if sacred. The other

thing that happened was that Pope Julius had taken Bologna and gone to stay there, and he was in a very joyful mood because of this acquisition. This encouraged Michelangelo and gave him confidence to appear before the Pope.

So then having arrived one morning in Bologna, and gone to San Petronio to hear Mass, Michelangelo suddenly saw before him the Pope's grooms who, after recognizing him, conducted him to His Holiness who was at table in the palace of the Sixteen. And once he saw him in his presence, the Pope turned to him with a look of rage and said: 'You were supposed to come to find us, yet you've waited for us to come to find you.'

He wished to make it understood that as His Holiness had come to Bologna, a place far nearer to Florence than to Rome, it was as if he had come to find him.

Michelangelo, kneeling, in a loud voice asked for his pardon, making the excuse that he had erred not from ill will but from being enraged as he had not been able to bear being chased away in the way that he was. The Pope looked about himself with lowered head, without saying anything, when a certain monsignor, sent by Cardinal Soderini,* in order to recommend and make excuse for Michelangelo, interrupted and said: 'Your Holiness, pay no regard to his error, because he has erred from ignorance. Painters, except for their art, are all just as ignorant.'

The Pope was enraged at this and said: 'You are abusing him, and we are not. It is you who are ignorant and you're a miserable wretch, not him. Get out of my sight, and bad luck to you.'

And when he did not move, the monsignor, as Michelangelo used to recall, was driven outside by the Pope's servants with a hail of blows.

So then, having disgorged most of his anger on the bishop, the Pope called Michelangelo closer to him, pardoned him, and charged him not to leave Bologna until he should have been given another commission by him. Nor did the Pope wait long before sending for him to say that he wanted Michelangelo to portray him in a large statue in

bronze, which he wanted to place over the door of the church of San Petronio.

And for this purpose, the Pope left 1,000 ducats with the bank of Messer Antonmaria da Ligno and returned to Rome.

It happened that before he left, Michelangelo had already done the figure in clay. And being uncertain what he should put in the left hand, having raised the right hand as if it were giving a benediction, he requested of the Pope, who had come to see the statue, if it would please him if he added a book. So then the Pope replied: 'Why a book? Do a sword; for I'm not a man of letters.'

And making a joke of the right hand, which was boldly outstretched, he said to Michelangelo smilingly: 'This statue of yours, is it giving a benediction or a malediction?'

Michelangelo said: 'It is warning the people here, Holy Father, to be prudent.'

But as I have said, after the Pope had returned to Rome, Michelangelo stayed in Bologna; and he spent sixteen months in completing the statue and placing it where the Pope had ordered. Subsequently when the Bentivogli re-entered Bologna, this statue was cast down and destroyed through the fury of the people. In height it was over three times life size.

Once he had finished that work, Michelangelo came to Rome where Pope Julius, wanting to use his services, and yet resolved not to make the tomb, had the idea put into his head by Bramante and others who were jealous of him that he should have him paint the vault of the chapel of Pope Sixtus IV,* inside the palace; and they made him hopeful that Michelangelo would work miracles. They performed this role out of malice, to divert the Pope from works of sculpture, and also because they held it for certain that either Michelangelo would not accept the enterprise, and so turn the Pope against him, or if he did accept, would succeed far less well than Raphael, on whom from hatred of Michelangelo they bestowed all their

favours. For they reckoned that Michelangelo's principal art was that of statuary, as indeed it was.

Michelangelo, who up to then had not worked in colours, and knew that painting a vault was a difficult task, tried as hard as he could to off-load the burden, proposing Raphael, and making the excuse that it was not his art and that he would not succeed; and his refusals were so insistent, that the Pope was about to fly into a rage. But then, seeing his obstinacy, Michelangelo set out to do the very work which today can be seen in the palace of the Pope, to the wonder and admiration of all; it brought him such a reputation that it placed him beyond all envy, and I shall now give some brief details about it.

It is what is usually called a barrel vault, and it rests on a series of lunettes, of which there are six to the length of the chapel and two across; and so the whole vault consists of two and a half squares. On the vaulting, Michelangelo has painted principally the Creation of the World; but he went on to embrace almost all the Old Testament. He has arranged this work as follows.

Starting from the corbels, which support the springing of the lunettes, up to about a third of the curve of the vault, he simulated a flat wall, bringing down to this point some pilasters and socles that appear to be marble; these project forward above a ledge like a parapet, with their own corbels below and with other small pilasters on the same level as the seated Prophets and Sibyls. These first pilasters which rise from the curves of the lunettes have the corbels in the middle; and the width of the compartments over the curves of the lunettes is greater than that of those over the spaces between the pilasters. Above the socles some nude little children are depicted in various poses, and, like terms, support a cornice which encompasses the whole work, leaving the middle of the vault, from one end to the other, like an open sky. This opening is divided into nine bands; for over the pilasters some arches, with mouldings, spring from the cornice and pass through the very summit of the vault and proceed to the opposite side,

creating between them nine segments, alternatively large and small. In the small ones there are two small bands, looking like marble, which cross the embrasure to produce in the middle two parts to one part at each side where the medallions are placed, as will be described in the right place; and this Michelangelo did to avoid the tediousness of repetition.

Then in the first segment at the head of the ceiling, which is one of the lesser ones, is to be seen Almighty God, dividing light from darkness with the motion of His hands. In the second is when He created the two greatest luminaries; and He is seen there with arms outstretched, and His right arm pointing to the sun and with His left to the moon. There is a group of little angels near by, and one of them on the left is hiding his face, shrinking closer to his Creator, as if to protect himself against any harm from the moon.

Also in this segment, on the left, appears the same figure of God, turning to create the grasses and plants of the earth, and depicted with such skilful craft that, whenever you turn yourself, He seems to follow you, revealing the whole length of His back down to the soles of the feet. This is a very beautiful effect, showing what foreshortening can do. Again, God in His greatness appears in the third segment, similarly attended by angels; and He gazes upon the waters, commanding them to produce all those kinds of animals which are nourished in this element, just as in the second segment He gives His command to the earth.

In the fourth is the creation of man, where with His arm and with His hand extended God is seen as giving Adam the precepts for what he should do and not do, while with His other arm He gathers up His child-angels.

In the fifth is when He draws from the side of Adam the woman who, as she comes with her hands clasped and stretched towards God, bowing down in a pose of great sweetness, seems to be thanking Him while He blesses her.

In the sixth is when the devil, formed like a human from the middle upwards and like a serpent elsewhere, with legs

transformed into coils, wraps himself around a tree; and giving the semblance of conversing with the man, he is inducing him to defy his Creator, while he holds out the forbidden apple to the woman. And in the other part of the segment are to be seen both of them, driven out by the angel, fearful and grieving as they flee from the sight of God.

In the seventh is the sacrifice of Cain and of Abel: the former's pleasing and acceptable to God, the latter's hateful and rejected.*

In the eighth is the Flood; and here can be seen Noah's Ark, afar off, in the midst of the waters, with several men clinging to it for safety. Also in the depths of the sea, but nearer, is a boat laden with various people which because of the many violent poundings of the waves, has lost her sail and deprived of all human help or contrivance is seen to be already shipping water and sinking to the bottom. And in this it is an amazing thing to see humankind perish so miserably in the waves.

Similarly, nearer the eye, a mountain top appears above the waters in the semblance of an island; and there, fleeing from the rising waters, have sheltered a multitude of men and women, who display varying emotions, but are all miserable and fearful, as they drag themselves under some canvas stretched over a tree for self-protection against the extraordinary downpour; and above this is represented with great skill the anger of God, who moves violently against them with flood, thunder and lightning. There too, on the left, is another mountain summit, still nearer the eye, with a multitude of people stricken by the same disaster, about whom it would take a long time to give every particular: enough to say that they are all dreadfully lifelike and just as they could be imagined in such a disaster.

In the ninth and last is the story of Noah when, lying drunk on the ground exposing his shameful parts, he was derided by his son Ham and covered over by Sem and Japheth. Under the above mentioned cornice, which completes the wall, and over the corbels where the lunettes are placed, between one pilaster and the next there are seated

twelve figures, either Prophets or Sibyls, all truly marvellous as much for their attitudes, as for the adornment and variety of their garments.

But marvellous beyond all of them is the Prophet Jonah, placed at the head of the vault. This is for the reason that against the plane of this vault and through the power of light and shadow, the torso, which is foreshortened to recede inwards, is in the part which is nearer to the eye, and the legs which project forwards are in the part farther away. A stupendous work, and one which makes clear how much knowledge this man had of principles and the use of line in creating foreshortenings and perspectives. And then in the space below the lunettes, and likewise in that above, which is in the form of a triangle, he has painted the entire genealogy, or we should rather say ancestry, of the Saviour; excepting the triangles at the corners which, joined together, merge into one and form a double space. Thus, in one of these, near to the wall of the Last Judgement, on the right hand, is seen Haman who was hanged on a cross by the command of King Ahasuerus; this being done because in his pride and haughtiness he wanted to hang Mordecai, uncle of Queen Esther, for having failed to honour and reverence him when he passed by.

In another is the story of the brazen serpent, raised aloft by Moses on a spear; we see the people of Israel, having been wounded and tormented by the darting little snakes, being healed as they gaze at it. And Michelangelo has shown marvellous force in those who want to struggle free of the vipers surrounding them.

In the third corner, lower down, is the vengeance taken by Judith on Holofernes. And in the fourth, that of David on Goliath. And there in short is the whole of the history.

But no less marvellous than this is the part that does not belong to the history itself. There are certain male nudes seated on the plinths over the above-mentioned cornice, one this side and one on that, and holding up the medallions which, as said, appear to be of metal and on what seem to be reverses are shown histories of a varied kind but all in accord with the principal one.

In all these items, whether for the loveliness of the different compartments, or the diversity of the different attitudes, or the contrasts of the different planes, Michelangelo displayed tremendous skill. But to narrate all the details of this and the other things would be a labour without end, and an entire volume would not be enough. So I have reviewed them briefly, wishing only to shed a little light on the whole rather than specify the various parts.

In the meanwhile he did not escape tribulations, because after he had started the work, and had finished the picture of the Flood, it began to grow a mould in such a manner that the figures were scarcely discernible. And then thinking that this excuse should be enough to let him escape being burdened with this task, he went to the Pope and said to him: 'I have indeed told your Holiness that this is not my art: what I have done is spoilt: and if you won't believe it, send to see.'

The Pope sent San Gallo, and when he saw it he realized that Michelangelo had put the lime on too wet, and because of this when the moisture ran down it had this effect; and after Michelangelo was told of this, the Pope made him proceed and no excuse helped.

While he was painting, many times Pope Julius wished to go to see the work, climbing up by a step-ladder and being given a helping hand by Michelangelo on to the platform. And as one who was by nature eager and impatient of delays, once half was done, namely from the door to the middle of the vault, he wished it to be revealed, even though it was imperfect and lacked the finishing touches. Michelangelo's reputation and the expectations that he aroused drew all Rome to view it, along with the Pope, even before dust that had been raised from taking down the scaffolding had settled.

Afterwards, Raphael, when he saw the new and marvellous style of this work, being a brilliant imitator, sought through Bramante to paint the remainder himself. Michel-

angelo was greatly disturbed by this; and having presented himself to Pope Julius, he protested strongly about the injury done to him by Bramante; Michelangelo complained to the Pope himself, declaring all the ways he had been persecuted by Bramante; and next he revealed many of his faults, and especially that when he was demolishing the old St Peter's Bramante pulled down those marvellous columns that the church contained, neither caring nor worrying whether they were broken in pieces, while he could have lowered them gently and preserved them intact.

He pointed out that it was an easy thing to place one brick upon another but that to make such a column was most difficult, and he added many other things there is no occasion to report: and in such a manner that the Pope, having heard about all these bad practices, wished Michelangelo to continue and did him more favours than ever. He finished all this work in twenty months, without any help whatsoever, not even just from someone grinding his colours for him. It is true that I have heard him say that it was not finished as he would have wished, as he was obstructed by the haste of the Pope. Indeed, one day the Pope asked when he would finish that chapel, and was told: 'When I'm able to.'

In a temper the Pope continued: 'You want me to have you thrown off that scaffolding, don't you now?'

When he heard this, Michelangelo said to himself: 'No, you won't have me thrown off', and he had the platform demolished and revealed the work on All Saints' Day.

Then it was viewed with great satisfaction by the Pope (who went to the chapel that day) and admired by all Rome crowding to see it. It lacked retouching with ultramarine *a secco** and in one or two places with gold, which would have made it appear richer. Julius, whose fervour had calmed down, now wished Michelangelo to provide this; but Michelangelo, considering the bother that he would have in reassembling the scaffolding properly, replied that what was lacking was nothing of importance.

'It must still be necessary to have it re-touched with

gold,' replied the Pope; and Michelangelo, talking familiarly, as he used to with His Holiness, said: 'I do not see that men should wear gold.' And the Pope: 'It will look poor.'

Then: 'Those who are painted here', Michelangelo replied, 'were poor themselves.' So he turned things into a joke, and it has remained as it was.

For this work, to cover everything, Michelangelo had 3,000 ducats, of which as I have heard he had to spend 20 or 25 on colours.

After this work had been completed, because he had been painting for such a long time with his eyes raised towards the vault, when he was looking down Michelangelo found he saw very little; thus if he had to read a letter or look at other very small things it was necessary for him to hold them with outstretched arms above his head. None the less little by little he subsequently grew used to reading looking downwards as well. From this we can realize with what attention and assiduity he had applied himself. Many other things happened to him, during the remaining years of Pope Julius, who loved him utterly and was more caring and jealous for him than for anyone else whom he had around him; and this can be realized clearly enough from what we have already written. Indeed, one day, fearing that Michelangelo was angry with him, the Pope sent at once to placate him.

What happened was this. Michelangelo wished to go to Florence for the feast of St John* and so he asked the Pope for some money; and the Pope enquired of him when he would finish the chapel. Michelangelo in his usual way replied: 'When I'm able to.'

The Pope, who was a man of impulse, struck him with the staff that he held, saying: 'When I'm able! When I'm able!'

And then after he returned home, Michelangelo was making arrangements to go to Florence then and there, when along came Accursio, a favoured young man, who brought him 500 ducats from the Pope, placated him as

best he could, and apologized on behalf of Julius. Michel-
angelo, having accepted the apology, went off to Florence.

So it seemed that Julius cared more about keeping this
man bound to him than about anything else. Nor did he
wish to make use of his services only when alive, but also
when he was dead. For, when approaching death, Julius
gave orders that he should be made to finish the tomb
which he had formerly started, and he put the care of this
into the hands of the elder Cardinal* Santi Quattro and his
own nephew Cardinal Aginense. And then they had him
make a new design, since it seemed to them that the first
project was too big.

So Michelangelo embarked once more on the tragedy of
the tomb, and progress for him was no easier than the first
time, rather far worse, for it brought him infinite troubles,
troubles, sorrows and vexations. And worse, through the
malice of certain men, it even brought him disgrace; and
scarcely after many years did he purge himself of this.

Michelangelo, then, started to have the work pushed
forward once more. He brought many master-craftsmen
from Florence; and Bernardo Bini, who was trustee, gave
him the money according to his need of it. But he had not
proceeded far, when to his great displeasure he was
obstructed, because Pope Leo, who succeeded Julius,
formed the wish to adorn the façade of San Lorenzo* at
Florence with marble work and sculptures.

This church was built by the great Cosimo de' Medici,
and apart from the front façade, the whole of it was
completely finished. So after he had determined to finish
the part mentioned, Pope Leo thought to make use of
Michelangelo, sent for him, and had him make a design;
and finally for this reason he wished him to go to Florence,
and to take all that load upon himself.

Michelangelo, who had very lovingly set about making
the tomb of Julius, offered all the resistance that he could,
alleging that he was under an obligation to Cardinal Santi
Quattro and to Aginense, and could not fail them. But the
Pope, who was resolved on the matter, answered him: 'Let
me deal with them and I'll satisfy them.'

Then having sent for both of them, he had Michelangelo given his release, to the latter's own great grief and that of the cardinals, especially Aginense, who, as said, was the nephew of Pope Julius; though Pope Leo promised them that Michelangelo would work on it in Florence, and said that he did not wish to obstruct him. In this manner Michelangelo, in tears, left the tomb, and went off to Florence; and when he arrived, having arranged everything for the business of the façade, he went to Carrara to supply the marbles, not only for the façade but equally for the tomb, believing, as he had been promised by the Pope, that he would be able to carry on with it.

In the meanwhile Pope Leo was informed in writing that in the mountains of Pietrasanta, a fortress-town of the Florentines, there was marble as beautiful and as good as at Carrara, but that after Michelangelo had been told about it, since he was a friend of the Marquis Alberigo,* and they understood one another, he preferred to quarry from the marble of Carrara rather than from that in the State of Florence.

The Pope wrote to Michelangelo, charging him that he must go to Pietrasanta to see whether what had been written to him from Florence was the case. Michelangelo then went there and found that the marble was difficult to work and hardly suited to the purpose; and even if it were suitable, it would be difficult and very costly to transport it to the coast. This was because one would have to build a road several miles long making use of pickaxes to drive through the mountains and employing piles over the plain, as it was marshy. After Michelangelo had written this to him, the Pope preferred to believe those who had written from Florence, and he ordered them to make the road. And so, to execute the will of the Pope, Michelangelo had the road built, and transported over it to the coast a great quantity of marble. It included five columns of the right size, one of which can be seen on the piazza of San Lorenzo; the other four, through the Pope having changed his mind and turned his thoughts elsewhere, are still lying

on the shore. But the Marquis of Carrara reckoning that Michelangelo, through being a Florentine citizen, had been the originator of quarrying at Pietrasanta, become an enemy to him. Nor subsequently did he wish him to return to Carrara for certain blocks of marble that he had had quarried there; and this was a great loss to Michelangelo.

Now having returned to Florence, and having, as was said, found that Pope Leo's fervour had completely died away, Michelangelo was grief-stricken and for a long time did nothing but kept just to himself, having to his great vexation thrown away so much time up to then, now on one thing and now on another. None the less, with some pieces of marble that he had at home, he began to work on the tomb again.

But then Leo passed away and Adrian was created Pope,* and once again he was forced to put the work aside. The reason was that they charged him with having received as much as 16,000 crowns from Julius for the work in question and with remaining in Florence uncaringly and just to please himself. So on account of this he was called to Rome; but the Cardinal de' Medici, who subsequently became Clement VII and who then had the government of Florence in his charge, did not wish him to go. And to keep him occupied, and provide an excuse, he commissioned him to make the fabric of the Medici Library in San Lorenzo, together with the sacristy for the tombs of his ancestors, promising to arrange matters and to satisfy the Pope on his behalf.

So, while Adrian lived in the papacy for a few months and was succeeded by Clement, for a time not a word was said about the tomb of Julius. But then Michelangelo was advised that Francesco Maria, the Duke of Urbino, the nephew of Pope Julius of happy memory, was complaining strongly about him, and being very menacing. And so he came to Rome; and there, conferring about it with Pope Clement, he was counselled by him to have the agents of the Duke called on to draw up an account with him of all that he had received from Julius and what he had done for him, the Pope knowing that Michelangelo would be left a

creditor rather than a debtor if his situation were properly assessed.

Because of this Michelangelo stayed in Rome against his will; and then having put some of his affairs in order, he returned to Florence, especially because of his foreboding of the ruin which was to come upon Rome a little while afterwards.

Meanwhile the Medici were driven from Florence by the opposing party, because they had seized more authority than a free city ruling itself as a republic will tolerate. Not doubting that the Pope must do everything he could to restore his family, and in the expectation of certain war, the Signoria turned its thoughts to fortifying the city; and it put Michelangelo in charge of this as commissioner general.

After being appointed to this task, as well as all the many other provisions he made for the whole of the city, Michelangelo threw a circle of strong fortifications round the mountain of San Miniato, which commands the town and overlooks the surrounding country. And if the enemy wrested control of that mountain, without any doubt they would also master the city. Thus this precaution secured the city's safety and brought great loss to the enemy. For as said, since it was of high elevation it greatly molested the enemy host, especially from the bell-tower of the church, where there were two pieces of artillery which continuously rained down destruction on the camp outside the walls.

Michelangelo, although he had made the right provisions, none the less to be ready for any eventuality remained on the mountain. Then, after he had already been there about 6 months, among the soldiers in the city there started to be murmurs of who knows what betrayal; and because of this, partly paying heed himself, partly advised by certain of the captains who were his friends, Michelangelo went to the Signoria, and revealed what he had heard and seen. He showed them the danger threatening the city and said there was time to take precautions, if

they wished. But instead of giving him thanks, they abused him; and he was admonished for being too suspicious and timid a man. And the one who replied to him like that would have done far better to have lent him his ear, for after the Medici entered Florence his head was cut off, whereas he might have stayed alive.

When Michelangelo saw that his words carried little weight and that certain ruin faced the city, he used his authority to have a gate opened; and going through with two of his people he went to Venice. Certainly the betrayal was no fable. But the one responsible judged that it would be accomplished with less infamy to himself if for the time being he made no move to reveal himself but let time achieve the same result, simply through his failing in his duty and impeding those who wished to do theirs. Michelangelo's departure caused great uproar in Florence, and he was held to be gravely contumacious by those who governed. None the less he was summoned back with great entreaties, appeals to the claims of country, and with the suggestion that he should not want to abandon the enterprise he had taken upon himself; and he was told that things had not reached the extremity he had been given to understand, and much else besides. Then in view of this and the authority of the personages who wrote to him, yet persuaded chiefly by love of his country, after receiving a safe conduct covering ten days from the day of arrival in Florence Michelangelo went back, though not without danger to his life.

After he arrived at Florence, the first thing that he did was to strengthen the bell-tower of San Miniato, which was all shattered from the continuous poundings of the enemy artillery and presented the threat that at length it would collapse altogether, to the great disadvantage of those within.

He strengthened it like this: taking a large number of mattresses well stuffed with wool, using stout ropes he slung them at night down from the summit to the base, so

that they covered the parts that could be hit. And for the reason that the cornice of the tower projected out, the mattresses hung at a distance of more than six spans from the main wall of the bell-tower; and so when the cannon-balls were fired, partly from the distance they had to travel, and partly from the presence of the mattresses, they did little or no harm, not even damaging the mattresses themselves, since they were yielding. In this way Michelangelo maintained the tower all the time the war lasted, which was a year, without it ever being damaged, and he rejoiced greatly in saving the town and inflicting harm on the enemy.

But then after the enemy were let in by consent and many citizens were seized and killed, the court sent to Michelangelo's house to have him seized as well; and all the rooms and chests were searched, including even the chimney and the privy. However, fearing what was to happen, Michelangelo had fled to the house of a great friend of his where he stayed hidden for many days, without anyone except his friend knowing he was there. So he saved himself; for when the fury passed Pope Clement wrote to Florence that Michelangelo should be sought for, and he commanded that, when he was found, if he wished to pursue the work on the tombs which had already been started, he should be left at liberty and treated courteously. When he learned this, Michelangelo issued forth, and although it was about 15 years since he had handled the tools, he set about the task with such zeal, that in a few months he made all the statues that are to be seen in the sacristy of San Lorenzo, driven more by fear than by love. It is true that none of them has had the final touches; yet they have been brought to such a standard that the excellence of the workmanship is clear to see; nor does the rough finish restrict the perfection and beauty of the work.

There are four monuments,* placed in a sacristy made for this in the left part of the church, opposite the old sacristy; and even though they are of the same form and design the

figures are none the less all different in their varied attitudes and movements. The sarcophagi are placed against the side walls, and along their lids stretch two great figures larger than life-size, namely a man and a woman, by which are signified separately Day and Night and, both together, Time which consumes everything.

And in order that his purposes should be better understood, he put with Night, who is made in the form of a woman of marvellous beauty, the owl and some other appropriate signs; with Day, similarly, his own attributes; and in order to denote Time, he left on the work a piece of the marble for the mouse he wished to make (but never did, as he was prevented) since this little creature is continually gnawing and consuming, just as time is continually devouring everything.

Then there are other statues which represent those for whom tombs were made, all in effect divine rather than human: but especially so a Madonna with her little son astride her thigh, about which I judge it better to stay silent than say just a little; and so I ignore it. The benefit of this work we owe to Pope Clement, and if he had done nothing else praiseworthy in life (though he did many things) it would be enough to cancel all his faults, since through him the world gained such noble statues. And we owe him much more, because, when Florence was seized, he showed to the genius of this man just the same respect that Marcellus had for that of Archimedes when he entered Syracuse; though the Roman general's example of goodwill had no effect whereas, God be thanked, the Pope's did.

For all that, Michelangelo remained in the greatest fear, because Duke Alessandro hated him deeply and was, as everyone knows, a wild and vindictive youth.* And there is no doubt that he would have got rid of him, were it not from consideration of the Pope. This was chiefly because when the Duke of Florence wanted to have his fortress built, and through Signor Alessandro Vitelli had Michelangelo summoned so that he should ride along with him to

to see where it could conveniently be sited, Michelangelo would not go, responding that Pope Clement had not commissioned him to do so. This greatly enraged the Duke; and thus because of this new consideration, because of the old ill will towards him, and because of the Duke's nature, Michelangelo went in fear with good reason. He certainly owed it to the help of the Lord God that on the death of Clement he was not in Florence, and this was because the Pope called him to Rome and received him very happily before he had completely finished the tombs.

Clement considered Michelangelo as something sacred, and he conversed with him, on both light and serious matters, with as much intimacy as he would have done with an equal. He sought to unburden him of the tomb of Julius, so that he could stay for certain in Florence and not only finish the projects he had begun but also undertake others just as worthy.

But before I say any more about that, I should write about another fact concerning Michelangelo, which I had inadvertently left out. It is this. After the violent departure of the Medici from Florence, the Signoria, being fearful, as was said above, of the future war, and planning to fortify the city, even though they recognized Michelangelo's high intelligence and great aptitude for this, all the same on the advice of some citizens who favoured the cause of the Medici, and wanted cunningly to hinder or delay the fortification of the city, wished to send him to Ferrara on the pretext that he should study the method that Duke Alfonso had followed in arming and fortifying the city.* For it was known that his Excellency was expert in these matters and very prudent in everything.

The Duke received Michelangelo with a joyful countenance, because of the latter's greatness and because his son, Don Ercole, that State's present Duke, was captain for the Signoria of Florence. And when he rode in person with Michelangelo, he showed him all the relevant items and more, from bastions to artillery; and he also opened up all his collection for him, showing him everything with his

own hands, notably some works of painting and portraits of his ancestors, masterpieces, which were excellent for the age in which they were made. But when Michelangelo had to leave, the Duke said to him jokingly: 'Michelangelo, you are my prisoner. If you want me to let you go free, I want you to promise me to make me something by your own hand, as suits you, just as you wish, sculpture or painting.'

Michelangelo gave his promise and then returned to Florence where, although very occupied on the work of fortifying the town, he all the same began a large easel picture, representing the coupling of the swan with Leda, and showing nearby the laying of the egg from which Castor and Pollux were born, according to what we read in the fables written by the ancients.

The Duke learned of this, and when he heard that the Medici family had entered Florence, fearing he might lose this treasure in the disturbances, he immediately sent one of his men there. This person having reached Michelangelo's house, saw the picture and said: 'Oh! This is but a trifle.' And having been asked by Michelangelo what art he practised (for one judges best the art in which one is experienced) he replied sneeringly: 'I am a dealer.' He was perhaps piqued by Michelangelo's query and the failure to recognize that he was a gentleman; and also, despising the work done by the citizens of Florence who for the most part are merchants and dealers, he intended to imply: 'You asked me what art I practised? Could you really think I was a dealer?'

Michelangelo, who understood what the gentleman meant, stated: 'You have just made a bad deal for your master; get out of my sight.'

So having dismissed the ducal messenger, he gave the picture shortly afterwards to one of his assistants, who had asked for his help as he had two sisters to be married off. It was taken to France, where it was bought by King Francis and where it still is.

Now, to return to where I was, after Michelangelo had

been called to Rome by Pope Clement, he started to be harassed by the agents of the Duke of Urbino with regard to the tomb of Julius. Clement, who would have liked to make use of his services in Florence, sought by every possible means to release him; and he gave him as his attorney a certain Messer Tommaso da Prato, who was later on made the datary. But Michelangelo knew the ill will that Duke Alessandro bore towards him and was very fearful; and as he also felt love and reverence for the bones of Pope Julius, and for the most illustrious house of Della Rovere, he tried his best to stay in Rome, and to keep himself busy on the work on the tomb; and all the more because everyone alleged that he had received from Pope Julius, as was said, a good 16,000 crowns for the purpose and had lived well on that money without doing what he was under obligation to do. And being unable to bear this reproach, as a man who was tender of his honour, he wanted the matter to be settled; and he would not refuse, old as he now was, the very heavy task of finishing what he had begun. With all this, when things came to a head Michelangelo's adversaries were unable to prove payments anywhere near to the sum that had previously been claimed; and in fact over two-thirds of all the payments under the agreement initially made with the two cardinals were unaccounted for. So then Clement, reckoning that he had been handed a most splendid opportunity to settle the matter, and in order to secure free use of Michelangelo's services, summoned him and said: 'Now then, you say that you wish to make this tomb, but also that you want to know who is to pay you for what is still to be done.'

Michelangelo, who knew the Pope's mind, and that he would have liked to keep him in his service, replied: 'And if someone were found to pay me?'

Pope Clement said: 'You're mad if you've let yourself believe that anyone is going to come forward and offer you even a penny.'

So when Messer Tommaso, his attorney, spoke in court and put the proposal to the Duke's agents, they started to look each other in the face, and they together came to

decide that he should at least build a tomb for the amount he had in fact received.

It seemed to Michelangelo that things had gone well and so he willingly consented to this; he was influenced especially by the authority of the elder Cardinal del Monte, favourite of Julius II and uncle of Julius III (thanks be to God, our present pontiff) who intervened in this agreement.

The agreement was as follows. That Michelangelo should make a tomb with one façade only, and he should make use of the marbles that he had already had prepared for the four-sided tomb, arranging them as best he could; and he was under obligation to add six statues from his own hand. None the less it was conceded that Pope Clement could make use of Michelangelo's services in Florence, or wherever he pleased, for four months of the year, as this was required by His Holiness for the work at Florence. Such was the contract which was drawn up between his Excellency the Duke and Michelangelo.

But here it has to be understood that, after all the accounts had been reckoned, in order to seem under greater obligation to the Duke of Urbino, and to make Pope Clement less assured about sending him to Florence (where by no means did he want to go), Michelangelo secretly agreed with his Excellency's spokesman and agent that they should say that he had received several thousand crowns more than he actually had. This was done verbally and also (without his knowledge or consent) put in the contract itself not when it was drawn up but when it was finalized. And this disturbed Michelangelo greatly. All the same the Duke's spokesman persuaded him that it would not be to his prejudice, never mind whether the contract specified 20,000 more rather than 1,000 crowns, since they were in agreement that the tomb should be scaled down according to the money actually received. And he added that no one except for himself would question the matter, and that Michelangelo could be sure of him, because of the understanding there was between them. Michelangelo then

calmed down, partly because he thought he was safe, and partly because he wanted this pretence to serve his purpose with the Pope as mentioned above. And this is how things were left for the time being; but it was not the end of the matter. For after Michelangelo had served for the four months in Florence, and then returned to Rome, the Pope sought to engage him on other work and to have him paint the wall of the Sistine Chapel. And being a person of great discernment, who had brooded on this project time and time again, he finally resolved to have Michelangelo depict the day of the Last Judgement, reckoning, because of the variety and grandeur of the subject, that he would thereby give this man the field in which to demonstrate all his powers to the full.

Michelangelo, knowing the obligation he was under to the Duke of Urbino, resisted the demand as much as he could. But since he was unable to free himself, he delayed things from day to day, pretending to be occupied on the cartoon, as he was in part, while secretly working on the statues destined for the tomb.

In the meanwhile Pope Clement passed on, and, after the elevation of Pope Paul III,* the latter sent for Michelangelo to ask him to stay in his service. Fearful of being impeded in what he was doing, Michelangelo replied that he could not do so, for the reason that he was bound under contract to the Duke of Urbino until he had finished the work that he had in hand. Disturbed and angry the Pope said: 'Already thirty years I have had this wish, and now that I'm Pope cannot I satisfy it? Where is this contract? I will tear it up.'

Seeing the straits he was in, Michelangelo was all set to leave Rome and go to the district of Genoa, to an abbey of the Bishop of Aleria, one of Julius's appointees and very much his friend, where he could bring his work to completion, as the place was convenient for Carrara and he could easily transport the marble because of its proximity to the sea. He also thought of going off to Urbino, where once before he had planned to dwell for its peacefulness, and

where he had hoped to be welcomed gladly for the sake of Julius. For this purpose he had sent one of his men there some months previously to buy a house and some land; but, fearing the greatness of the Pope, and rightly so, he stayed put, hoping to satisfy the Pope with soothing words.

But the Pope, sticking firmly to his purpose, one day accompanied by eight or ten cardinals, came to find him at home, and wanted to see the cartoon made under Clement for the wall of the Sistine Chapel, the statues that he had already made for the tomb, and every other single thing. Whereupon the most reverend Cardinal of Mantua, seeing the Moses, which has already been written about and will be written about more fully below, said: 'This statue alone is enough to honour the tomb of Julius.'

Then Pope Paul, after he had seen everything, once more charged him to enter his service, in the presence of many cardinals and of the above mentioned most reverend and most illustrious Cardinal of Mantua. And finding Michelangelo obdurate, he said: 'I shall arrange for the Duke of Urbino to be content with three statues from your hand, and for the others that remain to be given to others to do.'

In this manner, with the agents of the Duke, he created a new contract, which was confirmed by his Excellency the Duke, who did not wish to displease the Pope in this matter. Likewise Michelangelo, although he could have avoided paying for the three statues, being freed from the obligation by virtue of this contract, nonetheless wished to bear the expense himself; and for the statues and the remainder of the tomb he deposited 1,580 ducats. Thus his Excellency's agents gave the statues out to be done, and the tragedy of the tomb and the tomb itself came to completion;* and today it is to be seen in San Pietro ad Vincula. It is not based on the first design with four sides, but has a single façade, one of the shorter sides, not free-standing but, because of the obstacles explained above, flush against the wall.

It is true that the tomb, just as it is, botched and rebuilt, is yet the most impressive to be found in Rome and perhaps anywhere else. If for nothing else, this is so for the three statues it contains from the hand of the master. Marvellous among these is the one of Moses,* leader and commander of the Jews, who is shown sitting there in the attitude of a wise and thoughtful man, holding in his right hand the tablets of the law, and, appearing tired and full of cares, is supporting his chin with his left hand, between fingers of which spring several long strands of his beard, something beautiful to see. The face is full of spirit and vivacity, composed in a manner to induce both love and terror, as was doubtless the case. And following the way he is usually described, Moses has on his head two horns, just a little way from the top of the forehead. He wears a toga, and is shod and has his arms nude, all in the manner of the ancient world. A marvellous work, full of art; and all the more so since beneath the beautiful garments with which he is covered, he appears completely nude, and so the clothing does not destroy the sight of the beauty of his body; and it can be observed that this practice was universally followed by Michelangelo in all his clothed figures, either sculpture or painting. In height the statue is over twice life-size.

The next statue is on its right in a niche, and it represents the Contemplative Life, a woman larger than life-size, and of rare beauty, with one knee bent, not on the ground but on a plinth, and with her face and both arms raised up to heaven, so that every part of her seems to breathe love.

On the other side, on the left of the Moses, is the figure of Active Life, holding in the right hand a mirror in which she contemplates herself attentively, signifying by this that all our actions should be done with careful consideration, and in the left a garland of flowers. In this Michelangelo has followed Dante, of whom he has always been a student, for in his *Purgatory* Dante makes up the story of having found the Countess Matilda, whom he took for the Active Life, in a meadow of flowers. The whole of the

tomb is altogether beautiful, and especially the way its parts are bound together by means of the great cornice, which cannot be faulted.

Now that is enough, as far as this work is concerned; and I fear that it may indeed have been too much, and that instead of pleasing I may even have bored the reader. None the less I thought it was necessary to write it in order to extirpate the false and unfortunate opinion which had taken root in men's minds, namely that Michelangelo had received 16,000 crowns and did not wish to do what he was under obligation to do. Neither the one nor the other was true, because he received from Julius for the tomb just the 1,000 ducats which he spent during those months on quarrying marble at Carrara. And how could he subsequently have had money from him, seeing the Pope changed his mind and no longer wished to discuss the sculpture?

As for the money which after the death of Julius he received from the two cardinals who were executors of the will, Michelangelo has in his possession an open draft in the hand of a notary, sent to him by Bernardo Bini a Florentine citizen (who was the trustee and paid out the money), and it came perhaps to 3,000 ducats. Notwithstanding, never was a man more eager to apply himself to any work than he was to this; partly because he knew how much it would increase his reputation, partly because of the remembrance in which he always held the blessed soul of Pope Julius. This last has caused him always to honour and love the house of Della Rovere, and especially the dukes of Urbino, for whom he has joined battle with two popes, who as we have said, wished to withdraw him from that enterprise. And what Michelangelo grieves over is that instead of bringing the thanks due to him it won him only hatred and disgrace.

But to come back to Pope Paul, let me say that after the final agreement made between his Excellency the Duke and Michelangelo, he took him into his service and wanted

him to execute what he had already started in the time of Clement; and he had him paint the wall of the Sistine Chapel to which he had already applied a first layer of rough plaster and closed off with boards from ground to vault. Since this work had been conceived by Pope Clement and had been started in his time, Michelangelo did not place Paul's coat-of-arms there, even though the Pope had requested it of him. Pope Paul revered and loved Michelangelo so much that he would still never upset him, despite that being what he desired.

In this work Michelangelo expressed all that the art of painting can make of the human body,* leaving out not one single attitude or movement. The composition of the whole scene is judicious and beautifully thought out. But it would take a long time to describe and perhaps this is not necessary, since so very many prints have been made and sent everywhere. None the less for those who have not seen the actual painting or laid their hands on a print let us briefly say this: that the whole is divided into various parts, right and left, upper and lower, and centre. In the central part in the air, near the earth, are the seven angels described by St John in the Apocalypse who with trumpets at their mouths are calling the dead to Judgement from the four corners of the world. Among these are another two angels holding in their hands an open book in which everyone reads and recognizes his past life and so as it were is his own judge.

At the sound of these trumpets the burial places on earth are seen to open up and humankind issues forth in all kinds of marvellous attitudes. Some, following the prophecy of Ezekiel, have their skeletons just reassembled, others have them half-clothed in flesh, and others completely so. Some are naked, some attired in the shrouds and winding-sheets in which they were wrapped when borne to the grave, and from which they are seeking to divest themselves. Among these are some who as yet still do not seem really fully awake, and looking up to Heaven they stand there as if in doubt as to where divine justice is calling them. Here too it delights the eye to see some with

great effort still forcing their way out of the earth, while some take flight with arms outstretched to heaven. Others are already in flight: they soar in the air, some higher, some lower, displaying varied postures and attitudes.

Above the trumpeting angels is the Son of God in majesty, with arm and powerful right hand uplifted, in the form of a man who in anger curses the wicked, and drives them from His presence to the everlasting fire, while with His left hand extended to His right He appears to gather the good gently to Himself. As He delivers sentence the angels between heaven and earth appear as executors of the divine judgement; they speed on the right to the help of the elect, lest their flight be impeded by evil spirits, and on the left they go to hurl back to earth the damned, who by their audacity might have already raised themselves aloft. But the damned are being dragged below by the evil spirits, the proud by their hair, the lustful by their shameful parts, and following on this every one of the wicked by the part which occasioned his sin.

Beneath the damned, just as Dante described him in his *Inferno*,* on marshy Acheron, Charon appears in his boat raising his oar to strike any soul that lags behind; and when the bark reaches the shore, all the souls within it, spurred on by divine justice, strive with each other and push forward; and thus, as the poet says, fear turns into desire. Then after Minos has passed sentence, they are dragged by the evil spirits to the infernal pit, where can be seen all the marvellous expressions of the grievous and desperate emotions that the place demands.

Around the Son of God, in the middle part on the clouds of the sky, the blessed who have already been brought back to life form a circle or crown; and there standing apart, near to the Son, is His mother, wearing a timorous aspect as if not unafraid of the inmost anger of God, and so drawing herself as close as she can beneath her Son. Next to her are the Baptist, and the Twelve Apostles and the male and female saints of God, showing to the tremendous Judge the instrument by means of which, while confessing His name, each one was deprived

of life: St Andrew, the cross, St Bartholomew, his skin;* St Lawrence, the gridiron; St Sebastian, the arrows; St Blaise, the iron combs; St Catherine, the wheel, and other saints with other objects which identify them to us. Above the saints to the right and left, on the upper part of the wall, groups of little angels, in rare and charming attitudes, appear holding up in heaven the cross of the Son of God, the sponge, the crown of thorns, the nails, and the column where he was flagellated. This is to reproach the wicked with the loving kindnesses of God, repaid by them with great apathy and ingratitude, and to comfort and inspire faith in the good. There are countless other details in the painting, but I shall pass over them in silence. Enough to say that as well as the inspired composition of the whole scene, one sees represented everything it is possible for nature to do with the human body.

Finally, after Pope Paul had built a chapel on the same floor as the above-mentioned Sistine chapel,* he wished to decorate it with memorials of Michelangelo; and so he had him paint two large pictures on the side walls. In one is represented the story of St Paul, when he was converted by a vision of Jesus Christ; in the other, the crucifixion of St Peter: and both are stupendous, whether for the whole in general or for each particular figure. This is the last work of painting seen from his hand up to the present day, and he finished it when he was 75 years old.

Now he has on hand a work of marble which he is doing for his own pleasure, being a man who is full of ideas and so has to give birth to something every day. It is a group of four figures larger than life,* namely a Christ taken down from the cross, and in His death sustained by His mother, who has moved to support His body with her breast, her hands and her knee, in a wonderful pose. She is, however, helped by Nicodemus, who, upright and firm on his legs from above, lifts Him up under the arms, showing enormous strength, and by one of the Marys on the left. And although she is grieving deeply, none the less this Mary does not fail to perform that office for the dead Christ

which the mother cannot do because of her extreme grief. Christ, as He is let go, falls with all His limbs relaxed, but in a posture very different from the Pietà Michelangelo carved for the Marchioness of Pescara* or that of the Madonna della Febbre. It would be an impossible task to describe in words the beauty and emotions shown in all the melancholy, grief-stricken countenances, or in that of the afflicted mother alone; so let this be enough. I must just say that it is a rare thing, and one of the most laboriously wrought works that he has made till now, especially since all the figures are shown distinct from each other, nor are the garments of any one figure confused with those of the others.

Michelangelo has done countless other things which have not been listed by me. They include the Christ which is in the Minerva;* a St Matthew in Florence, that he started with the wish to make twelve apostles, which were to go against the twelve piers of the Duomo; cartoons for various paintings, plans for public and private buildings, without number; and for a bridge that was to go over the Grand Canal in Venice, in a new style and form, never seen before; and many other things which cannot be seen and would take a long time to write about. So I shall end here.

He has it in mind to give the Pietà to some church and to have himself buried at the foot of the altar where it is placed. May the Lord God in His goodness long preserve him for us, for I do not doubt that one and the same day will see the end both of his life and of his labours, as was written about Isocrates.* I am given every hope that he has many more years to live by the lively and robust nature of his old age and also the long life of his father, who lived until he was 92* without knowing a day's illness; and when he passed over it was as if he had faded away rather than succumbed to disease, so that, as Michelangelo put it, he kept the same colour in his face as when he was living and seemed to be sleeping rather than dead.

From childhood Michelangelo was very hard-working,

and he has augmented nature's gift with knowledge which he has always wished to acquire not through the work and industry of others but from nature herself, whom he has set before his eyes as the true model. For there is no animal which he has not wished to dissect, equally including human bodies, and so much so that those who have spent all their lives on this and make it their profession scarcely know as much as he. I am talking about the understanding needed for the art of painting and sculpture and not the kind of details the anatomists observe.

The truth of this is shown by his figures in which there are displayed so much art and knowledge that no other painter whatever could imitate them. I have always been of the opinion that the powers and propensities of nature have a prescribed limit, fixed and ordained by God, which cannot be exceeded by normal talent; and that this is true not only of painting and sculpture but of all the arts and sciences universally. And I believe that all this power of hers is concentrated in one man, who has to stand as the rule and measure in that particular skill and who is put in first place. This is so arranged that whoever then wishes to create something in that art worth reading or looking at, must either produce the same as has already been created by that first man, or at least something similar and along the same lines. And if it is not so, the more it departs from the right way, the more inferior it will be.

After Plato and Aristotle, how many philosophers who did not follow them were still held in esteem? How many orators after Demosthenes and Cicero? How many mathematicians after Euclid and Archimedes? How many doctors after Hippocrates and Galen? Or poets after Homer and Virgil? Someone may have laboured in one of these branches of knowledge, and by his own efforts proved well able to attain first place. None the less finding this place already occupied, because his forerunners have previously reached perfection in their work, such a person has either abandoned the undertaking or, with good judgement, devoted himself to imitating his forerunners as exemplars of perfection.

(We see this today in the case of Bembo,* Sannazaro, Caro, Guidiccione, the Marchioness of Pescara, and other writers and lovers of Tuscan rhyme. They are those who, however much endowed with sharp and outstanding intelligence, none the less, since they could not themselves bring to birth anything better than nature has produced through Petrarch, have given themselves to imitating him, though so happily that they have been judged worthy of being read and numbered among the best.)

Now to conclude this discourse, let me say that it seems to me that in painting and sculpture nature has given freely and generously to Michelangelo from all her rich stores; so I should not be reprimanded for saying that his figures are almost inimitable. Nor do I think I have let myself be carried away. For, let alone that he has been the only one until now who has been able to take up worthily both the chisel and the brush, although today no trace remains of the painting of the ancient world, much of its sculpture still survives and here, to whom should he defer? In the judgement of those who practise the art, certainly to no one; unless we follow in this matter the opinion of the common people who unthinkingly admire antiquity, and are envious of the talents and industry of their own times. But I have not heard anyone saying the contrary, since this man is so far above all envy.

Raphael of Urbino,* however much he wished to compete with Michelangelo, many times had to confess that he thanked God he was born in his time; for he had derived from him a style different from the one he had learned from his father, who was a painter, and from his master, Perugino. But what clearer and better sign of the excellence of this man could there ever be than the way the princes of the world contended for him? For not alone the four Pontiffs, Julius, Leo, Clement, and Paul, but even the Grand Turk,* father of the one who holds power today, as I said above, sent him certain Franciscan priests to beg him to go to stay with him; and he arranged through letters of credit that he should not only be disbursed by the

Gondi bank the amount of money he wanted for the needs of the journey but also that after he had reached Cossa, a town near Ragusa, he should be honourably accompanied from there to Constantinople by one of his grandees.

Francis I of Valois, King of France, sought after him in many ways, and he had him credited in Rome 3,000 crowns for the needs of the journey, whenever he wanted to go. Bruciolo was sent to Rome by the Signoria of Venice to invite him to dwell in that city and to offer him an allowance of 600 crowns a year: there was no obligation, save merely that he should honour the Republic with his presence; and also on condition that if he should make anything while in the city's service, he should be paid fully for it, as if he had received no allowance from them. Such arrangements are not usual, everyday occurrences; they are new and out of the ordinary and they do not happen except in instances of singular, outstanding talent, like that of Homer, for whom many cities contended, each one of them claiming him for its own possession.

In no less esteem than by all these I have already named is Michelangelo held now as ever by the present pontiff Julius III, a prince of perfect judgement, and a lover and sustainer of all the talents universally, but in particular inclined most of all to painting, sculpture and architecture. This can clearly be recognized from the works he has commissioned for the palace and the Belvedere, and is now having made for his Villa Giulia* (an enterprise and memorial worthy of such a lofty and generous mind). For the villa is filled with so many statues, ancient and modern, and such a great variety of most beautiful stones and precious columns, of stuccoes and of every other sort of ornament, that I shall delay writing about it till another time as is demanded by such a special work, still not fully perfected. The Pope has not pressed Michelangelo to work for him on this, out of respect for the age he has reached. He well recognizes and relishes his greatness, but he refrains from burdening him with more than he wishes to do. And this respect, in my judgement, enhances Michel-

angelo's reputation more than any of the work all the other pontiffs employed him to do. But certainly as regards the works of painting and architecture that His Holiness commissions, he almost always seeks Michelangelo's opinion and judgement, very often sending the masters of those crafts to find him in his own home. I grieve, and it also grieves His Holiness, that from a certain natural timidity, or let us say respect and reverence, which some call pride, Michelangelo does not avail himself of the benevolence, goodness and liberal nature of a great pontiff who is so devoted to him. The Pontiff, as I first heard from the most reverend Monsignor di Forlì,* his chamberlain, has many times stated that (if it were possible) he would willingly take from his own years and his own lifeblood to add them to Michelangelo's, so that the world should not be so soon deprived of a man of his quality. And I have heard this from his own mouth with my own ears, when I too have had access to His Holiness. Moreover, the Pope has said that if he survives Michelangelo, as the natural course of life seems to require, he shall have him embalmed and keep him near him, so that his corpse may be as everlasting as his works. The Pope also said this at the beginning of his pontificate to Michelangelo himself in the presence of many people. And I do not know what words could honour Michelangelo more or be a stronger sign of the esteem in which His Holiness holds him.

He again displayed this openly in consistory when Pope Paul died and he was made pontiff. All the cardinals who were in Rome at the time were present, and he then defended Michelangelo and offered him protection against the overseers of the fabric of St Peter's. These, for no fault of his (as they said) but of those who served him, wished to deprive Michelangelo of the authority he had been given by Pope Paul through a *motu proprio** (of which more will be said below) or at least to restrict it. The Pope defended him not only by confirming the *motu proprio* but with many noble words of praise, and he refused to lend ear to the complaints either of the overseers or of any others.

Michelangelo (as he has many times told me) appreciated the love and benevolence of His Beatitude and the respect he entertained for him; and since he cannot repay him for this and show his appreciation by serving him, he finds what is left of his life less pleasing, for it seems useless and thankless to His Holiness. One thing (as he is accustomed to say) that comforts him is that he knows His Holiness is a discerning man, and so he hopes to be excused at court and to have his goodwill accepted instead, as he has nothing else to give. Nor does he refuse, where he is able and as his powers extend, to do other than put his life at his service; and this I have from his own mouth. Michelangelo none the less, at the request of His Holiness, did make a design for the façade of a palace,* which he had in mind to build in Rome: something to look at, new and unprecedented, owing nothing to any ancient or indeed modern style or rule. He has done the same in many other of his works in Florence and in Rome, demonstrating that architecture had not been treated in such an absolute manner in the past as to leave no room for new invention, no less charming and beautiful.

Now, to return to the subject of anatomy, Michelangelo gave up dissecting corpses. This was because his long familiarity with the practice had so upset his stomach that he could neither eat nor drink beneficially. But truly when he parted from this branch of study his knowledge was so rich that he very often had in mind, as a service to those wanting to make works of sculpture and painting, to produce a treatise of his own on different kinds of human movement and appearance, and on the bone structure, with an ingenious theory which he had elaborated after long experience. And this he would have done, had he not been diffident about his own powers, and whether he would be able to treat a subject like this with the same grace and dignity as one versed in the sciences and in rhetoric.

I do know that when he reads Albrecht Dürer,* he finds it very weak, and he perceives how much more useful and beautiful his own ideas might be in this study. And to tell

the truth, Albrecht treats only of the proportions and varieties of human bodies, for which no fixed rule can be given, making his figures straight as posts; and even more important, he says not a word about human actions and gestures.

Now because Michelangelo is today in his ripe old age, and does not think he can show the world this concept of his in writing, he has very affectionately revealed everything to me in the minutest detail; and I have started to impart it to Messer Realdo Colombo,* a most excellent medical surgeon and anatomist and a great friend of Michelangelo's and mine. For this purpose Realdo sent him the corpse of a young Moor who was very handsome and, as far as one can say so, most suitable; and it was put in Sant' Agata, as a place well removed, where I lived and still live. And on this corpse Michelangelo showed me many rare and recondite things, perhaps never previously understood, all of which I have noted and hope one day to publish, with the help of some learned men, for the gain and convenience of all those who wish to produce works of painting or sculpture. But enough of this matter.

He devoted himself to perspective and to architecture, and his works demonstrate how much he profited thereby. Nor did he content himself with understanding the principal branches of architecture, but he also wanted to know everything that might in any way serve the profession, for example, making tie-ropes, scaffolding or platforms, and similar things; and in this he was good as those who have no other profession as was realized in the time of Julius II, in the following way.

Michelangelo had to paint the vault of the Sistine chapel and the Pope ordered Bramante to make the scaffolding. Bramante, despite being the architect he was, did not know how to do it and in several places he perforated the vault and through the perforations lowered some cables to secure the scaffold. Michelangelo laughed when he saw it, and asked Bramante what he would have to do when he reached those perforations; and Bramante, who had no

defence had as his only reply that he could not have done otherwise. The affair came before the Pope, and when Bramante repeated the same thing, the Pope turned to Michelangelo and said: 'Since this is not to the purpose go and do it by yourself.'

Michelangelo dismantled the scaffold and he retrieved so many cables that as a gift they enabled a poor man who helped him to marry off two of his daughters. So then he made his own scaffold without ropes, and it was so well interwoven and composed that the more weight there was on it, the firmer it grew. This was the reason why Bramante had his eyes opened and learned the method for making scaffolding; and this subsequently benefited him greatly on the fabric of St Peter's.

And for all that Michelangelo had no equals in all these matters, none the less he never wished to follow the profession of architect. Indeed, on the eventual death of Antonio da San Gallo, architect of the building of St Peter's, when Pope Paul wished to appoint Michelangelo in his place, he refused this employment, alleging that it was not his craft; and he refused in such a way that the Pope had to order him to do so and issue a most ample *motu proprio* which was subsequently confirmed for him by Pope Julius III, at present, as I said, thanks be to God our reigning Pontiff. For this service Michelangelo never wanted anything, and he wanted this fact to be declared in the *motu proprio*. Thus when one day Pope Paul sent him 100 gold crowns by Messer Pier Giovanni, at that time His Holiness's Master of the Wardrobe, and now Bishop of Forlì, to represent his earnings for the month, on account of the building, he would not accept them, saying that this was not what they had agreed together, and he sent back the money. This annoyed Pope Paul, according to what was told me also by Messer Alessandro Ruffino, a Roman nobleman, chamberlain, and steward to His Holiness at that time; yet this did not shake Michelangelo's determination. Once he had accepted the task, he made a new model,* partly because certain features of the old one on many accounts did not please him, partly because if it were

attempted, one would sooner have been able to hope to see the last day of the world than St Peter's finished. And so Michelangelo's model, praised and approved by the pontiff, is being followed at the present time, to the great satisfaction of those people who have judgement, though there are some who do not approve of it.

Now Michelangelo, when he was young, gave himself not only to sculpture and painting, but also to all those branches of study which either belong or are close to them; and he did this so zealously that for a while he came near to cutting himself off completely from the fellowship of men, except for the company of a very few. For this, he was held to be proud by some, and by others very touchy and temperamental, though he had neither one or the other of these faults. Rather (as has been the case with many men of excellence) it was the love of virtuosity, and the continuous practice of the fine arts, that made him solitary; he took so much delight and pleasure in them that the company of others not only did not bring him contentment but positively gave him displeasure, since it diverted him from his meditation, and he (as the great Scipio used to say himself*) was never less alone than when alone. Yet he has willingly kept the friendship of those from whose virtuous and learned conversation he could gather some fruit, and in whom there shone forth some ray of excellence: for instance, of the most reverend and illustrious Monsignor Pole,* for his rare talents and singular goodness; and likewise of my reverend patron, Cardinal Crispo, since he found in him, along with many other good qualities, rare and outstanding judgement. And he felt great affection for the most reverend Cardinal Santa Croce, a very grave and prudent man, of whom I have many times heard him speak with the greatest esteem; and for the most reverend Maffei, of whose goodness and learning he has always spoken well. And without exception he loves and honours all the persons of the Farnese house, for the lively memory he still has of Pope Paul, recalled by him with the utmost reverence, and con-

tinuously mentioned by him as a good and holy old man; and also the most reverend Patriarch of Jerusalem, formerly Bishop of Cesena, with whom he has long had a warm relationship, finding great pleasure in his open and generous nature. He also enjoyed a close friendship with my most reverend patron, Cardinal Ridolfi, of happy memory, the refuge of all talented men.

There are some others whom I shall leave out, not to be too prolix; such as Monsignor Claudio Tolomei,* Messer Lorenzo Ridolfi, Messer Donato Giannotti, Messer Lionardo Malespini, Lottino, Messer Tommaso Cavalieri* and other esteemed gentlemen, about whom I shall not write at any greater length.

Finally, he has become very fond of Annibale Caro, and he has told me that he regrets not having been familiar with him sooner, since he has found him much to his taste. In particular, Michelangelo greatly loved the Marchioness of Pescara, with whose divine spirits he fell in love, and by whom in return he was himself loved utterly and tenderly; he still has many of her letters, full of pure and most tender love, such as used to pour forth from her heart. And he correspondingly wrote for her many, many sonnets, full of innocent and tender longing. Many times she made her way from Viterbo or other places where she had gone for recreation or to pass the summer; and she would come to Rome for no other reason than to see Michelangelo; and he in return loved her so much that I remember having heard him say that what grieved him above all else was that when he went to see her as she was passing from this life, he did not kiss her brow or her face but simply her hand. Through her death, he many times felt despair, acting like a man robbed of his senses.

At the request of his lady he made a naked Christ being taken down from the cross; as His dead body is let go, if Christ were not supported under the arms by two little angels, He would fall at the feet of His holy Mother. But she, seated beneath the cross with tearful and sorrowful countenance, with open arms is raising both her hands to heaven, and utters this sentence, which we see written on

the stem of the cross: 'They do not realize how great the cost in blood!'* The cross is similar to the one which, at the time of the pestilence of 1348, was carried in procession by the Bianchi, and which was then put in the church of Santa Croce in Florence. For love of her, he also made a drawing of Jesus Christ on the cross, not in the semblance of death, as is commonly done, but in a godlike attitude, raising his countenance to the Father, and appearing to say 'Eli, Eli': and thus the body does not fall as if slumped in death but is seen as a living being, wracked and contorted by a bitter torment.

And just as he has delighted in the conversation of learned men, so he has found pleasure in studying the writers of prose, and equally so of verse, among whom he has especially admired Dante, delighted by the marvellous genius of that man, whose work he knows almost all by heart; though he thinks perhaps just as highly of Petrarch.

Then he has taken delight not only in reading but also in sometimes composing verse himself, as witness some of his existing sonnets, which give a very good example of his great inventiveness and judgement. And on some of them certain discourses and observations have been published by Varchi.* But he has attended to these matters more to give himself pleasure than to make a profession of them, and he has always denigrated himself and alleged his ignorance in these things.

Michelangelo has similarly with great diligence and attention read the holy scriptures, both the Old Testament and the New, as well as the writings of those who have busied themselves with their study, such as Savonarola for whom he has always had a strong affection,* and the memory of whose living voice he still carries in his mind. He has loved, too, the beauty of the human body, as one who knows it thoroughly and well. And he has loved it in such a fashion that among certain lewd men, who do not know how to understand the love of Beauty unless it is lascivious and impure, there has been occasion to think and talk evil of him: as if Alcibiades,* a most handsome

young man, had not been loved most chastely by Socrates; from whose side, when he lay with him, it used to be said that he did not get up otherwise than as from the side of his father.

I have many times heard Michelangelo talk and argue about love; and I have heard later from those who were present that he did not speak otherwise of love than is to be found written in the works of Plato. For myself, I do not know what Plato said on the subject: I well know, having been close to him for so long and so intimately, that I have never heard his mouth utter other than the purest words, which had the power to extinguish in youth every indecent and unbridled desire that could come along. And that he conceives no filthy thoughts can also be recognized from the fact that he has loved not only human beauty but universally every beautiful thing, a beautiful horse, a beautiful dog, a beautiful landscape, a beautiful plant, a beautiful mountain, a beautiful wood, and every place and thing beautiful and rare after its own kind, looking at them all with marvellous feeling and admiration and so selecting what is beautiful from nature, as bees gather honey from the flowers, to make use of it later in their works, and as do all those who have made some name for themselves in painting.

That ancient master* when he wanted to paint a Venus was not content just to see one virgin but wished to contemplate many; and then he took from each one the most beautiful and perfect feature to use for his Venus. And truly anyone who thinks he can reach some degree of excellence without following this path (which leads to the correct theory of beauty) deceives himself very badly.

Michelangelo has always been very frugal in his way of life, taking food more from necessity than for pleasure, especially when working; and at these times he has invariably been content with a piece of bread, even eating it while still at work. But for a while now he has been living more carefully, as called for by his more than mature years. Many times I have heard him say: 'Ascanio,

however rich I may have been, I have always lived as a poor man.'

And just as he has taken little food, so he has needed little sleep which, according to what he says, has rarely done him any good, seeing that when he sleeps he nearly always suffers a headache; indeed too much sleep gives him a bad stomach. When he was more robust he often slept in his clothes and in the boots which he has always worn for reason of cramp, from which he has continually suffered, as much as for anything else. And sometimes he has been so long in taking them off that subsequently along with his boots he sloughed off his skin, like a snake's. He was never penny-pinching, nor concerned to pile up money, being content with just so much as he needed to live honestly; and so when he was asked by growing numbers of lords and rich people for something from his own hand, and they gave lavish promises, he rarely did it, and when he did it was rather from friendship and benevolence than from hope of reward.

He has given away many of his things which, if he had wanted to sell them, would have brought him an unlimited amount of money; as for example, even if there were nothing else, happened with those two statues that he gave to his very close friend, Messer Roberto Strozzi. Nor has he been generous only with his works, for with his purse too he has often relieved in his need some poor studious and talented man, either a writer or a painter; and I can give testimony of this, having seen him act in this way towards myself.

He was never jealous of the works of others, even in his own art, though more from natural goodness than from any opinion he had of himself. Indeed, he has always praised everyone universally, and even Raphael of Urbino, between whom and Michelangelo there was once some rivalry in painting, as I have described. All that I have heard him say is that Raphael did not have this art from nature, but from long study. Nor is it true that as many have imputed to him, that he did not wish to teach; rather

he has done so willingly, and I have known this for myself, to whom he has revealed every secret of his art. However, misfortune has brought it about that he has either chanced upon pupils with little aptitude or, if they have had aptitude, they have not persevered but have considered themselves masters after being a few months under his instruction. And even though he did this very readily, yet he was not happy for it to be known, since he preferred to do good than to be seen to do so. It should also be known that he always sought to instil this art into persons of nobility, as the ancients used to do, and not into plebeians.

He has enjoyed a most retentive memory, and so much so that for all the many thousand figures he is seen to have painted he has never made two alike or with the same attitude; indeed I have heard him say that he never draws a line without remembering if he has ever drawn it before, and then cancelling it if it is to be seen in public. He is also endowed with a most powerful imaginative faculty, the basic reason why he has been little content with what he has done, and has denigrated it: for it has not seemed to him that his hand has realized the idea that he formed within.

Then for the same reason, as for the most part happens with those who devote themselves to a restful and contemplative life, it happens that he has also been timid, save for his just anger, when to him or others is done any unreasonable injury or wrong. In this case he displays more spirit than those who have a reputation for courage; for the rest he stays very patient.

Of his modesty it would be impossible to say as much as it deserves; and the same holds good for many of his other personal qualities and ways, which were also seasoned with charm and witticisms such as those he used in Bologna against a certain nobleman who, seeing the weight and size of the bronze statue which Michelangelo had made, marvelled at it and said: 'What do you think is bigger, this statue or a pair of oxen?'

To which Michelangelo replied: 'Depending on what

oxen you mean: if they are Bolognese oxen, then oh! without doubt they are bigger; if they are like ours in Florence, then much smaller.'

Again, when this same statue was seen by Francia, who at that time was regarded in Bologna as an Apelles, he said: 'This bronze is beautiful.' And as it appeared to Michelangelo that he was praising the metal and not the form of the statue, he said laughing: 'If this is beautiful bronze, then I have to be thankful to Pope Julius who gave it to me, as you have to be to the pharmacists who gave you your colours.'

And another time seeing a son of this same Francia, who was very good-looking, he said to him : 'My boy, your father's live figures are better-looking than those he paints.'

Michelangelo is of sound constitution; his body is sinewy and bony rather than fat and fleshy; it is healthy above all by nature and from physical exercise as well as his continence regarding sexual intercourse, as well as food; though in childhood he was very indisposed and sickly, and as a man he has had two serious illnesses. For several years now he has found it painful to urinate, and this affliction would have turned into stone if he had not been relieved through the attention and diligence of Messer Realdo, who was mentioned above. His face has always had a good complexion; and his stature is as follows: his body is of medium height, broad across the shoulders, the rest of the body in proportion and more slender than not. The shape of the front part of his skull is rounded so that over the ears it forms a half circle and a sixth. So his temples project somewhat beyond his ears, and his ears beyond his cheek-bones, and these beyond the rest. All this means that his head must be deemed large in poporction to the face. The forehead seen from the front is square; the nose is rather squashed, not naturally but because when he was a boy someone called Torrigiano de' Torrigiani,* an arrogant bestial man, with a blow of the fist almost tore off the cartilage of his nose, and so he was

carried home as if dead. However, Torrigiano was exiled from Florence for this, and he made a bad death. Yet, as it is, Michelangelo's nose is in proportion to his forehead and the rest of his countenance.

The lips are thin, but the lower one is somewhat thicker, and seen in profile it juts out a little bit. His chin is well matched to the features already mentioned. In profile the forehead almost projects beyond the nose, which is almost completely flattened save for a little bump in the middle. The eyebrows are sparse, the eyes can rather be called small than otherwise, the colour of horn, but changeable and flecked with tiny sparks of yellow and blue; the ears are the right size; the hair is black, as is the beard, save that now that he is in his seventy-ninth year, the hair is copiously flecked with grey. And the beard is forked, between four and five fingers long, and not very thick, as can in part be seen in his portrait.

Many other details remain for me to explain, but I have left them out from my hurry to publish what has been written; for I heard certain others hope to win honour for themselves from my efforts, which I had entrusted to their hands: and so if it should ever happen that someone else wishes to take up this enterprise, or to write the same *Life*, I offer personally to communicate all the details or to give them in writing most lovingly. I hope within a short while to publish some of his sonnets and madrigals, which for a long time I have collected both from him and from others; and this will be to give proof to the world of how great is his power of invention and how many fine concepts spring from that divine spirit. And with this I come to an end.*

*Selected Letters of
Michelangelo*

1 To Lorenzo di Pier Francesco de' Medici in Florence.*

[in the name of] Jesus. 2 July 1496

Magnificent Lorenzo . . . Just to inform you that last Saturday we arrived safe and sound, and we went at once to visit Cardinal San Giorgio* and presented him with your letter. He seemed glad to see me and wanted me to go forthwith to look at some statues,* and this used up the whole day; so on that day I did not give him your other letters. Then on Sunday the Cardinal went to his new house, where he asked for me; I met him there and he sought my opinion of the things I had seen. I told him my opinion, thinking them without doubt most beautiful. Then the Cardinal asked if I had it in me to undertake some beautiful work myself. I replied that I might not make such splendid works as he possessed, but he would see what I could do. So we have bought a piece of marble suitable for a life-size figure; and I shall start work on Monday.

Meanwhile last Monday I presented your other letters to Paolo Rucellai,* who offered me the money I needed, and likewise the letters for the Cavalcanti.* Then I gave Baldassare* his letter, and I asked him for the little boy,* saying I would give back his money. He answered very sharply, saying that he would sooner smash it into a hundred pieces, that he had bought the boy and it was his, that he had letters showing he had satisfied those who sent it to him, and he had no worry about having to give it back; then he complained a lot about you, alleging that you slandered him. Some of our Florentines are now seeking to make peace between us, but they have achieved nothing.

So now, following the counsel of Baldassare Balducci,* I am hoping to succeed through the Cardinal. Nothing more for this letter. I send you my regards. And God keep you out of harm's way.

Michelangelo in Rome.

(From Rome, 2 July 1496. Girardi, 1; Milanesi, cccxlii. Extant letter not in Michelangelo's hand, addressed to Sandro Botticelli on the outside.)

2 *To Domino Lodovico Buonarroti in Florence.*

In the name of God. 1 July 1497.

Most revered and dear father. Do not be surprised that I have not returned, because I have not yet been able to settle my affairs with the Cardinal, and I do not want to leave until I have been satisfied and rewarded for my labours; and with these high and mighty people* one has to go gently, since they cannot be forced. Still I am absolutely sure that everything will be dealt with quickly this coming week.

I must tell you that brother Lionardo returned here to Rome,* saying that he had had to flee from Viterbo and that his friar's robe had been taken from him. And he wanted to go to you in Florence, and so I gave him a gold ducat which he asked for, to take with him, and I expect you know this, since he must already have arrived.

I don't know what else to say to you, because I wait in suspense and I don't yet know how things will go; but I hope to be with you soon. I'm well, and hope you are too. My regards to my friends.

Michelangelo, sculptor in Rome.

(From Rome, 1 July 1497. Girardi, 2; Milanesi, i.)

3 *To Master Giuliano da Sangallo,* Florentine, architect to the Pope in Rome.*

Giuliano.—I have heard from one of your people how the Pope took my departure badly, and how his Holiness is to pay a deposit and to do what we agreed; and that I should return and not worry about anything.

As for my departure, it is true that on Holy Saturday I heard the Pope say, as he was talking at table with a jeweller and with the master of ceremonies, that he did not want to spend another penny on stones, whether the small kind or the large; and this amazed me. And yet before I left

I asked him for part of what I needed in order to pursue the work. His Holiness answered that I should return on Monday. And I did return on Monday and Tuesday and Wednesday and Thursday, as he saw himself. Finally, on Friday morning I was sent away, or rather driven out, and the person who sent me packing said that he knew me, but that he was under orders. So when I heard those words that Saturday, and then saw what followed, I fell into deep despair. But by itself that was not entirely the reason for my departure; there was something else again, but I don't want to write about it. Enough then that it made me wonder whether if I stayed in Rome my own tomb would not be finished and ready before the Pope's. And that was the reason for my sudden departure.

Now you are writing to me on behalf of the Pope; and so you will be reading this to the Pope. Then let His Holiness understand that I am disposed more than I ever was to pursue the work; and if he himself is absolutely determined to build the tomb, it should not annoy him wherever I do it, so long as at the end of five years as we agreed it is put up in St Peter's, wherever it pleases him then, and is as beautiful as I've promised it will be; for I am certain that if it comes to be made, there will be nothing like it in the whole world.

So if His Holiness wishes to proceed, let him make me over the deposit here in Florence, and I'll write to tell him where to send it and I'll bring here all the blocks of marble I have on order in Carrara and also those I have there in Rome. Although it meant a big loss for me, I wouldn't care so long as I could do the work here. And I would send the things as I made them one by one, so that His Holiness would be able to enjoy them just as much as if I had stayed in Rome; indeed, he would be even better pleased, since he would simply see what had been done and not be bothered otherwise. For the said money and work, I shall obligate myself as His Holiness wishes, and I shall give him whatever security he asks for in Florence. Whatever he wishes, I shall give him absolute assurances before all Florence. Enough.

But I must also tell you this: that it is simply not possible that the work in question could be made for that price in Rome; I'll be able to do it in Florence because of all the many advantages I have here but do not have there. And I'll do it better and more devotedly, because I shall not have so many things to worry about. Meanwhile, my dearest Giuliano, please give me an answer, and quickly. That is all. On the second day of May 1506.

Your Michelangelo, sculptor in Florence.

(From Florence, 2 May 1506. Girardi, 6; Milanesi, cccxliii.)

4 To Lodovico di Buonarrota Simoni in Florence

Dearest father. I realize from your last letter how things are going there and how Giovansimone is behaving.* I have had no worse news these past ten years than on the evening I read it, because I thought I had arranged matters for them, namely how they might hope to set up a good workshop with my help, as I promised them, and in this hope might apply themselves to becoming proficient and to learning their trade, so as to be able to run the shop when the time came. Now I learn they are doing the contrary, and especially Giovansimone, and so I've come to see that doing people good is no use at all. And if I had been able to, the day I had your letter, I'd have mounted a horse and by now would have settled everything. But as I can't do this, I am writing him a letter on how things seem to me; and if from now on he does not turn over a new leaf, or rather if he so much as takes a stick from home or does anything at all to displease you, I beg you to let me know about it, because I shall then seek leave from the Pope and I shall come there and show him his mistake.

I want you to know for certain that all the hardships I have ever endured have been on your account as much as my own, and what I have bought was intended to be yours as long as you live; had it not been for you, I would not

have bought it. So if you would like to let the house and lease the farm, do so as it suits you; then with the income provided and with what I'll give you, you'll live like a gentleman. And if summer were not on the way, as it is, I would tell you to do it now and come to live here with me. But now is not the right time of year, because you could scarcely live here during the summer. I have thought of taking back the money he has for the shop and giving it to Gismondo, and allowing him and Buonarroto to fend for themselves as best they can, while you let those houses and the farm at Pazzolatica, and with that income and the help I'll give you as well, retire to some place that suits you well, and keep someone to look after you either in Florence or outside Florence, and leave that wretch to scratch his arse.

I beg you to think of your own interest; and as for all the measures you are anxious to take to safeguard what is yours, I'll help you as I can as much as I know how. Let me hear about it. As for the matter of Cassandra,* I have taken advice about transferring the lawsuit here. But I am told that it would cost three times as much as in Florence, and that's certainly so, because you pay in pounds here for what can be done there for pence.* Moreover, there are no friends here whom I can trust, and I could not deal with such a matter myself. It seems to me that if you want to attend the lawsuit in person you should proceed in the normal manner, conduct yourself in a right and reasonable way, and stick up for yourself as much as you can and know how. And as for what you need to spend, I shall never let you down, as long as I have any money. Fear little as possible, because these are not matters of life and death. Nothing more. Don't forget to let me have the information requested above.

<div style="text-align: right">Your Michelangelo in Rome.</div>

(From Rome, June 1509. Girardi, 48; Milanesi, vii.)

5 *To Giovansimone di Lodovico Buonarroti in Florence*

Giovansimone.—They say that if you treat a good man kindly you make him even better, and if you treat a wicked man so you make him worse. I've tried now for many years with kind words and deeds to lead you back to a decent way of life at peace with your father and the rest of us, and yet you grow worse all the time. I am not telling you you are wicked, but the way you are carrying on, you never ever please me, or the others. I could speak volumes about your behaviour, but that would just be adding more to all the other words I've said about it. So let me be brief and just tell you that for sure you have nothing of your own in this world, and your spending money and home expenses are what I give you and have given you for some time, for the love of God. This has been in the belief that you were my brother just like the others. But now I am certain this is not so. For if you were my brother you would never threaten my father. In fact, you're an animal, and I shall treat you like an animal. You should know that if a man sees his father threatened or hurt he is bound to defend him with his life if need be. And that's all there is to it. I tell you that you own not a thing in the world; and if I hear anything more at all about the way you behave, I'll ride with the post all the way to Florence to show you your mistake, and teach you to squander all your belongings and to act like a firebrand in the houses and farms you've done nothing to earn. If I come there, I'll show you something that will scald your eyes with tears, and you'll soon know what your pride is worth.

I must say this to you once again, that if you will set about doing good and honouring and respecting your father, I shall help you as I do the others, and I'll shortly make it possible for you to start a decent shop. If you don't do this, I shall get there and settle your affairs in such a way, that you will understand just what you are, better than you ever did, and you'll realize just what you've got

in this world and you'll know it wherever you go. That's all. Words may fail me, but my actions will win the day.

Michelangelo in Rome.

I can't refrain from writing you another couple of lines; and this is to say that for twelve years now I've been traipsing around Italy, borne all kinds of disgrace, suffered every calamity, lacerated my body with cruel toil, put my own life in danger a thousand times, only to help my family; and now that I've started to raise our house up again a little, just you alone wish to be the one to confound it and ruin in an hour what I've achieved after so many years and through such great toil. And by the body of Christ, that's the truth! If needs be, I'm ready to confound ten thousand of the likes of you. Now be wise, and do not provoke a man who has other tribulations to endure.

(From Rome, June 1509. Girardi, 49; Milanesi, cxxvii.)

6 *To Lodovico di Buonarrota di Simoni in Florence.*

Dearest Father.—I have given Giovanni Balducci* here in Rome 350 broad ducats in gold, payable to you there in Florence. So once you've read this, go to Bonifazio Fazi and he will pay you; he will give you 350 broad ducats in gold. When you have received them, take them to the hospitaller* and have him make use of them for my purposes the same way he did the other ducats you know about. You still have some in loose change and as I wrote you should hold on to these. If you haven't taken any, do so just as and when it suits you. And if you need more, take what's necessary; for I give you as many ducats as you need, even if you spend them all. And if I should write anything to the hospitaller, let me know.

I understand how things are from your last letter; and I'm stricken by it all. There are no other ways I can help you, but do not be downcast and don't make a meal of

being melancholy, because losing belongings isn't the same as losing one's life. I shall provide you with more than enough to make up for all that you lose; but take care not to make too much of it, because it is a fleeting matter. However, with all due diligence thank God as you should that as this tribulation had to be, it came at a time when you could bear it better than you would have been able to in the past. Get on with your life and let your belongings go rather than suffer hardship, for you are more dear to me alive and poor than would be all the gold in the world, if you were dead. And if those blabber-mouths in Florence or any others blame you, let them go on talking, for they are men who know little and love less.

The fifteenth of September [1509].

Your Michelangelo, sculptor in Rome.

When you take the money to the hospitaller, bring Buonarroti with you, and neither you nor he say anything to anyone, for safety's sake; that's to say, neither you nor Buonarroti say that I send you money, now or ever.

(From Rome, 15 September 1509. Girardi, 50; Milanesi, xxii.)

7 *To Buonarroto di Lodovico Simoni in Florence.**

Buonarroto.—I learned from your last letter that the city was in utmost danger, and I was badly distressed by this. It is now said that once more the Medici family has entered Florence and that everything is settled; and for this reason I believe the danger has ceased, that is as regards the Spaniards, and I don't think it is any longer necessary to leave. So stay there at peace, and don't make a friend or intimate of anyone except God, and don't speak good or ill of anyone, because the outcome is uncertain: just attend to your own affairs.

As for the 40 ducats that Lodovico drew from Santa Maria Nuova, I wrote you the other day in my letter that

if your life were in danger you should spend not just
40 ducats, but all of them; but apart from that, I have not
given you leave to touch them. Let me tell you that I don't
have a penny and that I'm practically barefoot and naked,
and I cannot have the balance due to me till I have finished
the work; and I still have to endure great toil and hardship.
So when you too have to bear some hardship, don't feel
sorry for yourself; and while you can help yourself from
your own money, don't take mine, save in case of danger,
as I said. And moreover if you do have some urgent need, I
beg you please to write to me first. I shall be with you
soon. Absolutely without fail, I shall arrive in Florence by
the feast of All Saints, God willing.

The 18 of September.

<div align="right">Michelangelo, sculptor in Rome.</div>

[At the end in Buonarroto's writing] 1512; from Rome,
23 day of September: from the 18 as said.

(From Rome, 18 September 1512. Girardi, 78; Milanesi, xci.)

8 *To Lodovico di Buonarrota Simoni in Florence.*

Dearest father.—I replied to you regarding Bernardino,*
saying I wished to settle the matter of the house, as you
know; and I reply the same now. I first sent for him,
because I was given the promise that within a few days it
would be arranged and that I should start work.* Since
then I've come to see that it will take a long time, and I am
looking around in the meantime to find another suitable
house so I can leave here; and I don't want to start work at
all, until I am settled. So make it clear to him how things
stand. As for the young boy who came, that rascal of a
muleteer cheated me of a ducat: he swore on oath that so it
had been agreed, namely 2 broad ducats in gold; but for all
the boys who come here the muleteers are paid no more
than 10 carlini. I was more furious about this than if I had

lost 25 ducats, because I see it was the doing of his father who wanted to send him on a mule in grand style. Oh, as for me, I never had such grace and favour!

Another thing is that the father said to me, and so did the boy, that he would do everything, and that he would look after the mule and sleep on the ground if necessary; and yet I'm the one who must look after him. As if I needed anything else on top of all the trouble I've had here since I came back! For I've had my apprentice that I left lying ill from the day I returned up to the present. It's true that he is now better, but he has been at death's door, given over by the doctors, for about a month, and I've never once got to my bed. Then there've been countless other annoyances. And now I've had this stuck-up little turd who says, who says [sic] he does not want to waste time but wants to learn. And in Florence he told me that two or three hours a day would be enough; now all day isn't enough, and he wants to draw all night as well. This is his father's advice. If I said anything to him, he would answer that I did not want him to learn. I need help in the house and if he did not feel he could do it, they should not have put me to this expense. But they are frauds and they know what they're after; and that's enough. I beg you to have him taken away from me, because he has become so irksome that I can't stand any more.

The muleteer has had so much money that he could easily take him back to Florence; and he is a friend of his father. Tell the father to send for him; but I'll not give him a farthing more, for I have no money. I shall try to be patient till he sends for him; and if he does not send for him I shall send him away; though I did chase him away the second day he was here, and other times, but he did not believe it.

As for the business of the shop, I shall send you 100 ducats to Florence this coming Saturday, on this condition: that if you see that they endeavour to do well, you give the ducats to them and they make me their creditor, as I settled with Buonarroto, when I left. But if they do not

endeavour to do well, deposit the ducats in my account at Santa Maria Nuova. It is not yet the time to buy.

Your Michelangelo in Rome.

If you should speak to the boy's father, tell him everything politely: that he is a good boy, but that he's too much the little gentleman and not suitable for my service, and he should send for him.

(From Rome, February 1513. Girardi, 88; Milanesi, xviii.)

9 *To Lodovico di Buonarrota Simoni in Florence.*

Dearest father.—I am sending you 100 broad ducats in gold, on condition you give them to Buonarroto and the others make me their creditor with regard to the shop; and if they endeavour to do well, I shall help them step by step as much as I can. Tell them so. And then, when you've seen this letter, go to Bonifazio, or to Lorenzo Benintendi, you and Buonarroto together, and he will pay the money to you. He will pay you 100 broad ducats in gold against a similar sum which Baldassare Balducci has had from me here. I answered you that it was not the time to buy.

As for my affairs here, I shall do the best I can; God will help me. I wrote to you concerning the boy that the father should send for him and that I would not give him any more money; and I tell you this again: the carrier has been paid to take him back to Florence as well. The boy will be all right if he stays put and studies after returning to his father and mother; here he isn't worth a farthing, and he makes me labour like a beast of burden, and my other apprentice is still not out of bed. It is true that I don't have him in the house, because when I became so worn out that I could do no more, I sent him to the room of a brother of his. I have no money. What I am sending you is my life's blood; and I don't feel allowed to ask for any money myself, because I have no one at work and little work of

my own. When this business of my house is settled, I hope to start to work hard.

<div style="text-align: right;">Michelangelo, sculptor in Rome.</div>

(From Rome, February 1513. Girardi, 89; Milanesi, xix.)

10 *To Domenico [Buoninsegni in Rome].**

Messer Domenico.—I have come to Florence to see the model that Baccio has finished,* and I have found that it is just the same again, and childish. If you think it should be sent, write to me. I leave tomorrow morning and return to Carrara, where I have agreed with La Grassa to make a clay model,* following the drawing, which I'll send to him. And he tells me that he will have one made and it will be good. But I simply don't know how it will turn out; I think in the end it will be necessary for me to make it myself. This worries me on account of the Cardinal and the Pope. I've no other course.

Let me advise you that, for good reason, I have withdrawn from the partnership that I wrote telling you I had formed at Carrara, and I have contracted from the same people a hundred cartloads of marble at the prices I mentioned, or a little better. And from another partnership which I have formed I have contracted for another hundred and they have a year in which to deliver them to me by barge.

<div style="text-align: right;">[unsigned]</div>

(From Florence, 20 March 1517. Girardi, 118; Milanesi, cccxlvi.)

11 *To Domenico [Buoninsegni in Rome].*

Messer Domenico.—Since I last wrote to you, I have not been able to get on with making the model, as I said I would: it would take too long to explain why. I had earlier roughed out something very small, in clay, to make use of

here, and although it's puckered like a prune I will send it to you definitely so that you don't think it all a mare's nest.

I've something more to say: and read on patiently for a moment, because it's important. I tell you that I have the will to carry out the construction of the façade of San Lorenzo, so that both in architecture and sculpture it can be the masterpiece for all Italy; but both the Pope and the Cardinal must decide quickly if they want me to do it or not. And if they do want me to do it, they must come to some decision, namely whether to draw up a contract for it with me, and to trust me entirely in everything, or to deal with me in some other way as they think fit, I don't know what. And you will understand why.

As I said I would when I wrote to you, I have ordered many blocks of marble and handed out money here and there, and had the quarrying started in various places. And in some places where I have spent money, the marble produced has not been to my purpose, because of faults, especially in those large blocks which I need and which I want to have as fine as can be. And in one block that I have already had cut, several flaws have shown up near the base whose presence could not have been guessed. So two columns I wanted to make from it have not succeeded and I've wasted half my investment on it.

Because of these upsets I've been able to produce so little from so much marble that it will add up to only a few hundred ducats; and so I do not know how to get the accounts to balance, and in the end I won't be able to show I've spent out other than for the marble I shall deliver. I would gladly do like doctor Pier Fantini, but I don't have enough ointment.* Also as I am an old man, I don't feel like losing so much time to save the Pope two or three hundred ducats over this marble; and as I am being pressed to get the work started, I must therefore have a decision no matter what.

And my decision is this. If I knew I was to have the work and knew the cost, I shouldn't worry about wasting 400 ducats, because I would not have to account for them, and I would snatch three or four of the best men going and

commission all the marble from them. And its quality would have to be the same as what I have quarried so far, which is splendid though there is not much of it.

For this and for the money I'd advance them, I would arrange for insurance in Lucca, and I would have the blocks I already possess shipped to Florence and start work both on the Pope's account and my own. But if the Pope's decision isn't made on these lines, I can do nothing; I could not, even if I wished, ship the marble for my work to Florence and then have it shipped back to Rome, but would have to go to Rome to start work as soon as possible because, as I said, I am being pressed.

The cost of the façade, as I intend to design it and have it constructed, including everything, so that afterwards the Pope would not have to bother himself at all, could not, according to the estimate I have made, be less than 35,000 gold ducats. And for this I shall undertake to do it in six years: on the understanding that within 6 months, in respect of the marble, I must needs have at least another 1,000 ducats. And if it does not please the Pope to do this, it will be necessary either that the expenses I have started to incur here for the construction mentioned above go towards my profit or loss, and I must restore the 1,000 ducats to the Pope, or that he obtains someone else to continue with the enterprise, because for several reasons I want to get away from here at all costs.

As for the said price after the work has been started,* if at any time it can be done for less, I will approach the Pope and the Cardinal in such good faith that I'll tell them about it far sooner than I would if I were going to be out of pocket myself; but my intention is to do the work in a style which the price may not cover.

Messer Domenico, I beg you to tell me forthwith what's in the mind of the Pope and the Cardinal, and this will please me greatly on top of everything else from you.

[unsigned]

(From Rome, 2 May 1517. Girardi, 120; Milanesi, cccxlviii.)

12 *To Domenico Buoninsegni in Rome.*

Domenico.—The marble has proved splendid for my needs, and what is suitable for St Peter's is easy to quarry and nearer the coast than the rest, at a place called Corvara. And from here to the coast there is no need for the expense of a road, save where there's a stretch of marshy land towards the shore.

But to obtain marble I need for my statues, the existing road must be widened, a distance of about two miles from Corvara to above Serravezza; and for about a mile or so there will have to be a completely new road cut with picks through the mountain to where the marble I want can be loaded. So if the Pope will arrange matters only to meet what's needed for his own supply of marble, namely as regards the marsh, I have no means of arranging for the rest, and I won't have any marble to work for myself. And if he doesn't act, I will not be able to take care of the marble for St Peter's, as I promised the Cardinal; but if the Pope does do everything required, I will be able to do all that I promised.

About all of this I've written to you in other letters. Now you are wise and prudent and I know you wish me well. So I beg you to settle the matter in your own way with the Cardinal and reply to me quickly, so that I can take a decision, and if nothing else happens, can return to Rome to continue as before. I could not go to Carrara, because there I wouldn't get the marbles I need in twenty years. Then too I have incurred great enmity there in respect of this matter, and if I returned to Rome I would, as we discussed, have to work in bronze.

Let me tell you that the local Commissioners have drawn up great plans relating to this matter of the marble since they were informed all about it by me, and I believe that they have already fixed the prices and the tolls and the licences, and that the notaries and the head notaries and the purveyors and the assistant purveyors have already thought to double their earnings in that part of the

country. Do think about this and do what you can to stop this business falling into their hands, because then it would be more difficult to deal with them than with Carrara. Please answer me quickly what you think I should do, and remember me to the Cardinal. I am here as his man; so I shall do only what you write to tell me, because I shall assume that it will be what he intends.

If, in writing to you, I have not written as correctly as one should, or if I've sometimes left out the main verb, do excuse me, because there's a ringing in my ears which stops me thinking straight.

<div align="right">Your Michelangelo, sculptor in Florence.</div>

(From Florence, mid-March 1518. Girardi, 129; Milanesi, cccl.)

13 *To Buonarroto di Lodovico Simoni in Florence.*

Buonarroto.—From your letter I understand that the contract has not yet been made;* and this upsets me intensely. So I am sending one of my men to ride there with the post, just for this: to stay all day Thursday to see if the decision is reached, and on Friday morning to return to me with the answer. And if the agreement is made as I've requested, I shall carry the enterprise forward; if there is no decision during Thursday, I shall conclude not that Jacopo Salviati lacks the will to do it but that he isn't able to. Then I shall at once get on horseback and go to find Cardinal de' Medici and the Pope, and I shall tell them about my situation, and I shall abandon the enterprise here and return to Carrara, for I am being implored to do so, as if I were Christ.

Those stonecutters I brought from Florence don't know a thing in the world about quarries or marble. They have already cost me over 130 ducats and they haven't yet quarried a chip of marble that's any good, and they go about pretending to have discovered wonders and try to get work for the Cathedral authorities and others with the

money they have received from me. I do not know who favours them; but the Pope will know all about it. As for me, since I came here I have wasted about 300 ducats, and have still seen nothing for myself. It needs a miracle-worker to perform what I've undertaken here, to tame these mountains and introduce efficient methods into these country districts; and if the Wool Guild paid me 100 ducats a month, as well as the marble, to do what I am doing, it would not be doing badly, leaving aside giving me the contract. But remember me to Jacopo Salviati* and write through my man how the matter stands, so that I may make a decision at once, because I am tortured here by the suspense.

<div style="text-align:center">Michelangelo in Pietra Santa.</div>

The barges I chartered at Pisa never arrived. I think I have been gulled; and it's the same with everything. I curse a thousand times the day and the hour I left Carrara! That's the reason for my ruin. But I shall soon return there. It's committing a sin today to succeed. Remember me to Giovanni da Ricasoli.

(From Pietra Santa, 18 April 1518. Girardi, 126; Milanesi, cxvi.)

14 *To Ser Giovanni Francesco Fattucci in Rome.**

Ser Giovanni Francesco.—It is now about two years since I returned from arranging in Carrara for the marbles to be quarried for the tombs for the Cardinal, and when I went to talk to him he told me I should propose some good solution for doing the tombs quickly. So I sent him in writing all the ways they could be done (as you know, since you read it) saying I would do them on a salaried agreement by the month or day, or as a gift, just as it pleased his Lordship, because I was keen to do them. Nothing I said was accepted. It was alleged that I had no mind to serve the Cardinal.

Later when the Cardinal took the matter up again, I offered to make models in wood exactly the size the tombs were to be, and to include all the figures in clay and cloth, of the right size, and also finished exactly as they would be; and I showed that this would be a speedy and inexpensive way to do them. This was at the time we wanted to buy the Caccini garden. Nothing happened, as you know. Then as soon as I heard the Cardinal was going to Lombardy, I went to find him because I was keen to serve him. He told me that I should hurry up the marble and hire some men, and that I should do as much as I could, without asking him anything further so that he might see some progress made; if he lived, he said, he would also do the façade. And meanwhile he was leaving with Domenico Buoninsegni a money order for whatever was needed. After the Cardinal left, I wrote down everything he had told me for Domenico Buoninsegni, and told him that I was ready to do all that the Cardinal wanted; and I kept a copy of the letter, which I had witnessed, so that everyone should know I was not at fault. Domenico at once came to see me and told me that he had no authority whatever, and that if I wanted anything he would write to the Cardinal. I told him that I did not want anything.

Finally, the Cardinal returned and Figiovanni told me he had asked for me.* I went along at once, thinking that he wanted to discuss the tombs; and he said to me: 'We do indeed want one piece of good work in these tombs, namely something from your hand.' But he did not say that he wanted me to do the tombs. I went away, remarking that I would return to discuss them when the marble was there.

Now you know that in Rome the Pope* has been informed concerning the tomb of Julius, and that a *motu proprio* has been drawn up for him to sign and so that proceedings may start against me to get back what I have had for that work, with due interest; and you know that the Pope said that this was to be done, 'if Michelangelo will not do the tomb'. So then I am bound to do it, if I want to avoid suffering the damages that are threatened. And if the

Cardinal de' Medici, as you tell me, yet once again wishes me to make the tombs at San Lorenzo, you can see that I won't be able to unless he frees me from this business in Rome; and if he does free me, I promise him that I'll work for him all the rest of my life for absolutely no reward.

This is not to say I am asking for my freedom to avoid doing the tomb of Julius, for I would do it willingly, but in order to serve the Cardinal. And if he does not want to free me, but still wants something for those tombs from my hand, I shall endeavour while working on the tomb of Julius to find time to do something pleasing to him.

[unsigned]

(From Florence, April 1523. Girardi, 160; Milanesi, ccclxxix.)

15 *To Sebastiano del Piombo*(?) *or Buoninsegni*(?) *in Rome.**

When I was in Carrara, on my own business, namely finding the marble to ship to Rome for the tomb of Pope Julius, in 1516, Pope Leo sent for me on account of the façade of San Lorenzo which he wanted to have made in Florence. So on the fifth of December I left Carrara and went to Rome, and there I made a design for the façade, on the strength of which Pope Leo commissioned me to have the marble for the work quarried at Carrara. Then, after I returned to Carrara from Rome on the last day of that December, for the marble that was needed the Pope sent me 1,000 ducats through Jacopo Salviati, whose servant called Bentivoglio brought the money to me.

I received it about the eighth of the following month, namely January. And I gave a receipt. Then the following August I was requested by the same Pope for the model of the work, and I went from Carrara to Florence in order to make it; I did it in wood to scale, with the figures in wax, and I sent it to Rome. As soon as he saw it, he had me come to Rome; and once there I bound myself by contract to do the façade, as appears from the written agreement with his

Holiness which I have. Then so that I could serve His Holiness it was necessary for me to ship to Florence the marbles that had to go to Rome for the tomb of Pope Julius (as I have done) and then, after they were worked, send them back to Rome. And the Pope promised to cover me for all my expenses, namely the tolls and the freight, coming to about 800 ducats, although the document doesn't say so.

Then on the sixth of February 1517 I returned from Rome to Florence, having contracted to make the façade of San Lorenzo, all at my own expense; and Pope Leo was to have me paid in Florence 4,000 ducats on account of this work, as appears in the written agreement.

Then about the twenty-fifth I had 800 ducats for the work from Jacopo Salviati, to whom I gave a receipt before I went to Carrara. The contracts and orders I had placed earlier for the marble had not been fulfilled, and the Carrarese wanted to corner me, so I went to have the marble quarried at Seravezza, a mountain near Pietra Santa in Florentine territory. And then when I had already blocked out the six columns each eleven and a half *braccia*, and many other marbles, and had started the workings to be seen there today (for there was never any quarrying there before) on the twenty-sixth of March 1519 Cardinal de' Medici had me paid for the work on behalf of Pope Leo 500 ducats through Gaddi of Florence;* and I gave a receipt. Afterwards this same year, on the orders of the Pope, the Cardinal insisted that I should not pursue the work any further because, they said, they wished to relieve me of the bother of shipping marble, which they wanted to make over to themselves in Florence, and also to make a fresh arrangement: and that is how matters stand up to the present.

Now, at this time, the Wardens of Santa Maria del Fiore sent a certain batch of stonecutters to Pietra Santa, or rather Seravezza, to occupy the new workings, and to seize the marbles that I had had quarried for the façade of San Lorenzo, in order to make the paving for Santa Maria del Fiore. Pope Leo still wanted to pursue the façade of San

Lorenzo. And Cardinal de' Medici had allocated the marble for that façade to everyone except me, as well as giving those who had taken over the transport my workings at Seravezza, and settling nothing with me.

I complained strongly about this, because neither the Cardinal nor the Wardens could intrude on my interests unless I had first scrapped the agreement with the Pope; and if the work on San Lorenzo had been dropped in agreement with the Pope, with all the expenses paid and money received accounted for, then the quarry workings and the marbles and the equipment would of necessity have gone either to his Holiness or to me; and one or the other party after that would have been able to do with it whatever he wanted.

Now in regard to this, the Cardinal has told me that I should account for the money received and the expenses paid, and that he wants to free me so as to be able, both for the Board of Works and for himself, to take the marble he wants from the workings at Seravezza.

So I have accounted for the receipt of 2,300 ducats in the manner and on the occasions mentioned in this letter, and I have also explained the expenditure of 1,800 ducats. And of the latter, about 250 were spent for the freight along the Arno of the marble for the tomb of Pope Julius, which I shipped here so that I could serve Pope Leo, and then transported back to Rome, as I said.

All the other money, including the sum of 1,800, as I have said, I have explained as expenditure incurred for San Lorenzo, not charging to the account of Pope Leo sending back the marbles worked for the tomb of Pope Julius in Rome which would amount to over 500 ducats. Nor do I charge to his account the wooden model for the façade, which I sent to him in Rome; nor again do I charge to his account the period of three years which I wasted on this; nor again that I have been ruined by the work on San Lorenzo, nor the enormous insult of having brought me here to do this work and then have it taken from me. And why, I still do not know. And I do not charge to his account my house in Rome, which I left and where a loss

has been incurred, what with marble and equipment and finished work, of over 500 ducats. Leaving aside those items, I am left in hand only 500 ducats out of the 2,300.

Now we are in agreement: Pope Leo takes over the new working, with the marbles already quarried, and I the money that I still have in hand, and I am now free. And I am resolved to have a Brief drawn up and to have the Pope sign it.

Now you understand everything as it is. Please make me a draft for that Brief, and set down the money received for the work on San Lorenzo in such a way that I can never be asked for it; and also set down how, in exchange for the money I have received, Pope Leo takes over the workings, the marbles, the equipment . . .

[unsigned]

(From Florence, March 1520. Girardi, 152; Milanesi, ccclxxiv.)

16 *To Lodovico Buonarroti at Settignano.*

Lodovico.—I am responding to your letter only with regard to things I regard as important; the rest I treat with contempt. You say that you cannot draw the interest on the deposit because it is banked in my name. This is not true, and I have to reply to you on this, to let you know that you may be being deceived by someone you trust, who has perhaps drawn it out and used it for himself, and influenced your thinking to his own advantage.

I have not had the capital deposited in my own name, nor could I even if I wanted to; but it is certainly true that in the presence of Rafaello da Gagliano, the notary said to me: 'I should not want your brothers to make any arrangement regarding this capital, so that after your father's death you found it gone.' And then he took me along and had me spend 15 *grossoni* to add a clause saying that no one could dispose of the capital while you lived; but you are the beneficiary during your lifetime, in accord with the contract you know about.

I have explained the contract to you, namely about cancelling it if it suits you to do so; I have always done and undone things as you have wanted: I don't know what more you can want from me. If I annoy you by being alive, you have found the way to help yourself, and you'll inherit the key to that treasure you say I have and then you will prosper. Yes, the whole of Florence knows what a rich fellow you were and how I've always robbed you and deserve to be punished. You'll be highly praised! Grumble and complain about me as you like, but don't write to me any more, because you prevent me working; and I still need to make good what you have had from me during the past twenty-five years. I did not want to say this to you; but I simply must. Take care and be on your guard with those you must guard against. For one only dies once and doesn't come back to repair the things one botched. You've delayed till near death to put things right! May God help you.

<div style="text-align: right">Michelangelo.</div>

(From Florence, June 1523. Girardi, 163; Milanesi, xliv.)

17 *To Ser Giovan Francesco Fattucci in Rome.*

Messer Giovan Francesco.—In your letter you enquire how things stand between me and Pope Julius. I tell you that if I could ask for what I am owed along with interest, I think I'd have something coming to me rather than having to pay out. For when he sent for me to Florence, which was I believe in the second year of his Pontificate, I had undertaken to do half of the Council Hall of Florence, that's to say painting it; and I had 3,000 ducats for this. And the cartoon was already done, as all Florence knows; so I felt the money was already half earned. And of the twelve Apostles that I still had to do for Santa Maria del Fiore, one was already roughly hewn, as can still be seen, and I had already obtained most of the marble blocks.

Then Pope Julius took me away, and neither for one nor the other did I get anything. So now I was in Rome with

Pope Julius and had been commissioned to make his tomb, which would absorb 1,000 ducats worth of marble; and he had this paid to me and sent me to Carrara on account of it. And there I spent 8 months having the blocks roughly shaped, and for the most part transported to the piazza of St Peter's, with some remaining at Ripa. Then after I had finally paid the freight charges for the marble and come to the end of the money I'd received for the work, I furnished the house I had on the piazza of St Peter's with my own household goods and beds, relying on my hopes of doing the tomb; and, to work with me, I called from Florence for some assistants, some of whom are still living in wait; and I paid them from my own money. At this time Pope Julius changed his mind and no longer wanted to do it; and in ignorance of this I went to him to ask for money, and I was chased from the room.

Enraged by this, I left Rome at once; what I had in my house came to grief; and the marble blocks I had brought to Rome were left lying on the piazza of St Peter's till the election of Pope Leo. So on one side and the other everything was ruined. Among the matters I can prove, there were taken from me, from Ripa, by Agostino Chigi,* two pieces of marble of 9 feet each, which had cost me over 50 gold ducats. And these could be made good to me, because there were witnesses. But to return to the marble, from the time I went to get it and stayed at Carrara, till when I was chased from the Palace, there passed a year or more: and all that time I had nothing at all, and I invested scores of ducats.

Then when Pope Julius first went to Bologna, I was forced to go there with a rope round my neck to ask his pardon; and he ordered me to make his statue in bronze, seated and about fourteen feet high; and when he asked me what it would cost, I replied that I thought I could cast it for 1,000 ducats, but that this was not my branch of art and I did not want to commit myself. He replied: 'Go, start work, and cast it as many times as may be needed, and you will be given enough to make you happy.' To be brief, I cast it twice, and at the end of the two years I spent there,

I found I had 4½ ducats left. I had no more during this time; and all the outlay I incurred in these two years was included in the 1,000 ducats I had said would be needed to cast the statue; and these were paid to me in stages by Messer Antonio Maria da Legniano, of Bologna.

The statue was set up on the façade of San Petronio; and then after his return to Rome Pope Julius still did not want me to make his tomb but put me to painting the vault of the Sistine, in a deal worth 3,000 ducats. The first design for this work was for twelve Apostles in the lunettes, and for the usual ornamentation in the remaining space.

After the work was started, I thought it was turning out poorly; and so I told the Pope that if only the Apostles were done and nothing else I thought it would succeed very poorly. He asked me why; and I said, 'Because they themselves were poor men.' Then he gave me a fresh commission to do what I wanted; he would make me content, and I was to paint as far as the scenes below.

When the vault was almost finished, the Pope returned to Bologna; so I went there twice for the money that was due but received nothing and lost all that time, till he returned to Rome. Back in Rome, I started to make cartoons for the work I had to do, namely for the heads and faces all around the Sistine chapel; and hoping to have the money to finish the work, I could never obtain any at all. And when one day I complained to Messer Bernardo da Bibbiena* and to Attalante* that I could no longer stay in Rome and would have to take to my heels, Messer Bernardo told Attalante to remind him to ensure I was given some money no matter what. And he had me given 2,000 Camera ducats; and it is these along with the first 1,000 for the marble which they are putting to my account for the tomb; but I reckon I should have had more for all the time lost and the works I made. Also out of that money, as Messer Bernardo and Attalante had acted to save me, I gave the former 100 and the latter 50 ducats.

Then came the death of Pope Julius; and in due time at the start of Leo's reign, Aginense, wanting to have the

tomb made larger, creating a bigger work than the design I had made earlier, drew up another contract. And when I was unwilling to put into the account for the tomb the 3,000 ducats I had already received since I showed I was due far more, Aginense told me that I was a cheat.*

[unsigned]

(From Florence, December 1523. Girardi, 166; Milanesi, ccclxxxiii.)

18 *To Messer Giovan Francesco Fattucci in Rome.*

Messer Giovan Francesco.—Regarding your last letter, the four statues that were started are not yet finished, and there is still much to be done. The other four, for rivers, have not yet been started, because we don't have the blocks although they have arrived here. I am not saying how this happened, because it is not my concern. As for the matters to do with Julius, I shall be happy to make a tomb like the that of Pius in St Peter's,* as you suggested in writing to me, to have it done here little by little, now one thing and now another, and to pay for it out of my own pocket provided I have the salary and keep the house, as you wrote; namely the house where I was in Rome, with the marble and other contents; and also provided that I don't have to give anything, that's to say to the heirs of Pope Julius, to disengage myself from his tomb, other than what I've undertaken to give them so far: the tomb I mentioned like that of Pope Pius in St Peter's. Then let a reasonable time be set for doing it; and I shall make the figures with my own hand; and if I am given my salary, as I said, I shall never stop working for Pope Clement with all the strength I have, though it doesn't amount to much as I'm old. And also I must not go on being taunted the way I am, because this affects me deeply; and it has stopped me from doing what I want these many months, for one cannot work on something with one's hands and on

something else with one's brain, especially when it comes to marble.

Here it is said that it is being done to spur me on; but I tell you that they are poor spurs which force one back. I have not drawn my salary for a year now, and I am struggling with poverty. I am all very much alone with my worries and there are so many of them that they occupy me more than my art, as I cannot keep anyone to look after my affairs, since I haven't the means.

This is the copy of the letter that the sculptor Michelangelo sent today 24 October 1525 to Pope Clement; and I Antonio di Bernardo Mini,* made this copy in my own hand.

[unsigned]

(From Florence, 24 October 1525. Girardi, 187; Milanesi, cd.)

19 *To my dear friend Giovan Francesco, priest of Santa Maria del Fiore of Florence, in Rome.**

Messer Giovan Francesco.—If I derived as much strength as I did amusement from your last letter, I believe I could carry out all the things you write to me and be quick about it; but as I do not have the strength, I shall do what I can.

Concerning the eighty-foot high colossus which, so you inform me, must go or rather has to be put at the corner of the loggia of the Medici garden, and opposite the corner of Messer Luigi della Stufa, I have thought about its being there a good deal, as you told me to; but I think that it does not suit the corner, because it would take up too much of the road.

However, on the other corner, where the barber's shop is, it would, in my view, turn out much better, because the piazza is in front and so it would not cause so much trouble with the street. And then because perhaps removing the

shop wouldn't be tolerated, thanks to the income it provides, I've come to think that the figure could be sitting down, and that the seat could be made so high, that if the work were made hollow inside, which could conveniently be done using blocks, the barber's shop could go underneath, and so the rent would not be lost. And in order that the shop may, as now, have somewhere for the smoke to escape, I am thinking of giving the statue a horn of plenty in its hand, all hollow, to serve as a chimney. Then if I have the statue's head hollowed out, like the other members, I also think I can derive some benefit from that, because there is on the piazza here a huckster,* a great friend of mine, who has told me privately that he would make a fine dovecot inside it. Another idea has occurred to me that would be even better, but it would be necessary to make the figure very much bigger; yet it could be done, seeing that towers are made up of blocks. This is that the head should serve as the bell-tower for San Lorenzo, which badly needs one. And then with the bells flying round inside and the sound coming out through the mouth, the colossus would appear to be howling for mercy, and especially on feast days, when the bells ring out more often and the peals are louder.

Concerning how to get the marble for the statue, so that no one knows about it, I am thinking of having it brought at night, well wrapped up, so that it won't be seen. There'd be some risk at the gate;* but we shall have the means to deal with this too; at the worst, we can rely on the San Gallo gate where the postern's open all night long.

As for doing or not doing the things that have to be done, and that you say have to be put off, it's better to leave them to be done by those who do have to do them, for I'll have so much to do that I don't care to do any more. That will be enough for me, so long as it's dignified.

I am not responding to everything you wrote, because Spina is shortly coming to Rome,* and he'll do better with his mouth than I with the pen, and in more detail too.

<div style="text-align: right;">Your Michelangelo, sculptor in Florence.</div>

(From Florence, (December) 1525. Girardi, 189; Milanesi, cccxcclx.)

20 *To Messer Giovan Fattucci in Rome.*

Messer Giovan Francesco.—Next week I shall have the
figures that have been roughed out in the Sacristy covered
up,* because I want to leave the Sacristy free for those
marble-cutters, and I want them to start to do the other
tomb opposite the one already built and which is in place
and ready, or nearly so. And while they're building it, I
thought the vault might be made and I imagined that with
enough people it might be done in two or three months;
but I'm no expert in this. At the end of next week, our
noble Lord can send Maestro Giovanni da Udine as it
suits him*—if he thinks it should be made now, because I
shall be all prepared.

As for the vestibule, this week four columns have been
built and one was built previously. The tabernacles are a
little behind; but in twelve months from now I believe it
will be furnished. The floor might be started now, but the
linden wood is not yet ready; they will hurry on the
seasoning as much as possible.

I am working as hard as I can and within fifteen days I
shall make a start on the other Captain; then of the
important things I shall have still to do only the four
rivers. The four figures on the sarcophagi, the four figures
on the ground which are the rivers, the two Captains, and
Our Lady to go in the tomb at the head of the chapel, are
the figures I will make with my own hands; and six of these
have been started. And I'm ready and able to finish them
in good time and otherwise have the less important ones
completed as well. I've no more to say.

Remember me to Giovanni Spina, and beg him to write
a note to Figiovanni and ask him not to remove the carters
to send them to Pescia, because we'll be left without stone.
And also beg him not to charm the stonecutters here to
make them fond of him, by saying: 'Those people feel
nothing for you, the way they make you work till sunset,
now that the nights are short.'

We need eyes everywhere to keep even one of them at
work, and even he's been spoilt by that person being too

complaisant. But patience! God forbid I should be upset
by what doesn't upset him.

[unsigned]

(From Florence, 17 June 1526. Girardi, 190; Milanesi, cdii.)

21 *To my dear friend Battista della Palla in Florence.**

My very dear friend Battista.—I left Florence, as I believe
you know, to go to France, and when I reached Venice I
found out about the route, and I was told that leaving from
here one has to pass through German territory, and that
the journey is dangerous and difficult. So I thought I
would find out from you, if you please, whether you still
have a mind to go, and beg you, and I do beg you, to advise
me about this and where you want me to wait for you; and
we shall go together.

I left without saying a word to any of my friends, and
totally unprepared; and although, as you know, I wanted
to go to France come what may, and had many times asked
leave, without receiving it, it was not that I wasn't
resolved, wholly without fear, to see the end of the war
first,* but then on Tuesday morning, on the twenty-first
of September, someone came out from the San Niccolò
gate, where I was at the bastions, and whispered in my ear
that I should stay no longer if I wished to save my life; and
then he came home with me, and dined there, and had
horses brought for me, and never left my side till I quit
Florence, claiming this was for my good. Whether God or
devil, who he was I don't know.

I beg you to reply to me about my remarks at the
beginning of this letter, and as quickly as you can, because
I am dying to go. And if you no longer have it in mind to
go, I still beg you to let me know, so that I can arrange to
go as best I can by myself.

Your Michelangelo Buonarroti.

(From Venice, October 1529. Girardi, 197; Milanesi, cdvi.)

22 *To Messer Tommaso de' Cavalieri in Rome.*

Very inconsiderately, I presumed to write to your Lordship and make the first move as if I had to in response to something from you; later on I realized my error all the more as I read and savoured your welcome reply. Rather than seeming to behave like a new-born child, as you write, you seem to have been on this earth a thousand times before. And I would feel as if I had never been born or had died in disgrace with heaven and earth, had I not come to believe from your letter that your Lordship would gladly accept some of my works.

This has caused me great astonishment but equal pleasure. And if it is true that you feel inwardly the way you write to me openly, as regards your opinion of my works, then if one of them happens to please you as I hope it will, it must be through my good fortune rather than merit. I shall write no more, in case I tire you. Many things I could say remain unpenned; but our friend Pierantonio,* who I know can supply what I leave out, will furnish them by word of mouth.

It is right to tell the recipient the gifts one is sending him,* but for good reason I am not doing so in this letter.

[unsigned]

(From Rome, 1 January 1533. Girardi, 205b; Milanesi, cdxiii.)

23 *To Messer Tommaso de' Cavalieri in Rome.*

My dear Lord.—If I did not think that I had convinced you of my very great, indeed my boundless love for you, I would not have thought strange, nor marvelled at, the fear you show in your letter that since I have not written to you, I might have forgotten you. But it is neither unusual nor surprising, since so many things end at cross purposes, that our friendship too might go wrong; and what your Lordship says to me, I would have said to you.

But perhaps you did this to try me or to rekindle a

greater flame in me, if it were possible. Be that as it may, I know for sure that I'll forget your name the day I forget the food I live on; indeed, I could sooner forget my food, which sadly nourishes only the body, than your name, which nourishes body and soul, and fills both with such sweetness that I can feel no pain nor fear of death while my mind remembers it. Imagine in what a happy state I would be, if my eye also had its share.

[unsigned]

(From Florence, 28 July 1533. Girardi, 207; Milanesi, cdxvi.)

24 To Friar Sebastiano del Piombo in Rome.

My dear colleague.—I have received the two madrigals,* and Ser Giovan Francesco has had them sung several times, and, according to him, they are thought to be splendid music; but the words do not deserve the setting. This is what you wanted; and it has given me the greatest pleasure, and I beg you to advise me how I should respond to the composer so I do not appear at all ignorant or ungrateful.

Concerning the work on which I am engaged here* I shall write nothing more for the moment, since I think I have said enough about it recently, and I have tried as hard as I can to imitate the manner and style of Figiovanni in every particular,* because that seems to me what to do if one wants to say it all. Don't show this letter.*

You say you've given a copy of those madrigals to Messer Tommaso; I am most grateful for this and I beg you, if you see him, to remember me to him a thousand times. And when you write to me, tell me something about him so that I can bring him to mind, for if he faded from memory I am sure I would immediately fall down dead.

[unsigned]

(From Florence, August 1533. Girardi, 206; Milanesi, cdxv.)

25 To Febo.*

Febo.—Although you have come to hate me so greatly, I do not know why; I hardly think it is because of my love for you, but because of gossip by others, which you shouldn't believe as you have put me to the test yourself. However, I must write this to you. I leave tomorrow morning, and I am going to Pescia to find Cardinal Cesis* and Messer Baldassare;* I shall go with them as far as Pisa, and then to Rome; and I shall never come back here. You must understand that as long as I live, wherever I shall be, I shall always be ready to serve you faithfully and lovingly, more than any other friend of yours anywhere.

I pray God to open your eyes and make you understand as well that the man who desires your well-being more than his own good knows not how to hate, like an enemy, but how to love.

[unsigned]

(From Florence, September 1534. Girardi, 211; Milanesi, cdxx.)

26 To Messer Pietro Aretino in Venice.*

Magnificent Messer Pietro, my lord and brother.—On receiving your letter I experienced joy and grief simultaneously; I rejoiced greatly because it came from you, a man of unique talent: but I also grieved deeply, for having completed a great part of the composition I am unable to translate into reality this idea of yours which is so presented, that if the Day of Judgement had occurred, and you had seen it in person, your words could not have expressed it better.

Now in regard to your writing about me, let me say not only that this would be welcome to me but that I beg you to do so. After all Kings and Emperors accept as the highest favour being named by your pen. In the meantime, if I have anything that would please you, I offer it to you with all my heart. And lastly, just because you want to see

the picture I am painting, do not break your resolution not to journey to Rome, because it would be too much. I send my regards.

Michelangelo Buonarroti.

(From Rome, September 1537. Girardi, 214; Milanesi, cdxxi.)

27 To Vittoria Colonna, Marchioness of Pescara in Rome.

I wanted, my Lady, before accepting the things that Your Ladyship has so often wished to give me, to make something for you with my own hand, so that I should more deservingly receive them. Then having seen and realized that the grace of God cannot be bought, and that to keep you waiting is a great sin, I confess my fault and gladly accept those presents. And when they arrive, I shall know I'm in Paradise, not because they are in my house but because I'll be in theirs. Then, if possible, I shall be even more obliged to your ladyship than I am now.

The bearer of this letter will be Urbino, who lives with me and to whom your Ladyship can say when she wants me to come to see the head of Christ that she had promised to show me. And I send her my regards.

Your ladyship's servant, Michelangelo Buonarroti.

(From Rome, 1538/9. Girardi, 274; Milanesi, cdliv.)

28 To Vittora Colonna in Rome.

Lady Marchioness.—Being in Rome, I did not think it was necessary to leave the Crucifix with Messer Tommaso and in order to serve you make him intermediary between your Ladyship and me, your servant; especially as I was desirous of doing more for you than for anyone I ever knew in this world.

But the great task* on which I have been and am still

engaged hasn't let me tell your Ladyship of this: and
because I know that you know that love needs no task-
master, and a lover doesn't fall asleep, still less does love
need a go-between. And although it might seem that I did
not remember, I did something secretly in order to sur-
prise. And my plan was spoilt: *Mal fa chi tanta fè sì tosto
oblia.**

Your Ladyship's servant,
Michelangelo Buonarroti in Rome.

(From Rome, Spring 1539. Girardi, 275; Milanesi, cdlv.)

29 *To Messer Luigi del Riccio in Rome.**

Messer Luigi, my dear Lord.—In dealing with the discord
that has arisen between Urbino and Maestro Giovanni,*
your Lordship is not personally involved so you can judge
fairly. To do them both some good, I asked them to
undertake the work you know about. And now because
one of them is mean beyond words and the other is mad,
this estrangement could end in violence or murder and
cause some terrible scandal; and if such things were to
happen to one or the other of them, I would be very sorry
for Maestro Giovanni but even sorrier for Urbino, seeing I
brought him up.

So, if the partnership allows it, I am thinking of sending
them both packing and freeing the work just for myself, so
that their wrong-headedness does not ruin me and I can
get on with it. It has been suggested I should divide the
work, giving a part to one of them and a part to the other,
but this I cannot do and to give it . . .* only to one of them
would wrong the one to whom I did not give it. So I do not
think I have any other course but to take on the work for
myself, so that I can carry on with it; and as for the money,
namely the 100 crowns that I have given them, and the
efforts they have made, let them arrange the matter
between them in such a way that I do not lose by it. And I
beg your Lordship to get them to agree as best you can as

an act of charity. Perhaps one of them will claim to have made all by himself the little that has been done, and so end up by getting much more money besides what he's had already; and if this happens, I can also claim to have lost a month of my time on the work through their ignorance and brutishness, and to have fallen behind with the work for the Pope, which has cost me more than 200 crowns: so that I have more to come from them than they have to come from the work.

Messer Luigi, I have given you this statement in writing, because to do so by word of mouth in the presence of those men exhausts me so utterly that I have no breath left for talking.

Your Michelangelo Buonarroti in Macello de' Poveri.*

(From Rome, May 1542. Girardi, 236, Milanesi, cdxxxii.)

30 *To Monsignor . . .* *

Monsignor.—Your Lordship sends me word that I should paint and not worry about anything else. I reply that one paints with the head and not with the hands; and if he can't keep a clear head a man is lost. So until this business of the tomb is settled, I shan't do any good work. I have not had the ratification of the last contract; and on the strength of the other contract,* drawn up in Pope Clement's presence, people stone me every day just as if I had crucified Christ.

I say that to my knowledge the contract was not read over in the presence of Pope Clement as the copy I received later said it was. What happened was that Clement sent me to Florence the same day, and then the ambassador Gianmaria da Modena who was with the notary had him add to it in the way he wanted. Through this, when I returned and inspected it, I found that it specified 1,000 ducats more than had been fixed for me to pay; that the house I live in was included in the contract; and there were several other traps to destroy me, which Pope Clement would never have allowed. And Fra Sebas-

tiano can bear witness that he wished me to let the Pope know all this and to have the notary hanged. I would not do this, because I was not bound to do anything I could not have done had things been left as they were. I swear that I know nothing of having had the money the contract mentions and as alleged by Gianmaria. But let us agree that I did have the money since I've acknowledged receipt, and I cannot withdraw from the contract; and let's add more money besides, if more is claimed; and heap it all together. And then look at what I've done for Pope Julius at Bologna, Florence and at Rome, in bronze, marble, and painting, and all the time I stayed with him, which was as long as he was Pope; and judge what I deserve. I say in good conscience, with reference to the salary that Pope Paul gives me, that I am owed 5,000 crowns by the heirs of Pope Julius.

I also say this: that the reward from Pope Julius for my labours having been what it was (my fault for not knowing how to manage my affairs) were it not for what Pope Paul has given me, I would today be dying of hunger. Yet according to those ambassadors, I must have enriched myself and stolen from the altar. They make a great song and dance, and I know I should shut them up, but I haven't the strength.

Gianmaria, who was ambassador at the time of the old Duke, in Clement's presence, after the contract was made and I had returned from Florence and was starting to work on Julius's tomb, said to me that if I wanted to do the Duke a great favour, I should clear off altogether for he didn't care about tombs but he couldn't stand the idea of my working for Pope Paul. Then I realized why he had brought my house into the contract: to get shot of me and grab possession on the authority of that document; it's clear enough what tricks they're up to, and they are bringing shame on our enemies and their own masters.

The fellow who came to see me just now wanted to know all about what I had in Florence; that was his first question, before he asked to see what stage the work for the tomb had reached. And so I find that I have lost all my

youth tied to this tomb, defending it as best I could against the demands of Pope Leo and Clement. And my too trusting nature has gone unrewarded and been my ruin. That was my bad fortune! I see many who lie in bed and enjoy incomes of 2,000 or 3,000 crowns, while I wear myself out with my labours only to stay poor.

But to return to the painting: I can deny nothing to Pope Paul. And I shall paint miserably and make miserable things. I've written this to your Lordship, so that when it's opportune you will be better able to tell the truth to the Pope; I'll be glad for the Pope to learn the truth and to know what's behind the war waged against me. Let them understand, who can.

<div style="text-align: center">Your Lordship's servant, Michelangelo.</div>

I should also tell you the following: that this ambassador says I lent Pope Julius's money at interest, and that I made myself rich on it, as if Pope Julius had counted me out 8,000 ducats in advance. The money I had for the tomb was meant for the expenses incurred for it at the time, and it will appear to be about the sum that the contract made in Clement's time should state. For in the first year of Julius when he commissioned the tomb from me, I stayed for 8 months in Carrara to quarry marble and transport it to the piazza of St Peter, where I had my work rooms behind Santa Caterina; then Pope Julius decided not to have the tomb made during his lifetime, and he put me on to painting instead; then he kept me in Bologna for two years doing the bronze Pope which was destroyed; and then I returned to Rome and served him till his death, always keeping open house, with no pay or profit, and living all the time on the money for the tomb, since I had no other income. Then after the death of Julius, Aginense wanted to continue with the tomb, but to have it bigger; and so I brought the marble to Macello de' Corvi, where I finished the part which was put up in San Pietro in Vincoli and made the figure I have at home.

At this time Pope Leo, who did not want me to do the tomb, made out that he wished to do the façade of San

Lorenzo in Florence, and he asked Aginense for me; so the latter had perforce to give me leave, but on condition that I should make Pope Julius's tomb while in Florence.

When I was in Florence for the façade of San Lorenzo, as I had no marble there for the tomb of Julius, I returned to Carrara and stayed there 13 months, and I brought all the marble for the tomb to Florence where I built for it a shop in which I started the work. At this time Aginense sent Messer Francesco Palavicini, who is now the Bishop of Aleria, to hurry me on, and he saw the workshop and all the marble and the figures roughed out for the tomb, which are still there today.

Seeing this, namely that I was doing work for the tomb, Medici, who was in Florence, and later became Pope Clement, would not let me continue; and so I was left frustrated till the Medici was transformed into Pope Clement: whereupon the last contract for the tomb up to this present one was drawn up in front of him, and in it was stated that I had received the 8,000 ducats which they say I lent at interest. And now I want to confess to your Lordship the sin that, being at Carrara, when I stayed thirteen months because of the tomb, and lacking money, I spent on marble for that work 1,000 crowns that Pope Leo had sent to me for the façade of San Lorenzo, or to keep me occupied. And I sent him a word or two putting forward difficulties; and this I did out of my love and enthusiasm for the job, for which I am paid by being called a thief and a usurer by ignorant people who hadn't even been born at that time.

I am writing this account for your Lordship because I dearly wish to justify myself to you, just as I do to the Pope before whom I am spoken of so badly that, as he tells me, Piergiovanni has to speak out in my defence. I also write this account so that if your Lordship finds himself able to say a word in my defence, he may readily do so, since I write the truth. For among men, and I say nothing of God, I consider myself an upright person who never deceived anyone, and if I fly into a passion it's sometimes necessary, as you know, when defending yourself against evil people.

I beg your Lordship, when you have more time, to read this report and retain it, and be assured that for a large number of the things I've described there are still witnesses. Also I would be gratified if the Pope were able to set eyes on it, as I would be were the whole world to see it, because I'm setting down the truth and much less than could be told. And I am not a thieving usurer; I am a Florentine citizen, of noble birth, the son of an upright man, and not a man from nowhere.*

Since writing, I had a message from the ambassador of Urbino, to the effect that if I want the ratification of the contract, I should set my conscience to rights. I reply that in his heart he has made a Michelangelo to his own likeness.

Following on further about the tomb of Pope Julius, I recall that after he changed his ideas, as I said, about making it during his lifetime, there arrived at Ripa some boatloads of marble which I had ordered at Carrara some time before. And being unable to get money from the Pope, as he had changed his mind about the work, I had to pay freight charges on the marble of 150, or rather 200 ducats, with a loan from Baldassare Balducci (namely the bank of Jacopo Galli). And as also at that time some stonecutters whom I had sent for to work on the tomb, some of whom are still living, arrived from Florence, and as I had furnished the house behind Santa Caterina, given me by Julius, with beds and other fittings for the blockcutters and other things for the tomb, I found myself very frustrated by lack of money. And I pressed the Pope to push things forward as much as I could, and one morning when I was about to talk to him about this matter, he had me turned away by a groom. Then a bishop from Lucca who witnessed this said to the groom: 'Don't you know who it is?' And the groom said to me, 'Forgive me, sir, but I have been ordered to do this.' I went home and I wrote to the Pope as follows: 'Most Holy Father: I have this very morning been driven from the Palace at the behest of your Holiness; so I am giving you to understand that from now on, if you want me, you will look for me elsewhere than in Rome.'

I sent this letter to the steward Messer Agostino to give to the Pope; and I called into the house a certain carpenter named Cosimo, who stayed with me and made my household fittings and a stonecutter, who is alive today, and said to them: 'Go to find a Jew, and sell what is in the house, and come away to Florence.' Then I went, mounted one of the post horses, and took myself off towards Florence. The Pope, having received my letter, sent five horsemen after me, and when they caught up with me at Poggibonsi about three hours after nightfall they presented me with a letter which said: 'As soon as you have seen this, under pain of our displeasure, you must return to Rome.' Those horsemen wanted a reply from me, so they could prove they had found me. I replied to the Pope that any time that he kept to what he was obligated to do, I would return; otherwise he should never hope to have me. And then while I remained in Florence, the Pope sent three Briefs to the Signoria.

At length the Signoria sent for me and said: 'We do not want to wage war for you against the Pope: it is necessary for you to go; and if you return to him, we will draw up for you letters of such authority that if he should do you harm he will be doing it to this Signoria.' And this is what the Signoria did, and I returned to the Pope; and what followed would take long to tell. So that's enough. Yet this business lost me over 1,000 ducats, because after I had left Rome a great fuss was made about it, to the shame of the Pope; and almost all the marble that I had on the piazza of St Peter was looted, especially the small pieces; and I had to do them once more, in such wise, I say and affirm, that either for damages or interest I am owed 5,000 ducats by the heirs of Pope Julius. And those who have robbed me of my youth, my honour and my property call me thief! And now again, as I wrote before, the ambassador of Urbino sends to tell me that I should first set my conscience to rights, and then the ratification of the contract will come from the Duke. Until he made me deposit 1,400 ducats, he did not say that. In the things I am writing, I may only be mistaken in the dates from the beginning till now; everything else is true, and more than I write.

I beg your Lordship, for love of God and of truth, when you have time read these things, so that if the occasion arises you can defend me to the Pope against those who speak evil of me, though they know nothing, and with their false reports have led the Duke to believe that I am a great rascal. All the occasions for discord arising between Pope Julius and me, all of them resulted from the envy of Bramante and Raphael of Urbino: and this was the cause of his not continuing his tomb while he was still living, and was meant to ruin me. Raphael had good reason for this, for all his art he had from me.

(From Rome, October/November 1542. Girardi, 239; Milanesi, cdxxxv.)

31 *To the Most Christian King of France.*

Sacred Majesty.—I do not know what is greater, either the favour or the wonder that your Majesty deigns to write to one of my rank, and still more to ask him for some of his works though they are not in any way worthy of your Majesty's name. But such as they are, let it be known to your Majesty that I have desired to serve you for a long time past, but since even in pursuing my art in Italy I have found no opportunity or time to spare, I have not been able to do so.

Now I am an old man and I shall be busy for some months on behalf of Pope Paul; but if when I have ceased being so busy I have some life left to me, what as I said I have long time desired to do for your Majesty I shall strive to put into effect, namely something in marble, something in bronze and something in painting. And if death does interrupt this desire of mine, and one can sculpt or paint in the next life, I shall not fail you there, where there is no growing old. And I pray God to give your Majesty a long and happy life.

From Rome, day XXVI April MDXLVI.

Most humble servant, Michelangelo Buonarroti.

(From Rome, 26 April 1546. Girardi, 285; Milanesi, cdlix.)

32 *To Messer Bartolomeo Ferratini.**

Messer Bartolomeo, dear friend.—It cannot be denied that Bramante was as skilled in architecture as anyone else from the time of the ancients till now. It was he who drew up the first plan for St Peter's,* not full of confusion, but clear and uncluttered, luminous and free on all sides so that it did not detract at all from the palace. It was regarded as a beautiful achievement, as is still manifest; and thus anyone who has distanced himself from Bramante's arrangements, as did Sangallo, has distanced himself from the truth. And that this is so anyone whose sight isn't clouded can see from his model. For with his outside ambulatory, Sangallo immediately took away all and every light from Bramante's plan; and moreover it does so when it has no light itself whatsoever. And there are so many hiding-places above and below, all dark, that they provide great opportunities for no end of vile misdemeanours: such as the concealment of outlaws, the counterfeiting of money, getting nuns pregnant, and other sordid misbehaviour; and so in the evening after the church closes, you would need twenty-five men to seek out those who are hidden there. Even then it would be very difficult, the way things are. Also there would be this other inconvenience, that in adding to Bramante's composition the additional building shown in the model, you would be forced to tear down the Pauline Chapel, the apartments of the Piombo, the Rota, and more besides: nor, I believe, would even the Sistine Chapel survive intact.

Concerning the part of the ambulatory that has been put up, they say it cost 100,000 crowns, but this is not true, because it would have taken only 16,000; and if it were torn down little would be lost, because the stone used and the foundations could not be more useful, and the fabric would be better off by 200,000 crowns and 300 years in time. This is how I see things, quite disinterestedly; for to win would cause me enormous loss. And if you can make the Pope understand this, you will gladden me, because I do not feel very well.

Your Michelangelo.

If Sangallo's model is followed, this would also follow: that all that has been done in my time would be torn down, which would be enormously damaging.

(From Rome, January 1547. Girardi, 414; Milanesi, cdlxxiv.)

33 *To Messer Benedetto Varchi.*

Messer Benedetto.—So that it may be quite clear that I've received your treatise, and I have, I shall reply briefly to what you ask, though I'm ignorant of these matters. For me, then, painting may be considered better the more it approaches relief, and relief may be considered worse the more it approaches painting: and so I used to believe that sculpture is the lamp of painting, and the first related to the second as the sun to the moon. Now having read your treatise where you state that, in philosophical terms, things that have the same end are the same, I've changed my opinion, I now say that if better judgement used to surmount greater difficulties, obstacles and toil, does not produce nobler results, then painting and sculpture are the same. And if this is so, every painter should do as much sculpture as painting and every sculptor as much painting as sculpture. I mean by sculpture work which is fashioned by dint of taking away; what is done by way of adding is similar to painting.*

But enough that both sculpture and painting spring from the same intellect, and so can make their peace the one with the other, and put all these disputes behind them. For more time is spent on such dispute than on fashioning the figures themselves. As for the one who said that painting was nobler than sculpture, if he had understood as little about these other things he wrote about, my servant girl would have written about them much better. Countless things, as yet unspoken, could be said about similar kinds of learning;* but, as I mentioned, this would take too much time, and I have little enough of that, because I am not just an old man, but almost to be counted

amongst the dead. So I pray you to hold me excused. And I send you my regards and thank you the best I can for doing me too much honour, which is not deserved.

Your Michelangelo Buonarroti in Rome.

(From Rome, March 1547. Girardi, 355; Milanesi, cdlxii.)

34 *To Lionardo di Buonarroto Simoni in Florence.*

Lionardo.—I had your letter this evening but I have little time to write. As for the house belonging to the Corsi,* I was told the last time you wrote to me about it that a rich neighbour would soon take it, and if he does not, I fear it will be a risky thing; so keep your eyes open lest you buy a legal liability. Otherwise if you still want it, get it for as fair a price as you can.

As for the donation to charity, it's enough for me to be sure that you have given it, and enough to have the receipt from the Monastery, and you need make no mention of me at all. For Guicciardini's baby I have grieved fondly as if he were my own son:* help them to be patient and remember me to them. Remember me to Messer Giovan Francesco and thank him, and ask him to excuse me if I do not discharge my debt to him, because I am overwhelmed with worries and especially now that I have lost the ferry dues* and am left to live on my hard cash. God help us. There is no need to say more. Tell Messer Giovan Francesco to remember me to Bugiardino, if he is still living.

Michelangelo Buonarroti in Rome.

(From Rome, 24 September 1547. Girardi, 301, Milanesi; clxxix.)

35 *To Lionardo di Buonarroto Simoni in Florence.*

Lionardo.—I am glad you have advised me about the proclamation,* because if I have hitherto been on my guard against speaking with or frequenting the exiles, I shall be on my guard still more in the future. As for my staying when I was ill in the house belonging to the Strozzi, the important thing is not that I was in their house but that I was in the room of Messer Luigi del Riccio, who was my close friend; and since Bartolomeo Angelino died I have not found any man to look after my affairs better than him, or more faithfully. But since he died, I have no longer frequented that house, as all Rome can bear witness, as it can to the sort of life I lead, since I always live alone, and I go out little and speak to no one, least of all to Florentines. But if I am greeted as I go my way, I can only answer politely, and continue on my way; though if I knew exactly who were the exiles, I wouldn't reply for anything. As I said, from now on I'll be especially on my guard, above all since I've so much else to worry about that I found my life is a burden to me.

As for the shop, do what you yourself think would be a success, because that is not my kind of business and I can't give good advice about it; I tell you only this, that if you squander the money you have you will never get it again.

<div align="right">Michelangelo in Rome.</div>

(From Rome, 22 October 1547. Girardi, 318; Milanesi, cxcv.)

36 *To Lionardo di Buonarroto Simoni in Florence.*

Lionardo.—I had the little barrel of pears, and they amounted to eighty-six; and I sent thirty-three to the Pope, who thought they were splendid and was delighted with them. Regarding the little barrel of cheese, the

Customs say that the carter is a rogue and that he didn't take it into the Customs-house. So when I know that he's in Rome I'll give him what he deserves, not on account of the cheese, but to teach him to have more respect for people.

I've been very ill recently from being unable to urinate, which is a great weakness of mine; but now I'm better. I am writing to you about this lest some blabber-mouth writes a pack of lies to disturb you. Tell the priest that he should not write to me any more as *Michelangelo sculptor*, because here I am known simply as Michelangelo Buonarroti, and that if a Florentine citizen wants to have an altarpiece painted, he must find a painter: for I never was the sort of painter or sculptor who kept shop. Always, I have guarded against doing that, for the honour of my father and my brothers, though indeed I have served three Popes, as needs must. I've no more to say. From my last previous letter you will have understood my opinion concerning marriage. As to those lines I've written on the priest, tell him nothing, for I want to avoid showing I've had his letter.

Michelangelo Buonarroti in Rome.

[In Lionardo's writing] From Rome, 7 May, dated 2 May.

(From Rome, 2 May 1548. Girardi, 322; Milanesi, cxcix.

37 *To Lionardo di Buonarroto Simoni in Florence.*

Lionardo.—I sent you with my last letter a list of many marriageable girls, which was sent to me from Florence, I believe by some broker, who must be a man of little judgement, because as I have stayed put in Rome for sixteen or seventeen years, he ought to have realized what little information I could have about families in Florence.

So let me tell you that if you want to take a wife, you

should not wait on me for anything, because I can't advise you of the best; but I also tell you that you should not go after money, but only after goodness and good repute.

I believe that there are in Florence many poor and noble families, with whom it would be an act of charity to seek a relationship, even if there were no dowry; and then neither would there be any conceit. Lionardo, you need a woman who will stay with you and whom you are able to command, and who will not want to put on airs and spend every day going to feasts and gadding about; for parties can easily turn women into prostitutes, especially one who hasn't any relations at home. But pay no heed to anyone saying that you seem to want to ennoble yourself, because it is well known that we are as ancient and noble citizens of Florence as any other family. So trust yourself to God and pray that He may fulfil your need; and I shall be very glad, when you find someone who seems suitable for you, for you to tell me about it before you make the match.

As for the house you wrote to me about, I replied to you that I had heard it praised, and that you shouldn't worry over 100 crowns more or less.

You also informed me about a farm at Monte Spertoli;* and I replied that I'd lost my desire to have it, not because it was as you described it, but for some other reason. Now I tell you that if you find something worthwhile, and I can enjoy the income, inform me about it; because if it's a sound investment, I'll take it. Then as for the house, if you take it, tell me what money I have to send; and do quickly what has to be done, because time is short.

As to what I wrote to you about Santa Maria Nuova, I've been advised against it: so forget about it. The first day of February 1549.

[In Lionardo's writing] 1549, from Rome, 7 February, dated the first.

(From Rome, 1 February 1549. Girardi, 333; Milanesi, ccx.)

38 *To Lionardo di Buonarroto Simoni in Florence.*

Lionardo.—Last week through Urbino I sent Bettini* 50 gold crowns in gold payable to you there in Florence. I believe you will have received them by now and will use them as I suggested to you, either for one of the Cerretani or someone else, where you see the need; and you'll tell me about this. Regarding putting my affairs in order, as I wrote to you, I shall just say that, if only because I'm old and ill, I decided to make a will. And the will is as follows. That what I have is to be left to Gismondo and you, Lionardo, in this manner: that Gismondo my brother is to have the same amount as you my nephew, and neither one of you can take any of his share of my things without the consent of the other; and if you wish to have this done through a notary, I shall ratify it at any time.

Concerning my illness, I am much better. We are certain that I have the stone, but it is only small and thanks to God and by virtue of the water I drink, it is being dissolved little by little, so I hope to be free of it. And yet since I am old and for many other considerations I would be glad if the personal wealth I have here could be kept there in Florence, to provide for my needs and then go to you; and this would be a sum of about 4,000 crowns. I'd especially like this done now, as I have to go to the baths, and want to be as unencumbered as possible. Meet Gismondo and think about it for a while and advise me, because this is something for you no less than for me.

As for taking a wife, a friend of mine came to see me this morning and begged me to tell you about one of the daughters of Lionardo Ginori, whose mother was a Soderini.* I tell you about this as I have been begged to do so, but I am saying nothing else, because I have no details. So think carefully about it and keep your own counsel and when you've decided send me an answer, so that I can answer either yes or no to my friend.

The fifth of April 1549.

Michelangelo Buonarroti in Rome.

I should have been very glad if before you marry you had bought a more imposing and spacious house than where you are, and I would have sent the money.

What I write about the Ginori girl, I do only because I have been begged to do so, not for you to take her rather than some other. So do whatever you have in mind to do about it and keep your own counsel, as I've said more than once. It is enough that I know before it happens: so look around and think about it and don't delay once you've a mind to act.

(From Rome, 5 April 1549. Girardi, 340; Milanesi, ccxvii.)

39 *To Messer Giovan Francesco Fattucci, priest of Santa Maria del Fiore, most dear friend, at Florence.*

Messer Giovan Francesco, dear friend.—Although it is many months since we wrote anything to each other, our long and good friendship is not forgotten, and I desire your well-being as I have always done, and I love you with all my heart, the more for all the countless kindnesses you've done me. Concerning old age, which we share together, I would be glad to know how your lot seems to you, because mine doesn't please me very much. And so do please write to me about this.

You know that we have a new Pope,* and who he is. So all Rome rejoices, thank God; and nothing but the greatest good is expected from this, especially for the poor, because of his liberality. Concerning my own affairs, I would be glad, and you would give me the greatest pleasure, were you to let me know how things are going with Lionardo, the whole truth regardless, because he is young and I am jealous for him, and more so as he is by himself and without advice. I have no more to say, except that recently Messer Tommaso de' Cavalieri has begged me to thank

Varchi* on his behalf for a certain splendid little book of his that has been printed, where he says that Varchi speaks very honourably of him, and no less of me; Tommaso has given me a sonnet I once wrote for him, begging me to send it to Varchi for him to expound, and I am sending it with this. So please give it to him, or else put it in the fire, and reflect that I am fighting with death and have other matters in mind: though now and then one must do such things as this. For paying me such great honour in his sonnets, as I said, I beg you to thank Messer Benedetto, offering my services to him for what little they are worth.

<div align="right">Your Michelangelo in Rome.</div>

(From Rome, February 1550. Girardi, 360; Milanesi, cdlxvi.)

40 *To Messer Giovan Francesco Fattucci in Florence.*

Messer Giovan Francesco Fattucci, dear friend.—As I have to write to Florence to the painter Giorgio* I am using the opportunity to bother you by asking you to give him the letter that accompanies this, assuming he is a friend of yours; and so as not to be too brief, as I have nothing else to write about, I am sending you an example of one of the verses that I wrote for the Marchioness of Pescara,* who thought the world of me, as I did of her. Death took from me a great friend. I have nothing else to say. I go on as usual, supporting patiently the infirmities of old age. I suppose you do the same. The first of August 1550.

<div align="right">[unsigned]</div>

(From Rome, 1 August 1550. Girardi, 363; Milanesi, cdlxvii.)

41 *To Lionardo di Buonarroto Simoni in Florence.*

Lionardo.—Since the arrival of the *trebbiano** and the shirts I have had no cause to write to you; but now it would benefit me to have the two Briefs of Pope Paul,* containing the pension for life granted me by His Holiness, I being in his service in Rome: these Briefs I sent there to Florence with the other papers in the box that you received, and they will be under certain lead seals; so I know you will recognize them. You can wrap them in some waxed cloth and put them in a strongly bound little box; and if you can see your way to being able to do so through some trusted person so that they don't come to harm, send them to me, consigning them as you think fit, so they reach me safely. I want to show them to the Pope, so that he sees that according to them I am, I believe, the creditor of His Holiness for over 2,000 crowns. Not that I gain anything from this, but it will serve to satisfy me. I think that they can come by the courier, as they are a small package.

About taking a wife, you've said nothing further; but everyone tells me that I should find you a wife, as if I had a thousand women in my pocket. I have no way of making decisions, because I have no knowledge of present-day Florentines. I'd be glad if you found a wife, and you must do so; but I can do nothing more for you, as I've written to say several times.

There is nothing more. The 7 of August 1550.

　　　　　　　Michelangelo Buonarroti in Rome.

[In Lionardo's hand] 1550, from Rome, the 13 of August: date of the 7.

(From Rome, 7 August 1550. Girardi, 365; Milanesi, ccxxxiv.)

42 *To Benvenuto Cellini.*

My Benvenuto.—I have known you so many years as the greatest goldsmith we ever heard of, and now I shall know you as a sculptor of equal stature. Let me tell you that Messer Bindo Altoviti* took me to see a portrait head of him in bronze; and he told me it was by your hand. I took much pleasure from it; but I was also grieved that it was placed in a bad light: if it had been given its proper light, it would be seen for the beautiful work it is.

(From Rome, 1550. Girardi, 392; Milanesi, cdlxxi.)

43 *To Lionardo di Buonarroto Simoni in Florence.*

Lionardo.—I had the pears, namely ninety-seven of the cordon variety, as you christen them.* I have no more to say about that. As to the matter of your taking a wife, I sent you my opinion last Saturday, saying that you should pay no regard to a dowry but only to her being of good blood, and well brought up and healthy; and otherwise I don't know what to say to you in particular, because I know as much about this in regard to Florence as someone who's never been there.

Recently I've been spoken to about a woman of the Alessandri family, but I was given no details. If I do learn any, I'll tell you in my next letter.

Messer Giovanfrancesco asked me about a month ago for something from the belongings of the Marchioness of Pescara, if I had anything. I have a little book in vellum which she gave me about ten years ago, in which there are 103 sonnets, apart from those she later sent me from Viterbo on paper, which number forty; and I had these bound in the same little book and at that time lent them to many people, with the result that they are all of them in print. I've had many letters which she wrote to me from

Orvieto and Viterbo. That's what I have of the Marchioness's. So show this to the priest and tell me what he responds.

Concerning the money I have told you to give away there in Florence as alms, as I think I wrote to you on Saturday, I must exchange it for bread because of the scarcity here; and if no other help comes I fear we shall be dying of hunger.* The 7 day of March 1551.

<div align="right">Michelangelo Buonarroti in Rome.</div>

(From Rome, 7 March 1551. Girardi, 376; Milanesi, ccxliii.)

44 *To Lionardo di Buonarroto Simoni in Florence.*

To Lionardo.—I learn from your last letter that you have brought your wife home and you are very satisfied, and that you greet me on her behalf and that you haven't yet given security for the dowry. I take the greatest pleasure in you being satisfied and it seems to me we should thank God continually in heart and mind. As for giving security for a dowry, if you don't have the dowry, then don't give security for it; and keep your eyes open, because in these cases where money's involved there always arises some dispute.

I do not understand about such things, but it seems to me that you should have wished to settle everything before your wife came home. With regard to the greeting she sent me through you, thank her and pay her the compliments on my behalf that you'll know yourself how to do better by word of mouth than I would know how to write. I do indeed want it to be seen that she is the wife of a nephew of mine, but I've not yet been able to provide any token of this, because Urbino has not been here. He returned two days ago, however: so I intend to make some gesture. And I've been told that a necklace of valuable pearls would be suitable, I have asked a jeweller friend of Urbino's to look

out for one, and I hope to be successful. But don't tell her anything yet; and if you think I should do otherwise, let me know. I have nothing else to say. Live well, take care, and watch out, because widows are always far more numerous than widowers.

The twentieth day of May 1553.

Michelangelo Buonarroti in Rome.

(From Rome, 20 May 1553. Girardi, 397; Milanesi, cclxiii.)

45 *To Giorgio Vasari.*

Messer Giorgio, dear friend.—I took great pleasure in your letter, seeing that you still remember this poor old man, still more because you were at the triumph you write to me about, and you saw the coming afresh of another Buonarroto; for which news I thank you as best I know how. Yet such pomp does not please me, because no one should laugh when all the world is crying; and so it seems to me that Lionardo does not have much judgement, and especially for celebrating a birth with all the joy that should be reserved for the death of a person who has led a good life. I've no more to say. I thank you warmly for loving me, unworthy as I am. Things here go just so-so.

On I don't know what day in April 1554.

Your Michelangelo Buonarroti in Rome.

(From Rome, April 1554. Girardi, 405; Milanesi, cdlxxii.)

46 *To Giorgio Vasari.*

Messer Giorgio, dear friend.—You'll surely say that I am old and mad, wanting to write sonnets;* but since so many say that I'm in my second childhood, I want to act the part. From your letter I see how you love me; and you should take it for certain that I'd be very glad to lay these fragile bones of mine alongside my father's, as you beg me.

But if I were to leave here now, I would be the cause of the utter ruin of the fabric of St Peter's, as well as of great scandal, and of very great sin. But when the whole structure is all so settled that it cannot be changed, I hope to do all you ask me to, if it's not indeed a sin to keep disgruntled the handful of greedy people who can't wait for me to leave soon.

The 19 of September 1554.

Michelangelo Buonarroti in Rome.

(From Rome, 19 September 1554. Girardi, 406; Milanesi, cdxxiii.)

47 *To the most excellent painter Giorgio in Florence.*

I was forced to work on the fabric of St Peter's, and my service for about eight years has not only been a free gift but done me great harm and caused me unhappiness; but now that it is well advanced and there is money to spend, and I am shortly to vault the dome, it would be the ruin of the building if I were to quit. It would bring me enormous disgrace throughout Christendom, and be a terrible sin and stain my soul. So, my dear Messer Giorgio, I pray you to thank the Duke on my behalf for the very great offers about which you write to me, and pray ask his Lordship to let me continue here by his kind grace and permission till I can leave, still keeping my good name and honour and without sinning.

The eleventh of May 1555.

Your Michelangelo Buonarroti in Rome.

(From Rome, 11 May 1555. Girardi, 415; Milanesi, cdlxxv.)

48 *To my dear Messer Giorgio Vasari in Florence.*

Messer Giorgio, dear friend.—One evening recently there came to find me at home a very discreet and worthy young man,* namely Messer Lionardo, the Duke's chamberlain, and on behalf of his Lordship with great love and affection he made me the same offers as you did in your last letter.

I replied to him the same as I did to you, namely that he should thank the Duke on my behalf for such generous offers, as best and well he could, and that he should beg his Lordship to let me continue here with his permission on the fabric of St Peter's, until it was brought to completion, so that it could not be changed and given a different form. For if I were to leave earlier, it would be the cause of great ruin, great disgrace and great sin; and I beg you for love of God and St Peter to beg the Duke for this, and please remember me to his Lordship. I know that you understand in what I write that I am at the eleventh hour and not a thought arises in me that does not have Death carved within it: but God grant that I keep him waiting in suspense for a few years yet.

The 22 of June 1555.

Michelangelo Buonarroti in Rome.

(From Rome, 22 June 1555. Girardi, 418; Milanesi, cdlxxvi.)

49 *Messer Giorgio Vasari, dear friend in Florence.*

Messer Giorgio Vasari, dear friend.—I can hardly write, but I shall say something in reply to your letter. You know that Urbino has died:* and this for me was a truly great instance of God's grace, though to my terrible hurt and infinite grief. The grace was that whereas in life Urbino kept me alive, in dying he has taught me how to die, not in unhappiness but with the desire for death.

I had him with me twenty-six years, and I found him ever most loyal and faithful; but once I made him rich and was expecting him to be the staff and refuge of my old age, he was snatched from me; and I am left bereft of everything save the hope of seeing him again in Paradise. And of this God has given a sign through the very happy death that Urbino made; and much more than by his own dying was he vexed by leaving me alive in this traitorous world, with so many afflictions; however the best part of me has gone with him, and I am bequeathed nothing except infinite sorrow. I greet you and beg you, if it is no trouble, to make my excuses to Messer Benvenuto* for not replying to his letter, because I am filled with so much sorrow by these thoughts, that I cannot write; greet him for me, as I now greet you.

The 23 of February 1556.

Your Michelangelo Buonarroti in Rome.

(From Rome, 23 February 1556. Girardi, 425; Milanesi, cdlxxvii.)

50 *To the most illustrious Lord Cosimo Duke of Florence.*

Lord Duke.—About three months ago, or a little less, I gave your Lordship to understand that I could still not leave the fabric of St Peter's without doing it great damage and bringing myself the greatest disgrace; and that if I were to leave it as I wanted, given all the conditions necessary, I needed no less than a year's more time; and it seemed to me that your Lordship was ready to allow me this time. Now however I have a fresh letter from your Lordship, which presses me to return in stronger terms than I had expected; and this has made me suffer not a little, since I'm involved in more toil and trouble over the business of the fabric than I ever was. And this is because in the vaulting of the chapel of the King of France, which is skilfully fashioned and novel, as I am old and cannot go there very often, an error has been made, and it is

necessary for me to destroy a large part of what was done there; Bastiano da San Gimignano can witness what chapel this is, having been superintendent there, and say how important it is for all the rest of the building. After the chapel has been put right I believe that all and everything will be finished by the end of this summer; and then there will rest nothing else for me to do, save to leave behind the model for the whole work, as I'm begged to do by everyone and especially Carpi; and then to return to Florence resolved to lie down with death, with whom day and night I seek to make friends, so that he does not treat me worse than other old men.

Now, to return to the subject, I pray your Lordship to concede me the time I request of still another year on account of the fabric, as it appeared to me you were ready to do when I wrote last.

<div style="text-align: right">The least of your Lordship's servants,</div>

<div style="text-align: right">Michelangelo Buonarroti.</div>

(From Rome, May 1557. Girardi, 447; Milanesi, cdlxxxi.

51 *To Giorgio Vasari.*

Messer Giorgio, dear friend.—I call God as witness, that against my will and under tremendous pressure I was set to work by Pope Paul on the building of St Peter's in Rome ten years ago; but if I had continued to work on the fabric till now, as I did then, I would today have reached the point in the building that I wanted to, and been able to return to Florence. However, through lack of money it has been much slowed down; and the work is still slowing down, as it reaches the most laborious and difficult part. So if it were abandoned by me now, it would only bring the greatest disgrace and I would lose all reward for the hardships I have endured over those ten years for the love of God.

I have given this account to you in reply to your letter, and because I have a letter from the Duke which has made

me marvel that his Lordship should have deigned to write in such kind and gentle terms. For this I thank God and his Excellency as best I know and can. I drift away from the subject, because I have lost my memory and my wits, and to write is tiresome for me, since it is not my kind of art. The last point is this: I want to make you understand what would follow if I abandoned the work on the fabric and quit. First of all, I should make a few thieves happy, and would be the cause of the building's ruin, and perhaps even of having it shut up for ever; next, I have certain obligations here and a house and other things, to the value of some thousands of crowns, and if I left without permission, I don't know what would happen to them; and then I am indisposed at my age with gravel, the stone, and pain in my side, as are all old men; and Master Eraldo can bear witness to this,* for I owe my life to him. So to go back to Florence just to return here again is something I don't have the heart for. And as for returning for ever, some time is needed to settle things here so that I don't have to worry about them any more.

The fact is that I left there so long ago that, when I reached here, Pope Clement was still living, though only to die two days later. Messer Giorgio, I greet you and beg you to remember me to the Duke, and act on my behalf because I have no heart for anything now except dying, and what I write to you about my state here is more than true. I gave the reply I did to the Duke because I hadn't the heart to write to his Lordship, and especially so instantly; and if I had felt up to riding a horse, I would immediately have ridden from Rome to Florence and back without anyone being any wiser.

<div align="right">Michelangelo Buonarroti.</div>

(From Rome, May 1557. Girardi, 448; Milanesi, cdlxxxii.)

*Selected Poems
of
Michelangelo*

Translated by
PETER PORTER
and
GEORGE BULL

I' ho già fatto un gozzo in questo stento,*

This comes of dangling from the ceiling—
I'm goitered like a Lombard cat*
(or wherever else their throats grow fat)—
it's my belly that's beyond concealing,
it hangs beneath my chin like peeling.
My beard points skyward, I seem a bat
upon its back, I've breasts and splat!
On my face the paint's congealing.

Loins concertina'd in my gut,
I drop an arse as counterweight
and move without the help of eyes.
Like a skinned martyr I abut
on air, and, wrinkled, show my fate.
Bow-like, I strain towards the skies.

No wonder then I size
things crookedly; I'm on all fours.
Bent blowpipes send their darts off-course.

Defend my labour's cause,
good Giovanni, from all strictures:
I live in hell and paint its pictures.

(Girardi, 5, 1509–10.)

S'un casto amor, s'una pietà superna,

To Tommaso Cavalieri*

If one chaste love, if one God-given piety,
if one same fortune by two lovers dared,
if one the grief but two the pain it shared,
if one will rules two hearts whose souls agree,
if bodies doubled set one spirit free
and both to heaven rise on quick wings paired;
if love's fire in two self-same souls has flared
from one thrust of one dart's trajectory;
if loving one another they spurn self
by mutual pleasure, zest and certain aim
which speeds them both to where they want to go:
if this were true a thousand fold, its wealth
would be a hundredth of the love I claim
is ours, which disdain only could bring low.

(Girardi, 59, 1532.)

S'i' avessi creduto al primo sguardo

To Tommaso Cavalieri

If I'd believed that day he saw me first,
my phoenix love, that in his blazing gaze,
as in a myth, my self should be upraised,
renewed in ripe old age, I might have burst
beyond the ring of fire, a leopard's thirst
my speed or stag's hot fear, and so amaze
him by my secret closeness to his ways
in which through sluggard speediness I'm versed.
But why should I grieve more, since now I see
a happy angel's eyes which bring in sight
my peace, my rest and my secure salvation?
The things which were not mine at first will be
the happier to have now, since for my flight
he gives me wings to share in his elation.

(Girardi, 61, 1532.)

Sol pur col foco il fabbro il ferro stende

To Tommaso Cavalieri

The smith when forging iron uses fire*
to match the beauty shaped within his mind;
and fire alone will help the artist find
a way so to transmute base metal higher
to turn it gold; the phoenix seeks its pyre
to be reborn; just so I leave mankind
but hope to rise resplendent, new-refined,
with souls whom death and time will never tire.
And this transforming fire good fortune brings
by burning out my life to make me new
although among the dead I then be counted.
True to its element the fire wings
its way to heaven, and to me is true
by taking me aloft where love is mounted.

(Girardi, 62, 1532.)

Felice spirto, che con zelo ardente,

To Tommaso Cavalieri

Dearest of friends, whose zealous love preserves
my ageing soul's poor life from death's cruel claw
and chooses from the joys you have in store
this greeting that some nobler mind deserves;
as once my eyes, so now my mind observes,
the comfort that you bring may come no more
from others; hope alone will keep the door
for grief, a pain which in my heart long serves.
And since this soul that's yours a spokesman meets
in you, whose cares restrain no kindnesses,
I'll write in kindliness to pay in kind.
But oh how niggardly he'd be who greets
your letters with such ugly likenesses*
instead of words which light the human mind.

(Girardi, 79, 1533.)

Veggio nel tuo bel viso, signor mio,

To Tommaso Cavalieri

My Lord, in your most gracious face I see
what here on earth may never be portrayed:
my soul, which mortal flesh and blood pervade,
climbs Godward with it to eternity.
And should the mob with its stupidity*
foist on to others feelings which degrade,
no less intense is my sweet longing made,
my love, my trust, my honest amity.
So from the sacred fount whence all men come
each earthly beauty takes its attributes
and we are told that these from God are sent;
And for its image there's no other home,
for heaven on earth, or for our worldly fruits.
Thus loving you makes death beneficent.

(Girardi, 83, *c.*1534.)

Sì come nella penna e nell'inchiostro

To Tommaso Cavalieri

Just as each writer's pent-up pen and ink
awaits the page to show his choice of style,
and marble figures both bold and servile
attend the artist's genius they link,
so, my dear lord, within your heart, I think,
your pride with humble thoughts you reconcile;
but of your traits be those seen in my smile
(my face reveals) from which I do not shrink.
If sighs and tears be seeds of grief one sows,
(on earth the purest rain of heaven falls
on varied soils and varied harvests brings),
one reaps pure sorrow, dire a crop as grows:
he to whom perfect beauty sadly calls
is prey to fortune's arrows and her slings.

(Girardi, 84, *c.*1534.)

Vorrei voler, Signor, quel ch'io non voglio:

I wish to want, Lord, what eludes my will:*
between your passion and my heart a block
of ice deflects your fire, and makes a mock
of everything I write with perjured quill.
I love you with my lips, then groan that still
your love can't reach my heart, nor will it knock
and force the door, that joys of all kinds flock
about my heart, your purpose to fulfil.
Dissolve that block, my lord, tear down the wall
whose thickness keeps me from the piercing light
of your sweet presence, no longer seen on earth.
Be like a bridegroom, let your brightness fall
upon a yearning soul which at your sight
is warmed at heart, having from you its birth.

(Girardi, 87, *c.*1534.)

Sento d'un foco un freddo aspetto acceso

To Tommaso Cavalieri

I sense far off a cold face lit with fire
which burns me, but in burning freezes still;
the force which holds me in its embrace will
move mountains and unmoving never tire.
This precious soul, all mine, serves to inspire
deathless, another's death, and aims to chill
with his free-wheeling love my captive will,
so innocently does his force conspire.
How can these handsome looks, lord, yet appear
full of such opposites to my fond eyes?
No man may give what he does not possess.
Thus you are like the sun which men revere;
you warm the earth but heatless sail the skies;
you rob my life of every happiness.

(Girardi, 88, *c.*1534.)

Veggio co' be' vostr'occhi un dolce lume

To Tommaso Cavalieri

With your bright eyes I see the living light*
which my blind eyes alone can never see;
and your sure feet take up that load for me
which my lame gait would let fall helplessly.
Wingless, but with your plumes, here I'm in flight;
in your strong mind are my weak thoughts set free
and as it pleases you I'm pale or bright,
cold in the sun, hot in the winter's night.
In what you wish is all that I would want,
my very thoughts are framed within your heart,
my words are uttered with the air you breathe.
Thus, like the moon, a lonely suppliant,
invisible myself, I sail apart
until the sun reveals me with its beams.

(Girardi, 89, *c.*1534.)

A che più debbi'i' omai l'intensa voglia

To Tommaso Cavalieri

Why should I still indulge my deep desire
and let it seek release in tears and sleep,
if heaven, which touches souls its love to teach,
will late or never quench the very fire?
Why whip my heart to act when it would tire
to death? For at my final moment's reach
these lights, my eyes, would its sweet sleep
 beseech,
knowing all joy must sink as grief climbs higher.
If then the blows of love which so obsess
me may not be evaded, who may own
that feeling space between my dark and bright?
If I must be defeated to be blessed,
don't marvel that one, naked and alone,
should prove a prisoner of an armoured knight.*

(Girardi, 98, *c.*1534–8.)

O notte, o dolce tempo, benché nero,

O dark yet lovely night,* the gentlest time,
you seal with peace the work of every hand
and only those who praise you understand
the good; who honour you know the sublime.
Our trailing thoughts we trim and clip like rhyme;
your moist shade sheds a quietness on the land
and then you raise me in my dreams to stand
in hoped-for heaven where my soul would climb.
O shadow of our death, who takes from life
the wretchedness of both the heart and mind,
the last and healing salve of wounded flesh,
you mend our bodies torn by Fortune's knife,
you dry our tears; in you deep rest we find,
our anger calmed, our tiredness refreshed.

(Girardi, 102, 1531–41?)

Colui che fece, e non di cosa alcuna,

(To Tommaso Cavalieri?)

The Creator, who from nothingness could make*
all Time and every creature in the void,
divided Time: He kept the sun employed
by day, the moon He set in night's dark lake.
Thus fortune, chance and fate are all awake
to fix for each what no man can avoid;
to me they give that time of sun devoid,
a dark which at my birth set up the stake.
And like a shadow which must imitate
itself, as night advancing darker grows,
so I in sin advancing grieve and mourn.
Some consolation yet this gift creates:
your sun is born for me whose brightness shows
through my dark night and ushers in the dawn.

(Girardi, 104, 1535–41?)

Non vider gli occhi miei cosa mortale

(To Tommaso Cavalieri?)

No mortal being would my eyes behold
when in your eyes my utter peace I found,
but my own likeness proved on pure ground,
the one whose arms my heart by love enfold;
and were not God Himself my soul's own mould,
the handsome looks which all our eyes astound
would satisfy; but no such charms are sound;
the soul with abstract beauty is enrolled.
No man can gratify through what must die
all his desires; nor can there be achieved
eternal form in time, since flesh decays.
For here our senses must our love belie
and kill the soul; but if on earth perceived
as friends, we're perfect when to heaven we're
raised.

(Girardi, 105, c.1535–41.)

Non ha l'ottimo artista alcun concetto

To Vittoria Colonna

No block of marble but it does not hide*
the concept living in the artist's mind—
pursuing it inside that form, he'll guide
his hand to shape what reason has defined.
The ill I flee, the good I hope to find
in you, exalted lady of true pride,
are also circumscribed; and yet I'm lied
to by my art which to my will is blind.
Love's not to blame, nor your severity,
disdainful beauty, nor what fortune shows,
or destiny: I fixed my own ill course.
Though death and mercy side by side I see
lodged in your heart, my passion only knows
how to carve death: this is my skill's poor force.

(Girardi, 151, 1538–41/4.)

A l'alta tuo lucente diadema

To Vittoria Colonna

To your resplendent beauty's diadem*
no one may hope to rise, O Lady,
except by long and steep ascent—the way
on high is by your gentle courtesy.
My strength is failing me, I spend
my breath half-way—I fall, I stray,
and yet your beauty makes me happy
and nothing else can please my heart
in love with everything sublime
but that, descending here to me
on earth, you are not set apart.
It comforts me meantime,
forseeing your disdain, that this my crime
pardons in you the bringing of such light
down so closely from your hated height.

(Girardi, 156)

Costei pur si delibra

This savage woman,* by no strictures bound,
has ruled that I'm to burn, die, suffer, though
the sins she scolds weigh but an ounce or two.
My blood, however, she drains pound by pound;
She strips my nerves the better to undo
my soul; then to her trusted looking-glass
she turns and sees an equal Paradise;
this way she hopes her beauty to renew.
And then to me she turns her gaze to fashion
me in ways that with my age will pass
to all her loveliness new rapture,
that I being ugly satirize my passion,
set there beside her in the truthful glass
and so increase her beauty, conquering nature.

(Girardi, 172, 1542–6.)

Com'esser, donna, può quel c'alcun vede

To Vittoria Colonna

How chances it, my Lady, that we must
from long experience learn that what endures
in stone is but the image it immures
though he who liberates it turn to dust?
This cause to its effect will so adjust
that our fine work defeat of time ensures.
I know this true and prove it in my sculptures:
art lives forever, death forfeits its trust.
Therefore, long life in colours or with stone,
in either form, I give to you and me
and our own two resemblances devise,
and for a thousand years when we have gone
posterity will find my woe, your beauty
matched, and know my loving you was wise.

(Girardi, 239, 1545?)

Dal ciel discese, e col mortal suo, poi

Out of heaven in his mortal dress*
he came, and having witnessed for us hell
and Mercy, he returned with God to dwell,
leaving his vision like a light to us.
Resplendent star which with its rays would bless
that nest of infamy I know so well,
the place where I was born! None can compel
due recognition there of his distress.
I speak of Dante, whose poetic works
left those ungrateful people quite unmoved,
for only just men could conceive his fate.
Would that I were he and to such quirks
of fortune heir, in exile and by talent proved,
for this I would forego the world's best state.

(Girardi, 248, 1545–6.)

*La carne terra...**

Flesh turned to clay, mere bone preserved (both
 stripped
of my commanding eyes and handsome face)
attest to him who earned my love and grace
what prison is the body, what soul's crypt.

(Girardi, 197.)

Qui serro il Braccio...

Here Braccio and his beauty shall I keep in trust
and just as flesh to soul true life and substance
 brings,
so does my shape reflect such noble pleasing
 things:
the plain sheath still shows how the splendid
 dagger thrust.

(Girardi, 216.)

Qui stese il Braccio...

Death took Braccio in its arms: his years
a mere fifteen, an unripe fruit, a flower.
His tomb is now his favour and his dower,
and all the rest of us are turned to tears.

(Girardi, 222.)

I' fu' de' Bracci...

A limb of the Bracci, I lie lifeless here,
my body's beauty changed to bone and clay.
May this tomb be never opened where I stay;
May I seem fair to those who hold me dear.

(Girardi, 225.)

*Caro m'è 'l sonno. . .**

Dear to me is sleep; still more to sleep
in stone while harm and shame persist;
not to see, not to feel, is bliss;
speak softly, do not wake me, do not weep.

(Girardi, 247, 1545/6.)

EXPLANATORY NOTES

LIFE OF MICHELANGELO

3 *Julius III*: Cardinal Gianmaria Ciocchi del Monte reigned as Pope Julius III from 1550 to 1555. He is best remembered for building the beautiful Villa Giulia (now housing Rome's Etruscan Museum) and for his benign support of Michelangelo.

all the works that will issue from my hands: Condivi collected but never published Michelangelo's poetry and observations on anatomy.

talent: *virtù*.

subtleties of the art, and for the rules they establish: *per finezza, e per istabilmento dell'arte*.

5 *First, because there have been some who in writing about this rare man*: Vasari's *Lives* first appeared in 1550. In the second (1568) edition he made use of Condivi's work, but vigorously defended his own status as biographer.

7 *magistrate*: *podestà*, a magistrate or mayor appointed from outside the city.

sestiere: the six Florentine administrative districts were replaced in 1343 by four *quartieri* which sent representatives to the chief governing body of Florence, the *Signoria*.

from a Ghibelline he became a Guelf: originally, perhaps, the Weiblingen and Welf families, the names came to stand loosely for supporters of emperor and pope respectively, the former tending to be noble and martial, the latter wedded to trade and industry.

rake: *rastrello*.

8 *Pope Leo X*: Cardinal Giovanni de' Medici, son of Lorenzo de' Medici, reigned as Pope 1513–21. In 1515 during negotiations with Francis I following the French King's invasion of northern Italy, Leo made a formal entry into Florence, under Medici rule since 1512.

year of our Saviour 1474: in the modern style 1475.

9 *So the boy grew up*: Michelangelo's mother, Francesca, died aged 26 when he was 6. He was later to suggest to his

nephew Lionardo, that he should name his daughter after her. Michelangelo's four brothers were: Lionardo (b. 1473); Buonarroto (b. 1477); Giovansimone (b. 1479); and Gismondo (b. 1481).

Franceseo Granacci, a disciple of Domenico del Ghirlandaio: Michelangelo was apprenticed to Ghirlandaio (1449–94), then working on the frescos in the choir of Santa Maria Novella, in 1488, and stayed with him till 1490, when he went to the Medici household. Granacci (1467/70–1543) was later asked to help Michelangelo on the vault of the Sistine Chapel, but was soon sent away.

10 *Martin of Holland*: Martin Schongauer (first recorded 1456–d. 1491) a painter and engraver from Colmar.

11 *Lorenzo the Magnificent*: Lorenzo de' Medici (1449–92), avid collector, patron, and poet, continued to exercise the effective political control of Florence established by his father and grandfather. The faun which Michelangelo did in the Medici garden has been lost, though it appears in a seventeenth-century fresco by Ottavio Vannini (Palazzo Pitti).

14 *Poliziano*: Angelo Poliziano (1454–94) tutor to Lorenzo's sons, humanist scholar and poet whose chief works were *La Giostra* and *Orfeo*.

The rape of Deianira and the battle of the centaurs: large marble relief, perhaps based on a story in Ovid's Metamorphoses Book XII, showing the first surviving statement of Michelangelo's lifelong artistic obsession with the male nude in dramatic movement. Today it is in the Casa Buonarroti, Florence, along with another early and significant marble relief, the *Madonna of the Steps*. Both illustrate the wide range of influences on Michelangelo's style and concepts.

15 *2 palms high*: *palmi due*, i.e. about 29 cm. or 11½ in.

8 feet high: *braccia quattro*, i.e. just under 8 ft.

Piero de' Medici: Lorenzo's first son (1471–1503) was banished for life from Florence in November 1494. Savonarola was executed in 1498; the Republic appointed Piero Soderini Gonfalonier for life in 1502. Following the formation of the Holy League against its ally France, to avoid attack and pillage Florence in 1512 accepted the return of

the Medici, led by Giuliano (third son of Lorenzo the Magnificent), and Cardinal Giovanni. Giuliano married into the French royal family and became Duke of Nemours; he is buried in the tomb with the statues of *Day* and *Night* in the Medici Chapel of San Lorenzo.

16 *Michelangelo made a wooden crucifix*: possibly the crucifix to be seen in the Casa Buonarroti after its claimed rediscovery in 1962.

17 *Cardinal Bibbiena*: Bernardo Dovizi da Bibbiena (1470–1520) also served Giovanni de' Medici who made him a cardinal when he became Pope. A close friend of Castiglione (who portrayed him in *The Book of the Courtier*) and a patron of Raphael, who painted him.

Giovanni Bentivogli: ruler of Bologna from 1462 till his overthrow by Pope Julius II in 1506.

Bolognese coins: *bolognini*, small copper coins.

Gianfrancesco Aldovrandi ... then one of the Sixteen: a committee of citizens formed to resist Papal domination of Bologna. Aldovrandi was later ambassador for Julius II to Florence and Ferrara.

18 *the tomb of St Dominic*: Michelangelo made three small figures for the shrine which had been left unfinished by Niccolò dell'Arca—St Patronius and St Proculus and an angel holding a candelabrum.

19 *a god of Love*: this *dio d'amore* or *Cupidine*, sold as an antique at the suggestion of one of the Medici cousins, later came into the hands of, respectively, Cesare Borgia, the Duchess of Urbino, and then King Charles I of England. It disappeared when the royal collection was dispersed in 1631. The Cardinal of San Giorgio, Raffaele Riario, was the grand-nephew of Pope Sixtus IV, and Michelangelo's first patron in Rome.

Cupid: *Cupidine*.

20 *Duke Valentino*: Cesare Borgia.

21 *Messer Jacopo Galli, a Roman gentleman*: banker and neighbour of Cardinal San Giorgio who acquired rather than commissioned the Bacchus which still survives (in the Bargello, Florence).

the Cardinal of Saint-Denis: Cardinale di San Dionigi, Jean

de Villiers de la Groslaye (or Jean Bilhères de Lagraulas) was sent by Charles VIII of France as ambassador to Pope Alexander. The statue of Our Lady, the *Pietà*, which he commissioned in 1498 is today safeguarded behind thick glass in St Peter's, having been damaged by hammer blows in 1972. Condivi's long defence of Michelangelo's theology probably springs from the suspicious atmosphere of the Counter-Reformation and its concern for sexual and spiritual decorum.

23 *that statue, which everyone calls the Giant*: the statue of *David*, over twice life-size, which Michelangelo started to carve in 1501 and finished in 1504. Symbol of civic liberty, it was moved to the Accademia in Florence in 1873 and a copy stands on the original site.

24 *David with Goliath underneath*: this lost bronze was commissioned in 1502 by the French commander in Italy, Pierre de Rohan, and sent to France in 1508. The classic bronze *David* by Donatello (*c*.1386–1466)—Florence's greatest sculptor before Michelangelo and among the finest and most influential of Renaissance artists—is now in the Bargello.

a Madonna with her infant son: the *Bruges Madonna*, in marble not bronze, was perhaps first meant for the Piccolomini altar in Siena cathedral. The Doni Tondo painting of *The Holy Family* is in the Uffizi. At this period Michelangelo also carved the Taddei Tondo and the Pitti Tondo, not quite finished highly contrasted marble reliefs. Condivi's wording—'e similmente un David'—suggests there were two statues.

Italian poets and orators: poeti ed oratori vulgari, i.e. those who wrote in the vernacular.

he was called to Rome by Pope Julius II: the Cardinal of San Pietro ad Vincula, Giuliano della Rovere, reigned as Pope 1503–13. A vigorous and intelligent political and military leader, matching Michelangelo's *terribilità*, he embarked in Rome on grandiose projects for architecture and sculpture, notably St Peter's, following his own ill-fated tomb, to begin which Michelangelo in fact went to Rome in early 1505.

25 *from the corridor to Michelangelo's room*: this gallery ran between the Papal Palace and Castel Sant'Angelo. (Gangplank—*un ponte levatoio*.)

the architect Bramante: Donato Bramante (1444–1514) came

from Milan after the invasion of Charles VII of France in
1499 and was Julius's main collaborator in planning new
architecture for Rome. He pulled down old St Peter's and
laid the foundation for the new church in 1506. The
supervision of the construction of the new St Peter's passed
on Bramante's death to Antonio da Sangallo (1485–1546)
and then to Michelangelo in 1547.

26 *San Pietro ad Vincula*: rather, San Pietro in Montorio.

those two Prisoners: the *Prisoners*, or *Slaves*, are now in the
Louvre. The *Moses* is the main figure on the extant tomb in
S. Pietro in Vincoli. The original project for a free-standing
tomb with forty figures was modified by successive contracts
in 1513, 1516, 1532, and 1542. Under the third wall-tomb
contract of 1516, Michelangelo started work, probably in
1520, on the massive so-called *Florentine Slaves* (four in the
Accademia, Florence and one in the Casa Buonarroti)
which, including corner figures, are often cited as excellent
illustrations of his working methods.

30 *Turk*: Sultan Bajazet II (see note to p. 60).

that marvellous cartoon begun for the Council Hall: done in
competition with Leonardo da Vinci (1452–1519), the car-
toon was started by Michelangelo after completion of the
David in Florence. The fresco itself was started in
November 1506 but never finished and the cartoon was cut
into pieces all of which have disappeared.

31 *Cardinal Soderini*: brother of the *gonfaloniere* of Florence,
Piero Soderini.

32 *the chapel of Pope Sixtus IV*: Sixtus IV (1471–84) was the
uncle of Julius II. The chapel had already been decorated by
painters including Perugino, Botticelli, Ghirlandaio, and
Signorelli. Michelangelo completed the first half in 1510
and the whole work in 1512.

35 *In the seventh*: the seventh scene is in fact *The Sacrifice of
Noah*, followed by *The Flood*.

38 *a secco*: after the plaster was dry.

39 *St John*: patron saint of Florence.

40 *and he put the care of this into the hands of the elder Cardinal*:
Lorenzo Pucci, the Cardinal of Quattro Santi, and Leo-
nardo Grosso della Rovere, Cardinal Aginense, were
Julius's executors. Bernardo Bini worked in the Papal treas-
ury under successive popes.

the façade of San Lorenzo: this family church of the Medici
was begun by Brunelleschi in 1421. Leo, who succeeded
Julius in 1513, commissioned Michelangelo to complete the
façade but it was never finished.

41 *the Marquis Alberigo*: Marquis Alberico Malaspina, Lord of
Carrara.

42 *Adrian was created Pope*: Adrian VI, from Utrecht, former
tutor of the Emperor Charles V, reigned from January 1522
to September 1523. The new Pope, Cardinal Giulio de'
Medici, reigned as Pope Clement VII from 1523 to 1534. He
was the illegitimate son of Giuliano, Lorenzo de' Medici's
brother. For him Michelangelo continued to work on the
New Sacristy of San Lorenzo as a funerary chapel and on
the Laurenziana Library. After a brief period of Republican
rule (1527–30), Michelangelo again worked for the Medici
on the chapel, but left Florence to settle in Rome per-
manently in 1534.

45 *There are four monuments*: Condivi mentions four *sepolture*
and originally six were planned, for Lorenzo the Magnifi-
cent, his brother Giuliano, Giuliano Duke of Nemours,
Lorenzo, Duke of Urbino, Leo X and Clement VII. Com-
pleted were the figures of Giuliano, Duke of Nemours, and
Lorenzo, Duke of Urbino, placed over their tombs above
symbols of time and mortality—*Day* and *Night*, *Dawn* and
Evening—with the *Madonna* as the chapel's focal point.
Giuliano had died in 1516, ending the direct line of the
Medici, and Lorenzo in 1519.

46 *Duke Alessandro*: said to be the illegitimate son of Lorenzo de'
Medici, but almost certainly the offspring of Clement VII when
he was a Cardinal. Alessandro was declared ruler of Florence
in 1530 and assassinated by his cousin Lorenzino in 1537.

47 *Duke Alfonso*: Alfonso I d'Este was married to Lucrezia
Borgia. His son, Ercole II, ruled Ferrara from 1534 to 1559.
The *Leda* which Michelangelo painted in tempera was taken
to France by his pupil Antonio Mini and eventually disap-
peared.

51 *Paul III*: this Farnese pope was elected in September 1534
and put Michelangelo in charge of all his artistic projects,
naming him (in September 1535) the 'supreme architect,
sculptor, and painter of the Apostolic Palace'.

52 *the tragedy of the tomb and the tomb itself came to completion*:

after *The Last Judgement* was finished in November 1541, Michelangelo signed a fourth contract for the tomb in August 1542 and completed it in February 1545.

53 *Moses*: in fact, the left hand of the statue of the Old Testament prophet rests in his lap. The statue of the *Active Life* holds a diadem in her right, and laurel wreath in her left hand; not a mirror.

55 *In this work Michelangelo*: the biblical references are: 'Now when the Lamb broke the seventh seal, there was silence in heaven for what seemed half an hour. Then I looked, and the seven angels that stand in the presence of God were given seven trumpets.' (Revelation 8:1–2.)

'He said to me, "Prophesy over these bones and say to them, O dry bones, hear the word of the LORD. This is the word of the Lord GOD to these bones: I will put breath into you, and you shall live, and you shall know that I am the LORD." I began to prophesy as he had bidden me, and as I prophesied there was a rustling sound and the bones lifted themselves together.' (Ezekiel 37:4–8.)

56 *as Dante described him*: 'The devil, Charon, with eyes of glowing coals, summons them all together with a signal, and with an oar he strikes the laggard sinner.' (Dante, *Inferno*, Canto 3, trans. Mark Musa, Penguin Books.)

57 *St Bartholomew, his skin*: the notorious poet, playwright, writer, and pornographer, Pietro Aretino, was Michelangelo's model for St Bartholomew, whose flayed skin showed the face of Michelangelo himself.

Pope Paul had built a chapel: namely, the Pauline Chapel, designed by Antonio da Sangallo the Younger, where Michelangelo began the first fresco in November 1542 and the second in March 1546. The eyes of St Peter, crucified upside down, give the illusion of following you, as you walk along the aisle.

It is a group of four figures: this *Pietà*, left unfinished, is now in the Cathedral museum at Florence. The figure of Nicodemus was described by Vasari as a self-portrait of Michelangelo.

58 *the Pietà Michelangelo did for the Marchioness of Pescara*: Vittoria Colonna (1490–1547), one of Michelangelo's closest friends, was the granddaughter of Duke Federigo da Montefeltro, ruler of Urbino, and wife of Ferrante Francesco

d'Avalos, Marquis of Pescara. Widowed in 1525, she devoted her life to the friendship of Catholic reformers, pious practices and the pursuit of learning. The *Pietà* Michelangelo did for her and the *Crucifixion* mentioned below are preserved in drawings in Boston and London (British Museum).

the Christ which is in the Minerva: the second *Risen Christ* (a first version Michelangelo abandoned as flawed) was executed between 1519 and 1520 and is still in Santa Maria Sopra Minerva, in Rome. The massive St Matthew was left unfinished when Michelangelo went to Rome in 1505 and is in the Accademia, Florence. The Rialto bridge at Venice was designed by Antonio da Ponte and built between 1588 and 1591; no designs by Michelangelo survive.

Isocrates: ended his *Panathenaicus* in praise of Athens, and ended his life, in 338 BC.

who lived until he was 92: in fact, he died aged 87 in 1531.

60 *in the case of Bembo*: the Venetian Pietro Bembo (1470–1547) was a brilliant linguist, literary pundit, Papal secretary and cardinal; Jacopo Sannazaro (*c.*1456–1530) humanist and poet, best known for his classically inspired *Arcadia*; Annibale Caro (1507–66) humanist and translator of, for example, Virgil's *Aeneid*, Aristotle's *Rhetorica* (Condivi married his niece, Porzia); Bishop Giovanni Guidiccione, Bishop of Fossombrone, wrote poems and orations on Italy's woes.

Raphael of Urbino: Giovanni Santi, the father of Raffaello Sanzio (1483–1520), died in 1494 when Raphael was 11; by 1500 Raphael was working in the workshop of Perugino. After he began to study in Florence he was strongly influenced by Michelangelo and Leonardo. In 1508 he was drawn to the court of Pope Julius II.

even the Grand Turk: Sultan Bajazet II, who ruled 1481–1512, successor to Muhammad II, the Conqueror.

61 *his Villa Giulia*: reconstruction and decoration of this magnificent papal house and garden by Ammanati, Vasari, and Vignola was finished in 1554.

62 *Monsignor di Forlì*: Pier Giovanni Alliotti was Paul III's master of the wardrobe and was made a bishop and chamberlain (maestro di camera) by Julius III. Nicknamed *Tantecose* or Busybody.

through a motu proprio: an 'apostolic letter' represented the Pope's own wishes ('of his own accord').

Paul III charged Michelangelo with responsibility for St Peter's in a *motu proprio* of January 1547 followed in October 1549 by a second letter granting him complete authority. Julius III confirmed this with his own *motu proprio* of January 1553.

63 *the façade of a palace*: nothing survives.

Albrecht Dürer: several treatises including *Four Books on Human Porportion* were published by Dürer (1474–1528), the prolific engraver and Imperial Court painter and traveller in Italy, and transmitter of Italian Renaissance concepts and forms to northern Europe.

64 *Messer Realdo Colombo*: Colombo da Cremona (1520–99), professor of medicine and physician, was Michelangelo's doctor and wrote a treatise on anatomy with his help. *De re anatomica* (1559) anticipated Harvey in describing the circulation of blood.

65 *a new model*: part of this (lost) model can be seen in a painting of 1620 in the Casa Buonarroti and there is a wooden model of the dome in the Vatican copied from Michelangelo's clay model of 1557.

66 *the great Scipio*: Publius Scipio Africanus, conqueror of Hannibal.

illustrious Monsignor Pole: Reginald Pole (1500–88) English Catholic reformer, friend and spiritual adviser of Vittoria Colonna, was made Archbishop of Canterbury under Mary Tudor in 1557; Cardinal Tiberio Crispo (1498–1566) was castellan of Castel Sant' Angelo under Paul III and cardinal over Condivi's own diocese; the Cardinal of Santa Croce was prefect of the Vatican Library, Marcello Spannocchi Cervini (1501–55) later Pope Marcellus II; Bernardino Maffei (1513–53) was Cardinal of Santo Cirillo and secretary to Cardinal Alessandro di Pier Luigi Farnese; the Patriarch of Jerusalem, Cristoforo Spiriti da Viterbo (d. 1556) was entrusted with safeguarding Michelangelo's position as architect of St Peter's under the 1552 *motu proprio*. Cardinal Niccolò Ridolfi (1501–50) was a nephew of Pope Leo X and commissioned from Michelangelo the bust of Brutus (*c*.1540) now in the Bargello, Florence.

67 *such as Monsignor Claudio Tolomei*: the Bishop of Corsula

(1492–1555), a humanist and writer on Vitruvius; Lorenzo
Ridolfi (1503–76) Cardinal Ridolfi's brother and at one time
Apostolic Secretary; Donato Giannotti (1492–1573) Secre-
tary to the Florentine Republic of 1527–30, Florentine exile
and intimate friend of Michelangelo, whom he introduced
into his book on Dante, and poems he had collected for
publication in collaboration with Luigi del Ricco, who died
before the project was completed. Lionardo Malespini and
Gian Francesco Lottino da Volterra were humanists, the
latter an ardent servant of the Medici.

This account of Michelangelo's friendships breaks down
roughly into three important groups—the circle of Cardinal
Alessandro Farnese; Vittoria Colonna's friends; and Floren-
tine exiles. Condivi omits the friends of Vasari who were
painters and sculptors and who are mentioned in Vasari's
life of Michelangelo.

Messer Tommaso Cavalieri: the young Roman nobleman (d.
1587) of whom Vasari wrote: 'But infinitely more than any
of them Michelangelo loved the young Tommaso de Cava-
lieri, a well-born Roman who was intensely interested in the
arts,' adding, inaccurately, that he did of Tommaso the only
portrait he ever made from life 'because he hated drawing
any living subject unless it were of exceptional beauty'. For
Cavalieri, whom he first met in or about 1532, Michelangelo
wrote poems and letters and did several remarkable highly
finished drawings of sensual pagan subjects, a *Tityus* (now in
Windsor Castle) and a *Ganymede* (known from copies).

68 *they do not realize how great the cost in blood*: from Dante's
Paradiso, Canto 29, where Beatrice is talking of the spread of
the Gospel.

The Bianchi, wearing white as a sign of repentance, came
to Florence in 1399, rather than 1348, carrying a Cross with
a bar across the fork of the arms.

published by Varchi: Benedetto Varchi (1503–65), Florentine
humanist, historian, and critic, wrote a commentary on the
sonnets of Michelangelo (*Due lezioni*, published in 1550)
and delivered the main funeral oration at the memorial
service in San Lorenzo in 1564.

Savonarola: Girolamo Savonarola (1452–98) Dominican
friar born in Ferrara who won a large following in Florence
through his prophetic preaching from about 1491 when he
became prior of San Marco. Most influential from the

expulsion of the Medici till 1497, he was excommunicated by Pope Alexander VI, tortured, and executed. He was of some disputed influence on Michelangelo's thinking, drawing, and writing, as were Dante and Petrarch, and the humanist neo-Platonists.

as if Alcibiades: in Castiglione's *The Book of the Courtier* (published 1528) about conversations held in 1507, referring to the relationship between Alcibiades and Socrates, Cesare Gonzaga remarks: 'indeed it was a strange place and time— in bed and by night—to contemplate that pure beauty which Socrates is said to have loved without any improper desire.'

69 *That ancient master*: Zeuxis, who selected the most fetching features of five virgins when asked to paint a picture of Helen of Troy for the city of Croton in Southern Italy. (Pliny's *Natural History* book 35.)

72 *Torrigiano de' Torrigiani*: described by Vasari as proud and hot-tempered, Pietro Torrigiano (1472–1528) was a Florentine sculptor who grew up with Michelangelo in the Medici Garden and later worked in England on the tomb of Henry VII, Westminster Abbey. Benvenuto Cellini gives a vivid account of his relations with Michelangelo in his *Life*.

73 *I come to an end*: the first edition of Condivi's *Life (Vita di Michelangelo Buonarroti, raccolta per Ascanio Condivi dalla Ripa Transone)* was published in Rome on July 1553 in two printings.

The second printing, as well as some minor changes, contains three additions to the first: the sentence about contemporary writers and imitation (see p. 60); the details of his dealings and relationship with Julius III (p. 61); and the remark about Dürer's shortcomings (p. 63).

English translations of Condivi's *Life* include Charles Holroyd's (in *Michael Angelo Buonarroti*, 2nd edn., London, 1911, which also contains 'Three Dialogues from the Portuguese by Francisco d'Ollanda') and a scholarly, illustrated version by Alice Sedgwick Wohl (ed. Hellmut Wohl, Louisiana State University Press, 1976).

I have chiefly used the Italian texts edited by Emma Spina Barelli (Rizzoli, 1964) and Carl Frey (Berlin, 1887).

SELECTED LETTERS OF MICHELANGELO

In the order and dating of the letters I have followed the decisions made by E. H. Ramsden in her richly annotated two-volume edition of *The Letters of Michelangelo* (Peter Owen, London, 1963), an essential companion for students of Michelangelo's life and times. I have chiefly used the Italian texts of Milanesi (1875 and 1976) and Girardi (E.P.T. di Arezzo, 1976) and consulted the new edition in 5 volumes of Barocchi and Ristori (Florence, 1965–83), which includes all known letters to Michelangelo.

77 *Lorenzo di Pier Francesco de' Medici*: member of the younger branch of the Medici family. Michelangelo's letter was written on his first visit to Rome.

 Cardinal San Giorgio: Raffaello Riario (1450–1521) who was a nephew of Sixtus IV, a collector of antiquities and patron of the arts.

 Statues: figure.

 Paolo Rucellai: (1464–1509) banker and member of a famous Florentine family, who lived for a while in Rome.

 the Cavalcanti: merchant bankers who quite often came to do business for Michelangelo.

 Baldassare: a dealer who had sold the *Sleeping Cupid* by passing it off as an antique.

 little boy: bambino.

 Baldassare Balducci: a Florentine merchant and friend of Michelangelo.

 high and mighty people: gra' maestri.

78 *brother Lionardo*: Michelangelo's elder brother who was a follower of Savonarola and had become a Dominican friar in 1491.

 Giuliano da Sangallo: (1445–1517) a fellow-Florentine who influenced Michelangelo's early architecture and had suggested to Pope Julius II that he should call him to Rome.

80 *Giovansimone*: (1479–1548) Michelangelo's second younger, and tearaway brother whom he helped set up in business. At one time, he came near to migrating *via* Lisbon to India.

81 *As for the matter of Cassandra*: Cassandra di Cosimo Bartoli was the widow of Michelangelo's uncle, Francesco, who had

sued Lodovico and her nephews for the recovery of her dowry.

because you pay in pounds . . . pence: che si fa costà con un grosso, non si farà qua con dua carlina . . . Both *grossi* and *carlini* were silver coins, respectively Florentine and Neapolitan, of widely fluctuating values.

83 *Giovanni Balducci*: banker and friend of Michelangelo.

hospitaller: lo Spedalingo as the rector of the hospital of S. Maria Nuova.

84 *Buonarroto*: (1477–1528) Michelangelo's first and favourite younger brother, who was given the title of Count Palatine by Pope Leo X, of whose triumphal entry into Florence in 1515 he wrote a lively account. He died in Michelangelo's arms during the siege of Florence.

85 *Bernardino*: Bernardino di Piero di Bernardo Basso, a Florentine craftsman in wood and stone whom Michelangelo called to Rome to help with the tomb of Julius. The boy who was ill when Michelangelo came back from Florence was Silvio Falcone. The house in the Macel de' Corvi in which Michelangelo was to make the tomb of Julius was eventually granted to him rent-free.

start work: on the tomb of Julius II.

88 *Domenico Buoninsegni*: the Papal official appointed by Pope Leo X and his cousin Cardinal Giulio de' Medici to deal with Michelangelo over the completion of the façade of San Lorenzo.

Baccio: Baccio d'Agnolo Baglioni (1462–1543), architect and wood-carver who was making a wooden model of the San Lorenzo façade for Michelangelo.

Grassa: Francesco di Giovanni Nanni della Grassa, a stone-mason from Settignano.

enough ointment: Maestro Pier Fantini proverbially worked for nothing and threw in bandages and ointment too.

90 *As for the said price*: the contract dated 19 January 1518 set the price at 40,000 ducats and allowed 8 years for completion.

92 *the contract has not yet been made*: the decision to give Michelangelo authority to build a road came on 22 April 1518 when he was granted a life concession for quarrying marble at Pietrasanta and Seravezza.

93 *Jacopo Salviati*: (d. 1533) brother-in-law of Pope Leo X and a banker, revered Michelangelo as a close friend. He was a member of the Guild of Wool Merchants responsible for building work at Santa Maria del Fiore.

Ser Giovanni Francesco Fattucci: chaplain from the Cathedral at Florence who represented Michelangelo in the negotiations over the tomb of Julius.

94 *Figiovanni*: Giovanbattista Figiovanni (d. 1544) was a canon and (1534) prior of San Lorenzo who stirred up trouble for Michelangelo but helped him after the siege of Florence, when the artist went into hiding.

in Rome the Pope: Adrian VI who succeeded Leo and reigned from January 1522 to September 1523. Followed by Cardinal Giulio de' Medici who was elected as Pope Clement VII on 19 November 1523.

95 *Sebastiano del Piombo*: Sebastiano (*c.*1485–1547), Venetian painter who came to Rome in 1511 and was a supporter of Michelangelo; however, the letter is more likely to have been addressed to the Florentine notary Ser Bonaventura di Leonardo, according to E. H. Ramsden.

96 *Gaddi*: Florentine bank in Rome.

100 *Agostino Chigi*: (1465–1520) Sienese banker and Papal financier, member of a very wealthy family living in Rome in notorious luxury.

101 *complained to Messer Bernardo da Bibbiena*: Bernardo Dovizi (1470–1520), friend of Castiglione and patron of Raphael, he was made cardinal of Santa Maria in Portico by Leo X.

Attalante: (1466–*c.*1555) Florentine, one of the superintendents of the fabric of St Peter's.

102 *Aginense told me*: Cardinal Leonardo Grosso della Rovere, Bishop of Agen, was commissioned along with Lorenzo Pucci (who became Cardinal of Santiquattro) to ensure the completion of Pope Julius's tomb.

a tomb like that of Pius: the tomb of Pius II (1458–64) is now in Sant' Andrea della Valle.

103 *Antonio Mini*: one of Michelangelo's friends and helpers, especially in business matters. Took the painting of the Leda to France for King Francis I.

Giovan Francesco: Giovanni Francesco Fattucci, who promoted this letter of inspired comedy, the chaplain at Santa

Maria del Fiore who at one time acted for Michelangelo in Rome over Pope Julius's tomb. Pope Clement was serious about having a colossus made of blocks.

104 *a huckster*: refers to Giovanbattista Figiovanni, prior of San Lorenzo, who had accused Michelangelo of making the Library like a dovecot.

some risk at the gate: would presumably be the danger of running into the toll-collectors.

Spina is shortly coming to Rome: Giovanni Spina was an agent of the Medici often in touch with Michelangelo.

105 *figures that have been roughed out*: the statues for the Medici tombs in the New Sacristy. Michelangelo left Florence for good in 1534 and only two figures representing the Dukes (*Capitani*) were finished and set in place.

Giovanni da Udine: Giovanni dei Ricamatori da Udine (1494–1564) was engaged by Pope Clement to paint the vault of the New Sacristy. Because of the turmoil in Italy, he arrived in Florence for this purpose only in 1532.

106 *Battista della Palla*: Giovanni Battista della Palla from Lucca was employed by Francis I to buy works of art in Italy. He antagonized the Medici and died in prison.

to see the end of the war first: Florence rebelled against Medici dominance after the sack of Rome in 1527. Subsequently the Imperial army besieged the city (from October 1529). Michelangelo was made a member of the Council of Nine for the Militia, and fortified the strategically important hill of San Miniato. He came to suspect treachery from the *condottiere*, Malatesta Baglioni, fled from Florence, was declared an outlaw, but returned in November. In August 1530 Florence capitulated and he went into hiding, to emerge after Pope Clement's anger died down.

107 *Tommaso de' Cavalieri*: met Michelangelo in the latter's first long visit to Rome after the siege of Florence. Michelangelo made several drafts of this letter, which may not in fact have been sent. Tommaso was with Michelangelo when he died.

Pierantonio: Pierantonio Cecchini, member of the household of Cardinal Niccolo Ridolfi.

the gifts one is sending him: could mean friendship, or refer to drawings sent as gifts.

108 *the two madrigals*: written by Michelangelo and both set to music.

work on which I am engaged here: the Medici tombs.

the manner and style of Figiovanni: i.e. his trouble-making and fawning behaviour.

don't show this letter: that is, to the Pope.

109 *Febo di Poggio*: unknown but clearly intimate young friend of Michelangelo. In a letter dated 14 January 1534, Febo regrets that he did not see Michelangelo before he left Florence, asks for money, and adds that Michelangelo is like a father to him. Febo is also mentioned in two of Michelangelo's sonnets with references (punning on his name) to Phoebus, the sun, and *Poggio*, the height from which the poet had fallen.

Cardinal Cesis: Cardinal Paolo Emilio Cesis (1481–1537).

Messer Baldassare: Baldassare Turini da Pescia (1485–1543) served several Popes in succession (Leo X, Clement VII, and Paul III) as datary, secretary, and clerk of the Camera, and Nuncio to Charles V.

Messer Pietro Aretino: in one of his fulsome letters the writer Pietro Aretino had said magnificently that the world had many Kings but only one Michelangelo. Dated 15 September 1537, it contained a brilliantly imaginative description of the Day of Judgement and the flattering statement that to see Michelangelo's painting on this theme, he would break a vow he had made and return to Rome. In a subsequent letter, disappointed at Michelangelo's response to his requests, Aretino damned the *Last Judgement* as obscene, said it would be better in a brothel, and slipped in an innuendo over Michelangelo's generosity to certain *Gherardi* and *Tommasi*.

110 *the great task*: the painting of the *Last Judgement* in the Sistine Chapel.

111 *Mal fa chi tanta fè si tosto oblia*: a line from one of Petrarch's Canzoni (xv), meaning 'Who so soon forgets such trust does ill.'

Luigi del Riccio: (d. 1545) head of the Strozzi-Ulivieri bank in Rome and descendant of a noble Florentine family in exile in Rome, he looked after Michelangelo's business affairs. He was the uncle of Cecchino Bracci, a boy of great beauty and contemporary fame who died young and whom Michelangelo commemorated in a spate of curious epigrams praising his looks and charm.

discord that has arisen . . . Giovanni: Michelangelo had made a subsequently cancelled contract for the completion of the tomb of Pope Julius, dividing the work between his assistant Francesco di Bernardino d' Amadore da Urbino and Giovanni de' Marchesi da Saltri.

to give it . . .: MS is torn.

112 *Macello de' Poveri*: Poor Men's Street which Michelangelo wrote instead of Macello de' Corvi (Street of the Ravens).

To Monsignor . . .: the Monsignor may have been the Bishop of Sinigaglia, Marco Vigerio; but a strong case is made by Dr Ramsden for Cardinal Alessandro Farnese, grandson of Pope Paul III.

on the strength of the other contract: this third contract for the tomb of Julius was drawn up on 29 April 1532. Little progress was made, and on 20 August 1542 the fourth and last contract was drawn up. Under this Michelangelo was to deposit 1,400 *scudi* to pay for the completion of the tomb, and he was confirmed as owner of the house in the Macello de' Corvi. The tomb was completed in 1545.

116 *a man from nowhere*: Michelangelo says 'I am not a man from Cagli', which was a town of no consequence.

119 *Messer Bartolomeo Ferratini*: Ramsden establishes that the letter was addressed to Bartolomeo Ferratini and not as once thought to Bartolomeo Ammanati (1511–95) the talented sculptor and architect, a friend of Michelangelo, who worked for Duke Cosimo and was to help make the arrangements for Michelangelo's obsequies in Florence. Ferratini was the Prefect of the deputies of the fabric and a canon of St Peter's.

the first plan for St Peter's: partly to accommodate his projected tomb, Julius II asked for plans and chose a design by Donato Bramante, in the form of a Greek cross, for the rebuilding of the Basilica of St Peter. Leo X appointed as his architects Giuliano da Sangallo, Fra Giocondo, and Raphael, who was succeeded by Baldassare Peruzzi da Siena. Pope Paul III put in charge Giuliano's nephew, Antonio da Sangallo, and his very complicated design was approved in 1540 and much of it put into effect by 1547, when Michelangelo reluctantly took over at the age of 71, following Sangallo's death.

120 *by dint of taking away . . .*: *per forza de levare . . . per via di porre*.

similar kinds of learning: simili scienze.

121 *house belonging to the Corsi*: Giovanni de' Bardo Corsi (1472–1547) was a diplomat and thinker who died a short while before this letter was written.

Guicciardini's baby: Michele di Niccolò Guicciardini was the husband of Francesca Buonarroti, daughter of Michelangelo's brother, Buonarroto.

I have lost the ferry dues: some of Michelangelo's salary as the chief architect, painter, and sculptor was to be paid from the revenues of the river Po ferry, but there were frequent arguments over his right to them.

122 *I am glad you have advised me about the proclamation*: many Florentines opted for voluntary 'exile' after the return of the Medici and the downfall of the Republic. Under Duke Cosimo a succession of enactments were issued to stop any communication with them, and any further emigration. A *bando* of November 1547 confirmed previous measures.

124 *the farm at Monte Spertoli*: Michelangelo came to own a fair amount of property, houses and workshops, plots of land, possibly a farm, and a solid fortune.

125 *I sent Bettini*: Bartolomeo Bettini who worked for the Cavalcanti bank in Rome.

whose mother was a Soderini: Lionardo di Bartolomeo Ginori (1502–48) married Caterina di Tommaso Soderini, a woman whose beauty aroused the passions of Alessandro de' Medici, illegitimate son of Pope Clement VII and Duke of Florence from 1530, and who was used to lure him to his murder by Lorenzino in 1537. Lorenzino was himself murdered in 1547 by agents of Cosimo de' Medici.

126 *we have a new Pope*: the Del Monte Pope Julius III elected 8 February 1550.

127 *Varchi*: Benedetto Varchi (1503–65) Florentine critic and historian, gave the two public lectures in 1547 at the *Accademia Fiorentina* (founded to encourage Italian literature and preserve the Tuscan language) on one of Michelangelo's sonnets (*Non ha l'ottimo artista . . .*) and on the rival merits of painting and sculpture respectively. He was to deliver the oration at Michelangelo's funeral in Florence.

Giorgio: Giorgio Vasari.

Marchioness of Pescara: Vittoria Colonna.

128 *the trebbiano*: a sweet white wine from Tuscany.

the two Briefs: Pope Paul's Brief of 1 September 1535
appointed Michelangelo Supreme Architect, Sculptor, and
Painter at the Vatican and granted him a salary of 1,200
crowns (*scudi*) a year; a second Brief dealt more specifically
with the salary, of which 600 *scudi* were to be secured on
revenues from the ferry.

129 *Messer Bindo Altoviti*: Altoviti (1491–1557) whose bust was
done by Benvenuto Cellini in 1550 was a wealthy Florentine
banker and exile. The letter is quoted in Cellini's own
autobiography.

Christen them . . .: *bronche*, a kind of yellow pear.

130 *we shall be dying of hunger*: the shortages in Rome followed
failures of the harvest and the arrival of thousands of
pilgrims for Jubilee year 1550.

131 *wanting to write sonnets*: with this letter Michelangelo sent
the sad sonnet beginning *Giunta è già 'l corso della vita mia*.

133 *a very discreet and worthy young man*: Lionardo Marinozzi
da Ancona, chamberlain to Cosimo I and envoy to Pope
Paul IV.

you know that Urbino has died: (*c.*1515–55) Francesco da
Urbino, Michelangelo's loyal servant, died in the same year
as Gismondo, Michelangelo's brother. Urbino left Michel-
angelo as the guardian of his children.

134 *Benvenuto*: Benvenuto Cellini.

136 *Master Eraldo can bear witness*: Realdo Colombo, a famous
doctor, who was Michelangelo's physician till his death in
1559.

SELECTED POEMS

In the order and dating of the poems I have consulted the texts
edited by Girardi (Editori Laterza, 1967) and Barelli (Rizzoli,
1975).

139 *I'ho già fatto un gozzo . . .*: this is an early translation (1981)
or free imitation by Peter Porter of one of Michelangelo's
most startling poems among those dealing with art, his
feelings as an artist, or specific works. Addressed to a friend

and versifier, the *sonetto caudato*, or sonnet with a tail, ends with a protest against being given the task of painting the Sistine Chapel ceiling by Pope Julius II because 'I am not a painter' (*né io pittore*).

like a Lombard cat: the Italian for cats (*gatti*) could have been a colloquialism for 'peasants', according to Noè Girardi in his notes to Michelangelo's poetry. This would satisfactorily explain an otherwise baffling simile.

140 *Tommaso Cavalieri*: Michelangelo met this handsome young Roman nobleman for the first time in 1532, when he was 57, and Cavalieri probably in his early twenties. He was present at Michelangelo's death, and still a devoted friend, 32 years later. As well as writing sonnets for him, Michelangelo presented Tommaso with several allegorical drawings and did his portrait—a rare gesture—mentioned in Vasari's *Life*, but lost.

142 *The smith when forging iron*: fire, fame, giants, and the Christian phoenix, are frequent images in Michelangelo's verse among the minor themes counterparting the major subjects of love, art, religion, and death.

143 *your letters*: Cavalieri's earliest affectionate and respectful letters to Michelangelo in Florence thanking him for drawings of *The Fall of Phaethon*, *Ganymede* and *Tityus*, were written from Rome in 1532–3.

144 *And should the mob*: the *vulgo malvagio*. The lines are a revealing indication of Michelangelo's awareness and contempt for the gossip about his relationship with Cavalieri, which was also alluded to suggestively in the letter written in the 1540s by Michelangelo's critic, the writer Pietro Aretino.

146 *I wish to want, Lord*: addressed to God, a prayerful poem and example of Michelangelo's deep and troubled religious sensibility and of his midway stylistic course between Petrarchan and baroque imagery.

148 *With your bright eyes*: this greatly admired example of Michelangelo's lyricism has been set to music by William Platt and by Benjamin Britten.

149 *an armoured knight*: *un cavalier armato*, the last words of the poem contain a pun on the name of Cavaliero (other sonnets also pun on people's names) and perhaps an allusion to Michelangelo's portrait of Tommaso.

150 *O dark yet lovely night*: night was a theme often used by Michelangelo in his verse, and also in the tomb sculptures of the Medici Chapel in San Lorenzo.

151 *The Creator, who from nothingness*: the sun, in this sad, introspective sonnet, may refer to Cavalieri; the first lines illustrate the constant echoes of the themes and substance of Michelangelo's artistic work in his poetry—the first scenes of the vault of the Sistine Chapel show the Creation.

153 *No block of marble*: among the most famous of Michelangelo's sonnets and of special value for the light it throws on his theory and practice as a sculptor. His friend, the Florentine man of letters, Benedetto Varchi, who elicited from Michelangelo much of his opinion on the nature of art, delivered his erudite discourse on its significance to the Florentine Academy in 1547. Varchi's two lectures drew on Michelangelo's sonnet, *Non vider gli occhi miei cosa mortale*, and on two of the sonnets expressing Michelangelo's love for Cavalieri as well as discussing the rival merits of painting and sculpture.

Vittoria Colonna, Marchioness of Pescara, was herself a prolific versifier. Widowed in 1525, she led an intensely pious and austere life, and like Cavalieri was the recipient of Michelangelo's strong affection, drawings and verse.

154 *To your resplendent beauty's*: one of Michelangelo's many madrigals which he noted needed to be 'polished'.

155 *This savage woman*: another of the madrigals intended for publication by Michelangelo, which may have been among those inspired by an unknown 'beautiful and cruel woman' dreamed up by Michelangelo's editors; and possibly presenting an allegory by Michelangelo of the art he practised.

157 *Out of heaven*: one of Michelangelo's two sonnets in praise of Dante in whose work he had immersed himself, with whom he had great affinity, and whose influence may be seen most starkly in the drama of the painting of the *Last Judgement* in the Sistine Chapel.

158 *La carne terra*: this and the following three quatrains are samples of the forty-nine (possibly fifty) epitaphs which Michelangelo wrote for Luigi del Riccio, in memory of the latter's nephew Cecchino Bracci, when he died in January 1544. Michelangelo's contributions to the *florilegium* of verses that the doting del Riccio (who wanted Michelangelo to do a bust of the dead boy) insistently requested were

effusive, admiring, sarcastic, and loving in turn and raise difficult questions regarding their tone and significance.

Cecchino's family name (Braccio means arm) also, like the names of many others, including several Popes, gave Michelangelo irresistible opportunities of punning in verse.

160 *Caro m' è 'l sonno*: this famous and resonant epigram was in answer to one on the figure of *Night* for the tomb of Giuliano de' Medici in the Medici Chapel written by his admirer, Giovanni di Carlo Strozzi, who said the statue, sculpted by an angel, would speak if awoken. Michelangelo's reply reflected his disillusionment with the state of Florence under the restored Medici family.

The Oxford World's Classics Website

www.worldsclassics.co.uk

- Information about new titles
- Explore the full range of Oxford World's Classics
- Links to other literary sites and the main OUP webpage
- Imaginative competitions, with bookish prizes
- Peruse the Oxford World's Classics Magazine
- Articles by editors
- Extracts from Introductions
- A forum for discussion and feedback on the series
- Special information for teachers and lecturers

www.worldsclassics.co.uk

American Literature

British and Irish Literature

Children's Literature

Classics and Ancient Literature

Colonial Literature

Eastern Literature

European Literature

History

Medieval Literature

Oxford English Drama

Poetry

Philosophy

Politics

Religion

The Oxford Shakespeare

A complete list of Oxford Paperbacks, including Oxford World's Classics, Oxford Shakespeare, Oxford Drama, and Oxford Paperback Reference, is available in the UK from the Academic Division Publicity Department, Oxford University Press, Great Clarendon Street, Oxford OX2 6DP.

In the USA, complete lists are available from the Paperbacks Marketing Manager, Oxford University Press, 198 Madison Avenue, New York, NY 10016.

Oxford Paperbacks are available from all good bookshops. In case of difficulty, customers in the UK can order direct from Oxford University Press Bookshop, Freepost, 116 High Street, Oxford OX1 4BR, enclosing full payment. Please add 10 per cent of published price for postage and packing.